INSANE ACQUAINTANCES
Visual Modernism and Public Taste in Britain, 1910–1951

A British Academy Monograph

British Academy Monographs showcase work arising from:

British Academy Postdoctoral Fellowships
British Academy Newton International Fellowships

INSANE ACQUAINTANCES
Visual Modernism and Public Taste in Britain, 1910–1951

Daniel Moore

Published for THE BRITISH ACADEMY
by OXFORD UNIVERSITY PRESS

Oxford University Press, Great Clarendon Street, Oxford OX2 6DP

© The British Academy 2020
Database right The British Academy (maker)

First edition published in 2020

British Library Cataloguing in Publication Data
Data available

Library of Congress Cataloging in Publication Data
Data available

Typeset by Servis Filmsetting Ltd, Stockport, Cheshire
Printed in Great Britain by TJ International

ISBN 9780197266755

For my Mom and Dad

Contents

Figures

Colour plates

Acknowledgements

This book began as a British Academy Postdoctoral Fellowship project and, indeed, would not have even been begun had I not been awarded the Fellowship. The support I've received from the British Academy over the past few years has been instrumental, and they have made me feel like part of an academic family. The Fellowship programme has launched so many careers over the years—there are generations of academics out there who owe it so much—and I count myself lucky to be one of them.

Books that depend on the archives do not get written without the support of so many knowledgeable people who dedicate their lives to the preservation of the past. For this study, I have depended on staff at the British Library, the Bodleian Library, the University of East Anglia Special Collections, the University of Birmingham Special Collections, the Birmingham School of Art, the New York Public Library, the Harry Ransom Humanities Research Centre and the Yale Center for British Art. I thank them all for their support.

1

Revolutionising 'Bird's Custard Isle'

We kill what is best,
and on first insane acquaintance.[1]

This study was prompted by a throwaway comment on a radio show nine years ago. On Friday 22 October 2010, BBC Radio 4 broadcast an edition of the arts and culture programme *Front Row*.[2] The programme was largely devoted to a then-and-now analysis of Young British Artists (YBAs)—the ways in which figures such as Damien Hirst and Tracey Emin had changed the course of visual art in Britain and brokered a new relationship between art and its publics. Though YBAs were hardly out of the news during the last years of the 1990s, academic interest in their work remained thin on the ground and they became newsworthy because of public and media outcry rather than artistic significance. To this end, the art critic Matthew Collings (while dismissing the work of YBAs as facile) argued that the reaction to the work of Hirst and Emin highlighted a more universal problem, which concerned the British attitude to the arts over the course of a century or so: 'We're in a period of democratization of art,' Collings said, 'but it will be a long time before everyone is able to [...] comprehend the difficulties of art.' Just how long has this period lasted, and is there any evidence that it might be coming to an end? And, perhaps more importantly, is a state of affairs in which everyone comprehends the difficulties of art an ideal that artists and critics have been—or indeed should be—striving towards? These are the fundamental questions that lie behind this study of artistic modernism in Britain. The difficulties that the British public have with 'the artistic' (and even such a neutral word such as this has mutated over the last century to define a specific kind of attitude to art that is centripetal, elitist and

[1] Wols, *Aphorisms and Pictures*, trans. Peter Inch and Annie Fatet (Gillingham: Arc Press, 1971), 32.
[2] Matthew Collings, 'Damien Hirst and the British Art Show 2010', *Front Row* (22 October 2010), BBC Radio 4.

does not make concessions to the man in the street) come, largely, from modernism. Many of the works of visual and literary experimentation canonised today as modernist interrogated and reflected upon precisely those difficulties of art in modern secular culture with which Collings believes the general public is still struggling. Modernism, in most narratives about the subject, concerns itself with exploring the nature, meaning and significance of expressive acts in a modern world of speed, technology and global free-market economy, through formal experimentation, shock and alienation. As a modernist scholar, indeed, one's first encounter with its art and literature is attended by accounts of critical, public, even theological condemnation. Though there have been so many other iterations of the 'artist versus society' in Western aesthetic and literary history, the divide seems—at first glance—to be most unbridgeable in the work of those experimental writers and artists practising in the early decades of the 20th century.

As an art initially derided as chaff (or, even worse, as dangerously incendiary), modernists and their defenders were forced to operate as scorned outcasts, disapproved of by the media and gawked at by a herd-like public. 'In the last twenty years,' wrote Stephen Coleridge in 1925:

> we have had one set of persons painting men and women with heads like lard bladders and limbs like German sausages; followed by another set of persons who have represented the human form as an agglomeration of parallelograms, rhombs and triangles. Gaping crowds of uneducated donkeys have crowded into the little esoteric galleries at a shilling a head where these impertinences have been exhibited. [...] In Letters we have had the same eruption of uneducated nonsense [...] Various collections of words, possessing neither rhyme, rhythm, nor prosody, are printed in lines of no particular length down the middle of pages in books with 'Poetry' inscribed on their backs and title pages, and these are hailed by the critics as something superior to all those discredited masters from Homer to Tennyson.[3]

Hounded by the arbiters of morality and decency—the 'rabblement, placid and intensely moral' as James Joyce called them—modernist writers and artists retreated to the margins and reflected on societal fragmentation, the creeping effect that mass literacy and cheap paperbacks had on reading culture and on the impossibility of showing anything but pretty pictures in galleries.[4] Many of them died poor.

Their attitudes towards the general public ranged from aversion to downright exterminatory. Ezra Pound, writing on 'The New Sculpture' in 1914,

[3] Stephen Coleridge, [untitled], *English Review* (July 1925): 44–5; 44.
[4] 'The Day of the Rabblement', in James Joyce, *The Critical Writings*, ed. Ellsworth Mason and Richard Ellman (New York: Viking, 1968), 70.

declared that the artist's only recourse in defending his position against the world was 'slaughter'—artists were all set to 'take control', the public would 'do well to resent these "new" kinds of art' and the *avant gardiste* 'has no intention of trying to rule by general franchise'.[5] The nascent authoritarian politics brewing in Pound's language spilled over into a fully elaborated system in Wyndham Lewis's *The Art of Being Ruled* (1926). For Lewis, the public do not really ask for, nor require, freedom: 'Freedom postulates a relatively solitary life: and the majority of people are extremely gregarious [...] They wish to pretend to be "free" once a week, or once a month. To be free would be an appalling prospect for them.'[6] The mob needs, and wishes, to be ruled by a caste of philosopher-intellectuals, vigorous and potent leaders with no little of the *übermensch* about them. Within this dictatorship, the artist would prosper. And it was not too difficult to see how he would prosper, given that he 'should be accommodated with conditions suitable to his maximum productivity [and...] relieved on the futile competition in all sorts of minor fields, so that his purest faculties could be free for the major tasks of intelligent creation'.[7] This welfare system for the artist, at what must be the expense of the mob, often appears to be the guiding principle of a modernist polity. When faced with the real issues of the interwar years—mass unemployment and significant economic hardship—Pound reiterated that the artist was at the centre of his concerns, and that everyone else could go hang:

> The unemployment problem that I have been faced with, for a quarter of a century, is not or has not been the unemployment of nine million or five million, or whatever [...] It has been the problem of the unemployment of Gaudier-Brzeska, T. S. Eliot, Wyndham Lewis the painter, E.P. the present writer, and of twenty or thirty musicians, and fifty or more other makers in stone, in paint, in verbal composition.[8]

If this republic of the artist would disenfranchise the masses, then who precisely was modernist art and literature for? Richard Aldington, one of Pound's co-contributors to *Des Imagistes* in 1914, drew a clear picture of the chasm between the general public and advanced art:

> The conditions of modern popular art are so degrading that no man of determined or distinguished mind can possibly adopt them. 'What the public wants' are the stale ideas of twenty, or fifty, or even seventy years ago, ideas

[5] Ezra Pound, 'The New Sculpture', *The Egoist*, 4, 1 (16 February 1914): 68.
[6] Wyndham Lewis, *The Art of Being Ruled*, ed. Reed Way Dasenbrock (Santa Rosa, CA: Black Sparrow Press, 1989), 42.
[7] Ibid., 375.
[8] Ezra Pound, 'Murder by Capital', in William Cookson (ed.), *The Selected Prose of Ezra Pound: 1909–1965* (New York: New Directions, 1973), 229.

which any man of talent rejects at once as banal [...] The arts are now divided
between popular charlatans and men of talent, who, of necessity, write, think
and paint only for each other [...][9]

The creation of coteries of artistic production and consumption was neces-
sary for the survival of a high culture untainted by the demands of the
populace. For T. S. Eliot, writing as late as 1948, ham-fisted education of
the public would lead to a disastrous dilution of culture:

in our headlong rush to educate everybody, we are lowering our standards,
and more and more abandoning the study of those subjects by which
the essentials of our culture—of that part of it which is transmissible by
education—are transmitted; destroying our ancient edifices to make ready
the ground upon which the barbarian nomads of the future will encamp in
their mechanized caravans.[10]

With this very idea in mind, D. H. Lawrence did his best to stop the aver-
age reader from delving any further into *Fantasia of the Unconscious* (1922)
than the 'Foreword' on page one. 'The generality of readers had better just
leave it alone,' Lawrence wrote. 'I don't intend my books for the generality
of readers. I count it a mistake of our mistaken democracy, that every man
who can read print is allowed to believe that he can read all that is printed.
I count it a misfortune that serious books are exposed in the public market,
like slaves exposed naked for sale.'[11] Lawrence's criticism of the general
public would go far beyond their aesthetic sensibilities. Man, reduced to a
mere automaton—worse, to a biological machine—by the brutalising capi-
talist drive towards efficiency, had no inner core through which to appreci-
ate esoteric beauty and lacked the intellectual and imaginative capacity, for
the most part, to change the conditions of his existence. The public had
their own tastes—usually commercial, dictated by companies seeking to
profit from pseudo-beauty—and the sphere of high art need not go near
them. To this end, Margaret Anderson's *Little Review*, the magazine that
started to serialise James Joyce's *Ulysses* in 1918, even carried the slogan
'Making no compromise with the Public Taste' under its title.

It is easy to see, even in such a brief and obviously selective tour, why
the products of artistic modernism alienated a wider viewing and reading
public and seemed to make no effort to court approval or comprehension

[9] Richard Aldington, 'Some Reflections on Ernest Dowson', *The Egoist*, 2, 3 (1 March 1915):
37.
[10] T. S. Eliot, *Notes Towards the Definition of Culture* (London: Faber and Faber, 1972), 108.
[11] D. H. Lawrence, *Psychoanalysis and the Unconscious and Fantasia of the Unconscious* (New
York: Dover, 2005), 53.

on a wide scale. And one critical tradition, represented best perhaps by John Carey's *The Intellectuals and The Masses* (1992), has sought to show, exhaustively, how modernism scorned the people. Yet, and here is perhaps the most succinct argument for a book such as this one, modernism quite quickly became part of the middlebrow taste. More than that, it began to be valorised and valued, aesthetically and financially, more highly than the products of nearly any other historical period, not just by elites, but also by mainstream culture. John Xiros Cooper has influentially argued that modernism's complicated relationship with its markets actually led, over the course of the 20th century, to the development of emancipated, capitalist, cultural communities that characterise developed society today, and that 'the culture intrinsic to market society [...] spread from the avant-garde enclave to society at large, transforming, in its course, the everyday lives of the very philistine masses the early modernists haughtily kept at arm's length'.[12] Consequently, the modernist artefact (artistic, literary or otherwise) has been drawn closer to mainstream culture by becoming central to what constitutes the tasteful. Cooper goes on to say that the reclamation of subversive artistic energies by a hegemonic mainstream is a fact that colours all post-Enlightenment Western culture: 'The history of the last two centuries shows us again and again how the aesthetic as a primal source of value, no matter how radically disjunctive and oppositional it seems, can be absorbed over time by the dominant economic orthodoxy and recuperated as a sustaining pillar of the very system it was invented to oppose.'[13] In this sense, late capitalist culture is the offspring of an early 20th-century avant-garde abstracted from its political energies: 'The playfulness of the postmodern, the penchant everywhere for parody and pastiche, the pervasiveness of irony, the telescoping of history into simulacra of the past, like the theme park and the heritage industry, are the result of the spreading of the word of modernism without any of its original meanings and moods to weigh it down.'[14]

If we follow this argument to its end, then it was entirely unintentional that high-modernist art and literature ended up colonising mass public taste—in fact, the early 20th-century avant-garde would have been horrified by its own commodification and its consumerist and capitalist reification. But we need to be a little careful in separating two different effects here, and

[12] John Xiros Cooper, *Modernism and the Culture of Market Society* (Cambridge: Cambridge University Press, 2004), 4.

[13] Ibid., 6.

[14] Ibid., 5.

we need to be doubly careful of reducing modernism to a narrow pastiche of itself as entirely anti-democratic and oligarchic. While it is undoubtedly true, as Cooper argues, that modernism did not intend to court this kind of legacy, then it is not necessarily true to say that it rejected *any* public legacy at all. In fact, many of its promoters, brokers and mediators sought not to elide and avoid the public but to connect with it and modify its opinions and tastes—in short, they were involved not only in trying to improve the quality of art, but also the quality of art's reception. The intentions of these arbiters of taste were multiple. Often the aim was to make money. More often, however, it was their belief that, despite an adversarial relationship with the public, a wide and deep engagement with art and its difficulties was the basis of a sound and harmonious culture. Modernism, characterised so often by its focus inward towards the revitalisation of form, was also involved in re-engaging its audiences with art through an appeal to its cultural, national and political importance—as social commentary, as decoration and as a vessel for individual and cultural betterment. It did this by radically opposing the normative standards of a reactionary establishment and the aestheticist and decadent betrayal of art into the hands of a haughty, overly refined elite.

Recent criticism has gone some way to deconstruct the still oft-cited notion of modernism's abjuration of its publics and markets and has drawn critical attention away from the philosophies and actions of artists and writers to a reception history of their products. Lawrence Rainey's *Institutions of Modernism* began a process of seeking modernism's material contexts, and this has been enhanced and continued by the work of Kevin J. H. Dettmar and Stephen M. Watt, and by Edward P. Comentale.[15] Jonathan Rose has even suggested that modernism was, essentially, goal-oriented towards financial success.[16] With this body of work in mind, I want to develop an understanding of the mediation and promotion of modernism (foreign, as well as home-grown) in Britain by thinking about the propagation of a taste for its aesthetics in the public arena. This book is about the actions of individuals and groups who took possession of largely unpalatable, often European, avant-garde aesthetics and spread the word. Modernism's legacy

[15] Lawrence Rainey, *Institutions of Modernism: Literary Elites and Public Culture* (New Haven, CT: Yale University Press, 1998); Kevin J. H. Dettmar and Stephen M. Watt (eds), *Marketing Modernisms: Self-Promotion, Canonization, Rereading* (Ann Arbor: University of Michigan Press, 1996); Edward P. Comentale, *Modernism, Cultural Production and the British Avant-Garde* (Cambridge: Cambridge University Press, 2004).
[16] Jonathan Rose, 'Lady Chatterley's Broker: Banking on Modernism', in Pamela L. Caughie (ed.), *Disciplining Modernism* (Basingstoke: Palgrave, 2010), 182–96.

in Britain may not be the one it wanted—socially or aesthetically—but many of its agents and actors intended to transform the public perception of art and, by so doing, ameliorate British culture. We may yet be waiting (with Matthew Collings) to see if it succeeded.

There is some difficulty in erecting the improvement of public taste as a cornerstone of modernist philosophy and practice. For one, taste has a troubling heritage as a term associated with 19th-century aesthetic profligacy and decadence. As most socio-cultural histories of the 19th century have it, the concern for social reform in Victorian cultural commentary gave way slowly to a new interest in aestheticist ideas, whose original robustly socialist character (in the guild socialism of the Arts and Crafts movement, for example) mutated into the disinterested and rarefied discourse of decadence. Bringing the masses into the orbit of art was, of course, the aim of many a Victorian reformer. The greatest sages of the 19th century— William Morris, John Ruskin and Matthew Arnold, in particular—in different ways and for different reasons sought to bring about what amounted to an education in taste, because they believed that a better knowledge, understanding and appreciation for what we might broadly call the aesthetic would be beneficial for the spiritual, philosophical and moral well-being of the social body. However, the shifting sands of cultural and class relations scuppered their plans. Marxist narratives of cultural development in the industrial age site the disintegration of culture into elite and popular forms precisely in the mid-Victorian period. The advent of widespread literacy, the creation of wider cultural markets predicated on economic mobility and power, new distribution networks made possible through new technologies in publication, reproduction and dissemination—all were significant contributions towards mass culture marked by a monetisation of artistic products that was unprecedented in history. Pulp fiction and mass reproductions of paintings and sculptures flooded markets and standardisation all but killed off the artisan. Morris deplored the mass-produced—it was the 'hypocrisy, flunkeyism, and careless selfishness' of art that expressed 'the very worst side of our character both national and personal'.[17] Ruskin asked his readers to scan their own living rooms and analyse the 'perfectnesses' contained therein as evidence of 'slavery in our England a thousand times more bitter and more degrading than that of the scourged African,

[17] William Morris, 'Making the Best of It', in *The Collected Works of William Morris*, ed. May Morris, vol. 22 (London: Longmans Green, 1910–15), 85.

or helot Greek'.[18]Arnold was equally melancholic about this state of affairs. *Culture and Anarchy*, conceived in the wake of the Hyde Park Riots in 1866, bemoaned the difficulties that lay ahead in cultivating an aesthetically arid middle class: the middle classes, remaining as they are now, with their narrow, harsh, unintelligent, and unattractive spirit and culture, will almost certainly fail to mould or assimilate the masses below them. Worryingly, if the middle classes retreated further into philistinism, the results would be socially calamitous. If they could not lead by cultural example, he warned, society would be in danger of falling into anarchy.[19]

Ironically, given their broadly socialist philosophy of art, it was Ruskin, Morris and Arnold who paved the way for a later aestheticist retreat to coteries and cliques. Ruskin's sage-like personality, in particular, was the archetype of the powerful, individual arbiter of taste whose opinions were highly subjective and reliant on a deep knowledge of a history of the arts. T. S. Eliot blamed Arnold for the excesses of Walter Pater.[20] By the time of Pater's *Studies in the History of the Renaissance* (1873), which proclaimed the sovereignty of the aesthete and a firm belief in good taste enriched by exposure to classical forms, appreciation and discernment had fully withdrawn from the everyday life of the masses. The logical endpoint for this retreat was an insipid aesthetic couched in the languid language of decadence. Pater was old hat by 1910, harking back to an already outmoded Romantic genre of art writing where the critic possessed a discerning sensitivity and pontificated from an ivory tower. It all smacked of aristocratic dilettantism and decadent vampirism. Roger Fry bemoaned such vampires in 'Art and Socialism': 'As the prostitute professes to sell love, so these gentlemen professed to sell beauty [...] They adopted the name and something of the manner of artists; they intercepted not only the money, but the titles and fame and glory which were intended for those whom they had supplanted.'[21]

But if modernism was critical of these secluded, hedonistic groves where art and money were vice, could it be accused of doing something similar? For all its criticism of an anaemic aestheticism perched upon

[18] John Ruskin, *Stones of Venice* in *The Library Edition of the Works of John Ruskin*, ed. E. T. Cook and Alexander Wedderburn (London: George Allen, 1905), vol. 10, 93.
[19] Matthew Arnold, *Culture and Anarchy and Other Writings*, ed. Stefan Collini (Cambridge: Cambridge University Press, 1993), 22.
[20] See T. S. Eliot, 'Arnold and Pater', in *Selected Essays, 1917–1932* (New York: Harcourt Brace, 1950), 346–57.
[21] Roger Fry, 'Art and Socialism', in J. B. Bullen (ed.), *Vision and Design* (New York: Dover, 1998), 41.

high, modernism retreated inwards too, to a coterie culture of its own. 'From the soirées at the Stein salon,' John Xiros Cooper writes, '[...] or the gatherings of Bloomsbury at number 50 Gordon Square in London, or the "Ezra-versity" in Rapallo, Italy, the modernist avant-garde not only told itself the story of its own difference and superiority, but enacted it as well in the making of private communities.'[22] Salon culture even metamorphosed into escapist fantasy: while D. H. Lawrence and S. S. Koteliansky's 'Rananim', a planned utopian, selective community to be founded in Florida, is probably the most extreme example, Bloomsbury's figural insularity, on the other hand, is the focus of nearly every biographical study of its key members.[23] Yet, to dwell for a moment on Bloomsbury as the neatest modernist analogue to any late 19th-century ivory tower, the outward-facing rhetoric of many of its members—Roger Fry and Clive Bell in particular—was steeped in the democratisation of taste. More than any other artistic clique in Britain in the early 20th century, as I shall explore more fully in Chapter 2, Bloomsbury was involved in a relentless and increasingly market-driven self-fashioning founded largely on its own socially and aesthetically determined conception of good taste. Roger Fry's view of Britain as 'Bird's Custard Isle', conjuring up both the gaudiness of the British sense of colour and its preference for the most banal of tastes, is often used to demonstrate the fundamental disconnect between the high-minded Cambridge-educated group encircling Gordon Square and the public at large.[24] Yet Fry's desire, as a curator and as a (rather unsuccessful) businessman, was always the promotion of a democratic idea of taste, through what we might describe as a market capitalisation of a particular brand of avant-garde art. Virginia Woolf, in her biography of Fry, recalled his first instinct was always 'to educate the taste of [the] public', but characterises his slow-burning achievement with the promotion of Postimpressionism in Britain to have been as much of a stock-market success as an aesthetic one: 'Shares in Cézanne have risen immeasurably since 1910. That family, who [...] accumulated works by Matisse must today be envied even by millionaires.'[25] Woolf, with some time travel, could

[22] Cooper, *Modernism*, 3.

[23] See, for instance, Leon Edel, *Bloomsbury: A House of Lions* (London: Hogarth, 1979); S. P. Rosenbaum, *Aspects of Bloomsbury: Studies in Modern English Literary and Intellectual History* (Basingstoke: Macmillan, 1998); Jesse Wolfe, *Bloomsbury, Modernism and the Invention of Intimacy* (Cambridge: Cambridge University Press, 2011).

[24] Quoted in Quentin Bell, *Bloomsbury Recalled* (New York: Columbia University Press, 1995), 112.

[25] Virginia Woolf, *Roger Fry: A Biography* (New York: Hogarth Press 1940), 158, 159.

equally have been talking about Fry's own design company, the Omega Workshops. Deemed largely a failure in its own time on aesthetic as well as financial grounds, it nevertheless has to be revisited by the critic of modernism today because of the increasing market price of Omega-ware in the last few decades. Fry abhorred the idea that taste could be bought, but was willing to provide to the public *objets d'art* that—literally—were 'the last word', as the header on the receipt, with little irony, would testify with a large Ω.[26] Inherently contradictory though Fry's public words and actions might have been, his actions still point to something different from the enshrinement of taste by those older aestheticist cliques.

For a start, Fry and many of his contemporaries began to sever—or at least redefine—the connections between art and old money, because taste, patronage and aristocratic values were still very closely connected in Britain. As Penny Sparke writes:

> In the preindustrial context, when it was only the aristocracy that had the wherewithal to engage in the possession and display of artworks and luxury items in their interior settings, there was no need to add a qualifier to the term. In that context taste was a universally recognised, absolute value without a polarised set of meanings contained within it. [In fact, it was] ownership by the nobility that conferred status upon artworks, not the other way round.[27]

Artistic taste meant, for the group of people with the money to be able to patronise it, an attitude to art that privileged age-value above all else. As Roger Fry succinctly (and ironically) voiced it, 'Show me a Rodin with *patine* of the fifteenth century, and I will buy it.'[28] In Britain, the problem was that the traditional arbiters of good taste did not embrace modern work. Raymond Mortimer described this state of affairs best of all:

> Here no millionaire seems able to care for a picture unless its painter is dead and buried. That our motor manufacturers and tobacco magnates remain so consistently Philistine may be attributed to their education. But how mysterious is that insensibility to contemporary art of those rich aristocrats who have been brought up among the masterpieces of English painting, yet remain blind to the modern heirs of Gainsborough and Constable. An aristocracy that has ceased to give its patronage to art is like a tart who has lost her looks: it may still be useful, but it has no right to be expensive.[29]

[26] See, for example, Fry's abjuration of plutocratic tastes for 'pseudo-art' in 'Art and Socialism', 40–1.

[27] Penny Sparke, 'Taste and the Interior Designer', in *After Taste: Expanded Practice in Interior Design* (Princeton, NJ: Princeton Architectural Press, 2012), 15.

[28] Fry, 'Art and Socialism', 41.

[29] Raymond Mortimer, *The Star* (28 October 1939): n.p.

But the problem was deeper than the aristocracy—politically and economically endowed plutocrats had an increasing power to shape tastes. Tied more closely to consumerist thinking, their aesthetic tastes were always tainted by finance and capitalist economy. 'The aristocrat usually had taste,' Fry opined. 'The plutocrat frequently has not.'[30] He called for a break with all of these kinds of patronage and a revision on more democratic lines:

> It is not enough known that the patronage which really counts today is exercised by quite small and humble people. These people with a few hundreds a year exercise a genuine patronage by buying pictures at ten, twenty, or occasionally thirty pounds, with real insight and understanding [...] The work of art is not for them [...] a decorative backcloth to his stage, but an idol and an inspiration. Merely to increase the number and potency of these people would already accomplish much.[31]

For Clive Bell, too, the modernist coterie existed not with the support of the patron, but in his absence. Speaking of the Camden Town Group, the Friday Club and the London Club, Bell suggested that '[h]ere are men who take art seriously [because...] here are men who have no patron'.[32] If standards of taste were to improve, the relations upon which art and patronage had existed for so long needed a radical overhaul. If art was always a commodity, it still had to resist commodification. Redefined against its old status as the ultimate decorative luxury item, and put into the hands of people for whom taste meant something different, it could be revitalised as positive, social good. It is a significant irony, and perhaps somewhat related to both John Xiros Cooper's belief in the 'unintentional' commodification of the avant-garde and to Pierre Bourdieu's description of 'institutions of legitimation' that enshrined 'difficult' art and turned it into 'cultural capital', that the products of modernism have been monetised and institutionalised more those of any other period.[33] But such a thing should not be surprising. If many modernist artists resisted the reification of experimental aesthetics, plenty more were happy to emblazon them on a pot or a rug, and subsequent chapters focus on the tension between pure artistic creation and marketability.

There is a broader point to make here, though: that intellectualist interpretations of modernist aesthetics only tell half the story. As I explain

[30] Fry, 'Art and Socialism', 40.

[31] Ibid.

[32] Clive Bell, 'Contemporary Art in England', *Burlington Magazine for Connoisseurs*, 31, 172 (July 1917): 33–7; 36.

[33] Pierre Bourdieu, *Distinction: A Social Critique of the Judgement of Taste* (London and New York: Routledge, 2010), 3, 5.

in this book, the relationship between artistic experimentation and market forces is more nuanced than it may first appear. Modernist culture fits very neatly with Bourdieu's conception of 'cultural nobility'.[34] Modernist art seems to superficially depend on a cultural aristocracy for its production, consumption and appreciation. Small shows, short print runs, coterie aesthetics—these all point towards the centripetal impulse. The intellectualist history of modernist art—that avant-garde aesthetics in the early 20th century sought to exclude the majority—is undermined by Bourdieu's sociological analysis. This intellectualist view, according to Bourdieu, holds that taste is somehow a naturally acquired faculty: 'a work of art', in this view, 'has meaning and interest only for someone who possesses the cultural competence, that is, the code, into which it is encoded [...] A beholder who lacks the specific code feels lost in a chaos of sounds and rhythms, colours and lines, without rhyme or reason.'[35] Bourdieu's analysis of cultural trends tends to oppose such a view, carving out a category of taste dependent not on inside knowledge of difficult aesthetics, but firmly rooted in fine gradations of social and economic class. Modernism's encounter with its publics in Britain is best seen, therefore, as a series of encounters between forms and styles designed to resist reification and a marketplace conditioned to place high monetary value on things meant for the few.

For many modernist artists, though, at an idealistic level at least, aesthetic taste was not capital-driven. It should rather be brought closer to its Kantian roots in perception and disinterested judgement. And the same desire is expressed by others than Fry and Bell. For Wyndham Lewis, 'Taste is dead emotion.' To be a productive force, '[t]aste should become deeper and exclusive: definitely a STRONGHOLD—a point and not a line'.[36] But if Lewis critiqued the line that represents a fuzzy spectrum of appreciation, his redefined conception of taste, pulled to a point, is not a rejection but a reformulation. For Virginia Woolf, too, high art demanded a transformation—not an elimination—of taste:

> When the middlebrows [...] have earned enough to live on, they go on earning enough to buy—what are the things that middlebrows always buy? Queen Anne furniture (faked, but none the less expensive); first editions of dead writers, always the worst; pictures, or reproductions from pictures, by dead painters; houses in what is called 'the Georgian style'—but never anything

[34] Ibid., xxv.
[35] Ibid., xxv–xxvi.
[36] Wyndham Lewis, 'Life Has no Taste', *Blast*, 2 (1914): 82.

new, never a picture by a living painter, or a chair by a living carpenter, or books by living writers, for to buy living art requires living taste.[37]

Ezra Pound's guides to the perplexed and uninitiated—in particular *How to Read* (1929) and *Guide to Kulchur* (1938)—may be laced with irony, but they hint at an attitude that embraces the sovereignty of the individual and point towards a democratic belief in man's capacity to develop this kind of living taste. Filled with amorphous challenges to the reader, Pound employed what he calls the 'ideogramic method', by which means he attempts to present 'one facet and then another until at some point one gets off the desensitized surface of the reader's mind, onto a part that will register'.[38] The aim of this method was to shake the reader out of the cosy slumber of easy judgements and appraisals to develop a new and more alert critical acumen. 'Damn your taste,' Pound later said, in much the same vein. 'I would like if possible to sharpen your perception, after which your taste can take care of itself.'[39] The results of such a sharpened perception were as much social and communal as they were individual. An improved national taste in Britain, one that had sloughed off its Victorian skin, would be for the financial and international benefit of the country as much as for its emotional well-being.

For Margaret Bulley, 'a hundred years of industrialism of the wrong sort, with all its attendant evils, has so ruined taste that we have ceased to understand the difference between beauty and ugliness. When the history of our age is written it is easy to foresee the indictment to come.'[40] Drawing on the halcyon days of mediaeval craftsmanship à la Ruskin, she asks us to:

> [c]ontrast the position to-day. The mind of the people is largely shaped by an ultra-scientific outlook on life, by the crowding together of men in cities, the influence of a debased Press and cinema and a system of universal education as yet in its infancy. Teaching of art does little to free and stimulate inborn talent, and much to obscure it. Life is hard for the artist [...] Without living tradition of hereditary craft to guide him he replaces intuition by theory. He becomes incapable of spontaneous reaction. We have nearly killed him.[41]

The benefits to a change in the conditions of art and its consumption in Britain would revitalise the nation's aesthetic and financial life: 'Though

[37] Virginia Woolf, 'Middlebrow', in *The Death of the Moth and Other Essays* (New York: Harcourt Brace, 1974 [1942]), 198.

[38] Ezra Pound, *Guide to Kulchur* (New York: New Directions, 1970), 44.

[39] Quoted in Leonard Unger, *T. S. Eliot, A Selected Critique* (New York: Rinehart, 1948), 18.

[40] Margaret H. Bulley, *Have You Good Taste?* (London: Methuen, 1933), 2.

[41] Ibid., 13.

the levels of production and appreciation have risen in recent years in this country and in America, they are still unduly low. With the support of educated taste manufacturers could confidently employ the best designers, and the right kind of handicrafts would flourish.'[42] An editorial in the *Burlington Magazine*, too, stressed that the education and cultivation of public sensibility was vital to the success of the nation at home and abroad:

> [W]e propose, for the moment, to deal with art, not as a noble or desirable thing for its own sake, but as a national asset. Have we all realized, for instance, how much France and Italy have profited in hard cash by the taste, consistency, and liberality of their patronage of art, compared with a country like the United States, where not one man in a thousand takes even a superficial interest in it? Their cities are visited by hosts of travellers and students from all parts of the world, whose board, lodging, and railway fares alone would amount to an enormous sum annually. To this must be added the huge sales of works of art which their national reputation enables them to effect. Equally important is the effect of an artistic tradition upon the applied arts, for taste enables manufacturers to find a ready market in a thousand places which good workmanship and material could never reach unaided.[43]

The United States, that behemoth of Victorian industry and commerce, was the epitome of aesthetic indifference. If Britain went down the same road, its financial as well as aesthetic life would suffer. Heightened individual perception, democratic diffusion of art and a radical revision of the terms under which it was to be consumed had the power to divert Britain from following this course, and many of these ideas found a mouthpiece in the form of modernism.

Reformulating the concept of taste by freeing it from decadence encouraged, at least theoretically, a more democratic relationship between art and its publics, and had the potential to produce tangible benefits for society as a whole. The problems of using taste as an organising principle, however, descend not just from its 19th-century inheritance, but from our disciplinary and critical use of the term today, in the study of 20th- and 21st-century art practices especially. It seems to be a word or a concept that we can do without. One of the problems, of course, is its 'soft' associations, all of which are opposed to the rhetoric around canonical—and usually masculine—avant-garde aesthetics. As Clement Greenberg puts it:

[42] Ibid., 1.
[43] 'Art as a National Asset', *Burlington Magazine for Connoisseurs*, 5, 17 (August 1904): 429–30; 429.

Taste is a word that became compromised during the 19th century. It was in good standing in the 18th, when a philosopher like Kant, and English philosophers of aesthetics took for granted that that's the faculty you exerted in experiencing art and experiencing anything aesthetically. And then in the 19th century it wore down into something that had to do with food, clothes, furniture, decoration, and so forth, and became very much compromised.[44]

Greenberg connects taste with the ephemeral world of fashion here. Immutable taste had been 'compromised' by 19th-century industrial and commercial culture. Moreover, Greenberg shows just how closely taste became aligned with the superficial. 'Superficial', as a category, connotes a thing both predominantly concerned with surface appearance and surplus to needs. It is a negative concept because its opposite, depth, is consistently privileged in Western society. Plato treated the world of things with disdain, calling it transient and deceptive, and theorising it as one mere shadowy instance of a world of permanent and unchanging forms located elsewhere. We have to strip away the layers of the onion, get rid of the surface noise and detritus so we can look for the general and the universal. Depth is where meaning, knowledge and understanding traditionally lie. And modernism and the avant-garde, right back to the canon-forming treatises of F. R. Leavis and Edmund Wilson, has been consistently associated in criticism with depth. It is hard and it is deep. It conveyed difficult and esoteric truths through challenging and demanding aesthetic forms. It scorned the surface and the superficial. As a result, the critical lexicon around it elides 'taste', as a category, altogether. The study of avant-garde literature and art has been dominated, to some extent, by the language of hard science and vigorous philosophy. Machinery, war, technology, extreme politics, power and order make up the modernist lexicon. And, as a result, many of the non-representational iterations of modernism put on display, or indeed read, in Britain, seemed to actively reject good taste all together—it was, rather, deemed more than anything else to be ugly and in *bad* taste. It was its contraventions of good taste that made it loathsome to its critics more than any other quality. My contention here, though, is that if we reflect on taste, we might be able to redeem it. Taste lies somewhere in the negotiation between a subjective, emotive psychology and an objective philosophy and sociology. It draws simultaneously from the emotive and intellectual spheres. It is private and public, individual and collective. It is formed both in that instant, gustatory moment of sensation and in the

[44] Clement Greenberg, Transcript of a talk given at Western Michigan University (18 January 1983). See http://www.sharecom.ca/greenberg/taste.html for full transcript.

longer, reflective act. It is, in short, utterly nebulous. It is a product of, but does not belong to, the aesthetic objects it defines, and it is produced amid shifting class relations and swirling social conditions. But, to go back briefly to first principles, we can reflect on Kant's understanding of the term to demonstrate that two of the broad guiding principles of modernist aesthetics—a privileging of the individual as the site of valuable perceptive energy that can stand against the tyranny of social order and a rejection of realism as a representational trope—are both actually congruent with philosophical concepts of taste. Moreover, it might actually turn out to be a useful thing if we think about actual modernist aesthetics—and, remember, so far we have been mainly considering the public reception of art, not its inner workings—alongside concepts of the tasteful.

This seems counter-intuitive. Modernism polarises because it demands to be judged outside concepts such as the tasteful. But, and this may be a rather irksome regression for the reader so far into the chapter, we need to examine the word itself if we are to progress. Taste has a long philosophical history and comes to us in the present with the burden of unwelcome baggage. Immanuel Kant's treatise on taste lurks behind all the subsequent aestheticist and decadent sins of art. But revisiting it might allow us to reclaim something for modernism. Since Kant's explication of its meaning in relation to the nascent field of aesthetics in the 18th century, the value of taste in critical discourse has actually been in a state of flux. For all of the sound reasoning about matters of taste expressed in *The Critique of Judgement* (1790), which rejected the studies of beauty and the sublime undertaken by British empiricist philosophers such as Edmund Burke and David Hume to focus on the ontological nature of aesthetic judgement itself, Kant could not really extract the term from the philosophical conundrum he called 'the antinomy of taste':

> *Thesis:* The judgement of taste is not based upon concepts; for, if it were, it would be open to dispute (decision by means of proofs).
> *Antithesis:* The judgement of taste is based on concepts; for otherwise, despite diversity of judgment, there could be no room even for contention in the matter (a claim to the necessary agreement of others with this judgment).[45]

In other words, for Kant (and I am collapsing one of the more complicated philosophical arguments into a few lines here), taste may actually lie beyond the traditional categories of subjective and objective knowledge,

[45] Immanuel Kant, *Critique of Judgment*, trans. James Creed Meredith (New York: Oxford University Press, 2007 [1952]), 166.

resting on some rather different criteria. It is subjective, in a sense, but it is also non-relative. Aesthetic taste exists in a concrete way, but it depends on shared communities that define (in abstract ways) what constitutes it. Kant calls this the *sensus communis*:

> [...] the name *sensus communis* is to be understood [as] the idea of a *public sense*, i.e. a faculty of judging which in its reflective act takes account (*a priori*) of the mode of representation of everyone else, in order, *as it were*, to weigh its judgment with the collective reason of mankind, and thereby avoid the illusion [...] that would exert a prejudicial influence upon its judgment. This is accomplished by weighing the judgment, not so much with actual, as rather with the merely possible judgments of others, and putting ourselves in the position of everyone else [...]. This, in turn, is effected by so far as possible leaving out the element of matter, i.e. sensation, in our general state of representational activity, and confining attention to the formal peculiarities of [the] general state of representational activity. [46]

There is a lot to tease out here. Kant requires us to be at least *legion*, if not positively schizophrenic, to possess taste, hearing the voices of imagined others that correct us in an endless cycle of mirroring and self-reflection. Aesthetic judgements, however idiosyncratic or individual they may be, enjoy collective consensus because they command a universal consent: 'if we [...] call the object beautiful, we believe we have a universal voice and lay claim to the agreement of everyone'.[47] As Jukka Gronow ably notes, this Kantian 'republic of taste' is 'rather allusive and elusive [...] always keeping open the issue of whether or not it actually exists. This kind of consensus is definitely nothing but a cloud of community.'[48] But, more positively for us here, Kant asks that we leave out issues of 'matter' in our judgements and focus on the 'formal peculiarities' of 'representational activity'. We must leave our other sensations at the door and judge on shared formal aesthetics alone. Such a request chimes quite neatly with Clive Bell's demand in *Art* (1914), by way of legitimising the aesthetic emotions that non-representational art evokes in us, that we base our judgements on what he called 'significant form'. All great art, of all periods, possesses significant form:

> There must be some one quality without which a work of art cannot exist; possessing which, in the least degree, no work is altogether worthless. What is this quality? What quality is shared by all objects that provoke our aesthetic emotions? What quality is common to Sta. Sophia and the windows at Chartres, Mexican sculpture, a Persian bowl, Chinese carpets, Giotto's

[46] Ibid., 123.
[47] Ibid., 37.
[48] Jukka Gronow, 'The Social Function of Taste', *Acta Sociologica*, 36, 2 (1993): 93.

frescoes at Padua, and the masterpieces of Poussin, Piero della Francesca, and Cézanne? Only one answer seems possible—significant form. In each, lines and colours combined in a particular way, certain forms and relations of forms, stir our aesthetic emotions. These relations and combinations of lines and colours, these aesthetically moving forms, I call 'Significant Form'.[49]

Significant form is, as Kant demanded of judgement back in 1790, supremely democratic. A studied knowledge of two thousand years of artistic developments is not needed for the layman to make an aesthetic judgement on a Picasso or a Mondrian. Aesthetic emotion, something far purer than other sensations the layman might normally express ('this picture does not look like the things in the real world it is supposed to represent'), will be experienced by the viewer of even the most abstract or non-representational work by his going back to Kant's demand that we leave everything else except 'formal peculiarities' at the door.

It is possible to work through Kant's ideas further to bring them into an even closer rapprochement with the demands of modernist art. Kantian aesthetic judgements are, or should be, vectorless. They are not directed to a specific purpose and do not satisfy a utilitarian end. They are *disinterested*. 'Everyone must allow', Kant says, 'that a judgment on the beautiful which is tinged with the slightest interest, is very partial and not a pure judgment of taste.'[50] This Kantian disinterestedness lies behind all subsequent demands for the autonomy of art, and is familiar to students of modernism. For Theodor Adorno, '[i]nsofar as a social function may be predicated of works of art, it is the function of having no function'.[51] Art, and judgements about it, modernism effectively professed, needs to demonstrate no connections with *habitus* (even though this is severely problematised by Bourdieu) if it is truly going to inhabit an autonomous realm. So modernism retreated to a self-referential language of form and to a non-representational mode to shrug off the demands of realism, so bound up was the term in bourgeois culture. This is a narrow path to tread: if art was not going to plumb the depths of solipsism and relativism it sank to at the *fin de siècle*, it needed to maintain a strong independence. By internalising the difficulties of its own production, it became self-aware—and thus could comment on the conditions of its own production in a more self-conscious way.

Stressing the autonomy of art, through esoteric representational techniques and an intense privileging of subjectivity, modernist experi-

[49] Clive Bell, *Art* (New York: Frederick Stokes and Company, 1914), 4.
[50] Kant, *Critique*, 37.
[51] Theodor Adorno, *Aesthetic Theory*, trans. R. Hullot-Kentor (London: Athlone, 1997), 227.

mentation expressed this aesthetic disinterestedness through appeals to the individual rather than the collective. The individual mind was the site of battle between free thinking and dogmatic ideology. Win it over, by asking it to reassess the conditions of its existence, and art starts to serve a positive social end. To be victorious in this battle, art must reject realist representation outright. Oscar Wilde pointed to the disjuncture between advanced art and the public desire for realism in *The Soul of Man under Socialism*:

> [...] it is to be noted that it is the fact that Art is this intense form of individualism that makes the public try to exercise over it an authority that is as immoral as it is ridiculous, and as corrupting as it is contemptible. It is not quite their fault. The public have always, and in every age, been badly brought up. They are continually asking Art to be popular, to please their want of taste, to flatter their absurd vanity, to tell them what they have been told before, to show them what they ought to be tired of seeing, to amuse them when they feel heavy after eating too much, and to distract their thoughts when they are wearied of their own stupidity. Now Art should never try to be popular. The public should try to make itself artistic.[52]

Neat aphorisms aside, the anarchist and libertarian Wilde recognises the danger for society if it embraces an art that reflects back ideology. Courting popular taste could never be a social good. For modernism to claim possession of a pure realm of art where 'non-utilitarian values of aesthetic production' reigned, it had to reject the dominant, realist mode of representation.[53] Many of its most vehement critics assailed it on these terms. Georg Lukács objected to this rejection of realism because it did not allow the viewer or reader to see the unfolding of the historical process, but instead separated him from an understanding of his condition and only showed him that a relatively melancholic state of affairs persists where objectivity and rationalism were illusions. More recent work has problematised this position by showing that, far from being objective, the 19th-century belief in the transparency of observation—reflected in its art—was actually the product of more sinister forces of social control. Several commentators have drawn attention to the growing importance of technologies of seeing in modern culture.[54] Jonathan Crary has exhaustively and intelligently

[52] Oscar Wilde, *The Soul of Man under Socialism and Selected Critical Prose*, ed. Linda Dowling (London: Penguin, 2001), 141.

[53] Mark Gluck, *Popular Bohemia: Modernism and Urban Culture in Nineteenth-Century Paris* (Cambridge, MA: Harvard University Press, 2005), 5.

[54] See, for instance, Jonathan Crary, *Techniques of the Observer: On Vision and Modernity in the Nineteenth Century* (Cambridge, MA: MIT Press, 1990); Anne Friedberg, *Window Shopping:*

detailed the changes that the years before the beginning of the 20th century wrought upon modes of attention and observation, particularly around the subjective experience of art. For Crary, the 'emphasis on the creative [...] dimension of attentiveness of any given autonomous subject coincides with the historical emergence of increasingly powerful technologies and institutions that would determine and enforce *externally* the objects of attention for mass populations', and through such institutions attention would be 'conceived as an element of subjectivity to be externally shaped and controlled'.[55] Crary is keen to separate this 'imperative of a concentrated attentiveness within the disciplinary organisation of labor, education, and mass consumption' from 'an ideal of sustained attentiveness as a constituent element of a creative and free subjectivity'.[56] Postimpressionist experimentation with perception and the visual field, which is the subject of Crary's study, is one manifestation of such a separation, one designed to shock and destabilise bourgeois modes of seeing. In this sense, then, modernist aesthetics are a defence against the normative drives of social control, and their refusal of realist modes of representation are a way of contesting modernity. The Kantian disinterestedness of aesthetic taste can be understood, therefore, as the basis for an autonomous art whose rules and logic demand a separation from bourgeois culture. Taste has to be based on critical judgement and, though it can be used as a way of seeking communal betterment, it has to descend first from disinterested and formal principles. The non-representational aesthetics of modernism provided an art where the public could develop such judgements.

If the formation and cultivation of individual, disinterested taste was one of the professed aims of the promoters and mediators of modernism in Britain, then they were also alert to the possibility of achieving communal or collective good more directly. Encouraging individuals to see was one thing—a long-term goal, perhaps—but transforming the social sphere with more immediate effect was undoubtedly an ambition of some of the subjects of this study. To that end, the institutional, educational and social bases for modernist activity in Britain provided infrastructural support for the development of ideas and projects that applied the abstruse aesthetics

Cinema and the Postmodern (Berkeley and Los Angeles: University of California Press, 1993); Stephen Kern, *The Culture of Time and Space: 1880–1918* (Cambridge, MA: Harvard University Press, 1983).

[55] Jonathan Crary, *Suspensions of Perception: Attention, Spectacle, and Modern Culture* (Cambridge, MA: MIT Press, 1999), 63.

[56] Ibid., 1–2.

of art and design to more practical uses. If the mediators of modernism in Britain believed in the capacity for advanced art to democratise taste—a significant social change, but a nebulous one—then critics and educators such as Roger Fry, Herbert Read, Marion Richardson and others believed that direct, pragmatic action might achieve tangible real-world alterations to everyday life in Britain. It was with this egalitarian and ameliorative philosophy that a whole range of initiatives, groups, collectives and institutions were set up during the period 1910–51 to connect radical, often continental, aesthetics with tangible public and consumer action. In what follows, I explore some of these institutions—Roger Fry's Omega Workshops, projects such as The School Prints and Contemporary Lithographs that, along with changes to arts education policy, were directed at introducing schoolchildren to modern art, groups and initiatives such as the Design Industries Association and the Isokon building project—all of them with some professed aim to mediate modernism for better public reception.

The institutional basis of modernism has been the subject of a number of studies since Lawrence Rainey's *Institutions of Modernism,* a seminal intervention into the ways in which the modernist literary text sat in a reciprocal relationship with commodity culture. Recent work on the public encounter with literary and artistic modernism has helped to demonstrate modernism's complicity with consumer culture, the marketplace and the public sphere, to the point where critical elaboration of modernist aesthetics has been indelibly marked by considerations of the socio-economics of production and consumption.[57] Picking up on this thread, one of the stories that *Insane Acquaintances* tells is the gradual adaption and repackaging of avant-garde styles during the period 1910–51 that were so distasteful to the British public on first, insane, acquaintance. Postimpressionism, Surrealism, continental modernist architectural and interior design—all made their way quite quickly into the popular taste, in the home as much as in the museum or gallery. The real focus of the study is the ways in which this journey from first impression to lasting legacy took place. As such, I focus on individual mediators and, in turn, their role in the setting up or running of groups, collectives and schemes devoted to bridging the gap between

[57] See, for instance, Michael C. Fitzgerald, *Making Modernism: Picasso and the Creation of the Market for Twentieth-Century Art* (Berkeley: University of California Press, 1996); Rod Rosenquist, *Modernism, the Market, and the Institution of the New* (Cambridge: Cambridge University Press, 2009); Alissa G. Karl, *Modernism and the Marketplace* (London: Routledge, 2009); Carey James Mickalites, *Modernism and Market Fantasy: British Fictions of Capital, 1910–1939* (London: Palgrave Macmillan, 2012).

modern art and the public. The role of influential mediators of modernism in Britain in the reception and dissemination of avant-garde art, design and decoration has often been the subject of study. Even Rainey's persuasive work finds that the power to advance a challenging aesthetic on the public lay more with moneyed, committed individuals than anyone else. On the continent, too, powerful brokers of modernism such as Ambrose Vollard or Daniel-Henry Kahnweiler have most often been seen as the drivers of the market for modernist art and a taste for its products.[58] This study goes some way to complicating this 'great man' hypothesis about the adoption of modernist aesthetics in Britain. While the following chapters do indeed reflect on the individual vision of people such as Fry and Read—their belief that the social life of the nation was in no small way dependent upon its artistic tastes, and that only by changing the latter might some real-world difference be made—they also focus on the agency of institutions such as galleries and museums, groups and collectives and even government policy in effecting changes in the artistic tastes of the nation. Therefore I want to make the larger claim that agency for the cultivation and dissemination of a 'taste' for modernism in Britain is a complex field rather than one of hierarchical transmission from expert to public. Lisa Tickner claims that it 'is a mistake to view British art simply as a pallid reflection of developments elsewhere', and it is my intention in what follows to suggest that the adoption of continental avant-garde art in Britain was attended by a complex set of negotiations between individuals, groups and state actors.[59] The display of avant-garde art, its marketing and commercialisation, and its take-up by individuals and groups devoted to the amelioration of British taste and standards of living in the years before the Festival of Britain in 1951 all took place in an arena in which modernism's products were seen both as commodity and as symbolic and cultural capital.

So, though it may be easy to fall back with zest on that old lie that modernism—with its esoteric images, arcane and impenetrable narratives, and disturbing sounds—functioned to exclude swathes of the public from the echelons of high art and hence good taste, the converse might be equally true. Lawrence Rainey usefully summarises the old belief that 'modernism,

[58] Robert Jensen, *Marketing Modernism in Fin de Siècle Europe* (Princeton, NJ: Princeton University Press, 1994) traces out the early development of these kinds of promoter-dealers of modern art, and their efforts to manufacture markets.

[59] Lisa Tickner, *Modern Life and Modern Subjects: British Art in the Early Twentieth Century* (New Haven, CT: Yale University Press, 2000), 193.

poised at the cusp of th[e] transformation of the public sphere, responded with a tactical retreat', and without a doubt, the centripetal impulse in modernism is a pronounced one, protectively securing a niche for itself away from the clamour of those defending public decency and aesthetic tradition.[60] The products of modernism *were* alienating, bewildering and even hostile to their publics. But it is also true that much of modernist culture was public-facing, and if its reception was fraught with tension, that tension brokered a new relationship between art and its publics. A challenging artistic product demands a new kind of appreciation, one that the wider public had to acquire through a number of difficult and terse encounters. These encounters were to radically alter the public consumption of artistic culture, and such consumption helped to circumscribe and monetise an institutional space that still exists in 2020, securing the financial and cultural 'value' of modernist art, literature and performance a century later.

Insane Acquaintances explores initiatives to introduce children to modernist art, to drag the best avant-garde art to the four corners of Britain in travelling exhibitions and to bring modern design into the home. It rereads some of the events and 'moments' of modernism, charting the public debates and reception of experimental art to highlight changing notions of what constituted artistic culture and the role of the artist in society. It is primarily ordered around the case study, offering new archival research on some less-known individuals and ill-explored groups who helped to shape and publicise the contemporary art scene in the early decades of the 20th century, and reassessing the contribution that major movements—in particular Postimpressionism and Surrealism—made to changing public attitudes towards modern art. The methodology employed here is built around the study of *moments*. What follows is a series of synchronic studies that share common ground—histories of individual events and exhibitions and small-scale groups and movements. A full history of modernism's engagement with and attempted transformation of its publics is unlikely to be written soon. The difficulty of charting the dissemination and mediation of artistic experimentation in wider cultural fields is at base an empirical one; what dataset could one possibly collect that wouldn't be undermined by another equally valid set? How could we account for a national dissemination of avant-garde art, given modernism's inherent disregard for borders? But what is Pierre Bourdieu's *Distinction* other than a synchronic study of French culture in the middle of the 20th century? Bourdieu claims that it is possible to harmonise

[60] Rainey, *Institutions of Modernism*, 5.

his vast array of cultural data into a set of axiomatic truths that hold about the way in which taste functions to differentiate individuals, groups and classes in capitalist economies. The profit Bourdieu finds in using such an apparatus is that his study can range widely over a heterogeneous cultural field. Building on such a model, *Insane Acquaintances* explores the 'cultural formations', to borrow Raymond Williams's terminology, that grew up around modernist aesthetics in the period between the first Postimpressionist exhibition of 1910 and the Festival of Britain in 1951. Williams argues in *The Politics of Modernism* that the revolutionary potential of modernism was not carried in any programmatic or organised schema but rather that 'relatively informal movements, schools, and campaigning tendencies [...] carried a major part of our most important artistic and intellectual development'.[61] This decentred, organic model for the development of modernist and avant-garde activity in Britain is an appealing one, given the activities both of groups that were born of momentary encounters between advanced art and the public and of movements and initiatives that took place outside the capital and were directed towards local, regional, provincial or civic change.

Ultimately, though, this book is full of only partial successes. The revolutionary changes imagined by those whose energy charged the events and initiatives discussed here were in many cases only incompletely effective and often short lived. Moreover, the legacies that groups and movements left were not always what their creators had intended. The democratisation of taste, so often proclaimed by the promoters and mediators of modernist art in Britain, was not always the most visible legacy of those movements and initiatives designed to introduce advanced art to the public. Undoubtedly, the educational and informational work undertaken by the main actors in this study helped to shape an understanding and appreciation for modernist experimentation that persisted deep into the 20th century, but the wider cultural and political changes envisaged by some of the more utopian modernist thinkers did not materialise. Many of the case studies that follow were small-batch, time-constrained and not really scalable, ripples and eddies that bubbled and dissipated: exhibitions opened and closed, and movements rode the crest of public opinion, then faded from view when the energies of their founders dissipated. This particular revolution of 'Bird's Custard Isle' did not take place.

Yet this is to deny other legacies of modernism's assault on public taste that were perhaps unimagined by the protagonists of this study. For one,

[61] Raymond Williams, 'Metropolitan Perceptions and the Emergence of Modernism', in *The Politics of Modernism* (London and New York: Verso, 1997 [1988]), 174.

visual modernism undoubtedly found its place in British culture, though its full impact was delayed by both war and austerity. Looked at another way, the avant-garde activity that took place in Britain before the outbreak of the Second World War was just that—polemical, interventionist and confrontational work done at the vanguard of movements that necessarily laid the foundations for a more widespread take-up of a new artistic culture. The democratising, egalitarian impulse of modernism in Britain was bound over, perhaps, held in potential for a post-war world. For Herbert Read, writing at the end of the Second World War, modernism still had the potential to enact social change in Britain: 'individuals in whom the spirit of modernism is embodied still survive, still work, still create [...] When the cloud of war has passed, they will re-emerge eager to rebuild the shattered world.'[62] Many of the principles that the artists, critics and mediators fought for—a greater public presence of modernist artistic culture, funding bodies for arts and culture that functioned democratically and a more fervent institutional and governmental belief in the transformative power of artistic and cultural innovation—did indeed take place in the first years after the end of hostilities in 1945. This belief in the power of modernist art to reform public taste and to shape a new future was firmly embedded, for instance, in the philosophy of the Festival of Britain in 1951, which Becky E. Conekin argues 'set the broad parameters of a social democratic agenda for a new and modern Britain'.[63] I return to think about the Festival of Britain as an endpoint of modernism's social and cultural franchise in Britain in the concluding chapter here, but several of my case studies end with a look forward to the delayed achievements of the mediators and promoters of modernism in Britain. The educational policy changes driven, in part at least, by the experiments in arts teaching undertaken by Marion Richardson, the organisation of post-Second World War municipal and provincial galleries and collections based on the model of the Contemporary Art Society (CAS), and the construction of the Institute of Contemporary Arts (ICA) out of the ashes of a short-lived British Surrealist moment—all can be claimed as legitimate victories for the lead characters in this book.

A different legacy of the varied activities that *Insane Acquaintances* charts was, of course, the reification of modernist styles into the marketable objects

[62] Herbert Read, 'Threshold of a New Age', in J. R. R. Brumwell (ed.), *This Changing World* (London: Readers Union, 1945), 7–14; 12.
[63] Becky E. Conekin, *The Autobiography of a Nation: The 1951 Festival of Britain* (Manchester: Manchester University Press, 2003), 4.

of artistic culture that still persist today. If British Surrealism, for instance, demanded the disruption of a capitalist economy of art, its protagonists would balk at the prices now demanded for works by Conroy Maddox, Eileen Agar, Emmy Bridgwater and John Melville. Undoubtedly, the artistic and critical moment that is covered by this study did not result in the subversion of the capitalist economy around art but precisely its reverse; not the overthrow of a capitalist aesthetic economy but its reinforcement, and an institutional enshrinement of artistic modernism as a high-value good. In the case of the adaption of modernist architecture and design for the British interior, the result was not the democratisation of living space but rather the creation of valorised decorative schemes that could be packaged and sold. In the case of Postimpressionist, Surrealist or abstract art in Britain, the gradual reduction of artistic styles to decorative schema and eventually to pastiche and parody ultimately undoes some of the work that the original art objects did in the world. This point is an important one because the democratic impulse I return to repeatedly here demands an economic model for the arts somewhat antithetical to what actually emerged after 1945. The canonisation, and subsequent commercialisation, of Bloomsbury and its artistic styles—the subject of the second half of Chapter 2—is one example of this process. The egalitarian, democratic ideal enunciated by Roger Fry, Desmond MacCarthy and Clive Bell in so much criticism on modern art was a diminishment of the importance of education and class privilege in the arts, in favour of an appreciation that was innate rather than learned: response to colour, mood, line and tone is, certainly in Fry's many essays on the subject, more important than art-historical learning. While the popular press made hay with the resulting debate around the first Postimpressionist exhibition in 1910, the more muted, positive critical response to the principles that underpinned the rationale for the exhibition was, as we shall see, directed towards these democratic ideals. Yet this democratising philosophy is not the most obvious outcome of the event. Art criticism has drawn around Postimpressionism a critical language that makes its aesthetics opaque, one effect of which has been to raise its main players—Manet, Van Gogh, Cézanne, Picasso—to artist-deities. More interestingly for our purpose here, the most visible result was the codification of a Bloomsbury identity: its principles of liberalism (economic, political and sexual), its coterie modes of production and consumption, and its aesthetic schema derived at least in part from its formation in the wake of the Postimpressionist moment in Britain, which emphasised bold use of line and colour, expressive and emotive techniques, and a decorative dimension. As Christopher Reed, Victoria Rosner and others have shown,

Bloomsbury group identity and Bloomsbury aesthetics are inseparable. Reed's study *Bloomsbury Rooms* (2004) demonstrates the ways in which the decorative and visual objects of Bloomsbury elaborate lifestyle choices as much as artistic principles.[64] Reversing the usual direction of aesthetic flow from gallery to home, Reed argues that Bloomsbury 'made the conditions of domesticity its standard for modernity, projecting the values of home life outward onto the public realm in both its aesthetic and socio-political initiatives'.[65]

Of course, 'Bloomsbury' here in no way characterises the array of British modernist art and literature in the years after the 'Manet and the Post-Impressionists' exhibition in December 1910, nor does the word itself adequately circumscribe the variety of creative outputs of the artists, writers and intellectuals at its core. Criticism of the activities of its members abounds during the period, and many of its most severe critics— Wyndham Lewis and Herbert Read, most notably—feature in this study. However, the aesthetics and the philosophy of the group persist as a synecdoche for modernism in the public imagination today. In fact, this study suggests that rather than being an idiosyncratic case, Bloomsbury and Postimpressionism are just one example of how a subculture or coterie defines itself against the masses—in the case of Bloomsbury this is an exclusive, insular social and aesthetic economy set firmly against the demands of the market—and by so doing, generates a desire for its products. Borrowing from the terminology that Stuart Hall and Tony Jefferson brought to bear on the field of 20th-century cultural studies, I want to argue that one result of modernism's encounter with the public in Britain was the creation of subcultural desire for its products. Though their work is directed towards the modes of resistance to hegemonic culture enacted by youth and outsider groups, Hall and Jefferson usefully theorise the strategies by which non-mainstream groups cultivate distinctive cultural spaces. For Hall and Jefferson, these subcultural spaces 'cluster around particular locations [...]; they explore "focal concerns" central to the inner life of the group [...] They adopt and adapt material objects—goods and possessions—and reorganize them into distinctive "styles" which express the collectivity of

[64] See, for example, Christopher Reed, *Bloomsbury Rooms: Modernism, Subculture and Domesticity* (New Haven, CT: Yale University Press, 2004); Victoria Rosner, *Modernism and the Architecture of Private Life* (New York: Columbia University Press, 2005); Jane Garrity, 'Selling Culture to the "Civilized": Bloomsbury, British *Vogue*, and the Marketing of National Identity', *Modernism/modernity*, 6, 2 (April 1999): 29–48.

[65] Reed, *Bloomsbury Rooms*, 5.

their being-as-a-group.'[66] Thomas E. Crow, quoting Hall, suggests that modernist art movements also carved out niches that not only created axioms to define group activity but also helped condense these for external consumption.[67] Undoubtedly, there is a class dimension to all of this, most pronounced perhaps in the case of Bloomsbury but present elsewhere in this study. It is the class politics of this privileged world of coterie production and consumption that lurks behind Raymond Williams's extended critique of what he terms the 'Bloomsbury Fraction'.[68] For Williams, the talk of democracy and 'social conscience' in the public statements of those members, particularly Keynes and the Woolfs, only ever amounted to the consolidation of class lines, albeit showing 'sympathy for the lower class as victims'.[69] Though I have dwelt only on Bloomsbury—it is perhaps the most fraught with tensions around codifying and packaging an aesthetic designed, at least in part, to transform public taste—lots of what is bound up in the mediation of advanced or experimental aesthetics for wider audiences applies to many of the other movements and initiatives I explore here. From the class positions bound up in the design and marketing of tasteful, modernist decorative schema for the home, to the regional disparities exposed in the display of modern art, to the often hollow calls for a socialist revolution in the arts by the leading proponents of Surrealism in Britain, this study returns to the thorny issue of modernist art and class through its discussion of issues such as social mobility and access to the arts in the early 20th century.

The importation, too, of mostly European schema—the Post-impressionists, the Cubists, the Surrealists and even some of the atelier or salon models for producing and consuming art that certainly originated on the continent—creates friction in the debates around avant-garde culture in Britain in the early 20th century. Many of the key figures in this study, and many ancillary ones too (Eliot and Lewis in particular), were in search of an authentically *English* or *British* modern aesthetic, one rooted in the tradition—in Eliot's use of that term—of a national art. Though the modernist period is characterised by an increasing internationalism, and cross-border collaboration between artists and markets, so much of the

[66] Stuart Hall and Tony Jefferson, *Resistance through Rituals: Youth Subcultures in Post-War Britain* (London: Psychology Press, 1993), 180.

[67] Thomas E. Crow, *Modern Art in the Common Culture* (New Haven, CT, and London: Yale University Press, 1996), 84.

[68] Raymond Williams, 'The Bloomsbury Fraction', in *Culture and Materialism: Selected Essays* (London: Verso, 2005 [1980]), 148–70.

[69] Ibid., 155.

critical writing of the period on art and literature stresses the need to find an authentically national artistic response to the conditions of modernity. So many of the initial responses to movements such as Postimpressionism and Surrealism involve negotiating the 'foreignness' of the temperament and style of the artists and aesthetics. Underlying this, of course, is the well-rehearsed belief that a conflagration of authentically British avant-garde did not take place when the sparks of Cubism, Futurism and Surrealism were lit. Indeed, the partial successes I discuss here in this study nearly always provoke the same kinds of critical response: yes, European modernism is all well and good, but something home-grown needs to occur if British social and cultural life is to be touched by the artistic realm and shaped by its activities.

The Conclusion explores some of the ways in which modernism has institutional legacies and afterlives in Britain. To some extent, I argue, the successes of modernism's promoters in Britain were less to do with the transformation of public taste than the establishment of a network of interconnected artistic and cultural public, quasi-governmental and private institutions dedicated to fostering artistic and cultural activity across Britain in the years surrounding the Second World War. Though this study does not offer an institutional history of this activity, being outside its scope, it is clear that many of the educational, exhibiting and design initiatives I discuss helped to foster interest in and support of post-war institutions such as the ICA, the Arts Council of Great Britain and the Council for Art and Industry (CAI). If there is a success, then, in modernism's revolutionising of British arts and culture, it lies here. Many histories of post-war avant-garde activity in Britain find the embryonic roots of their object of study in the activities of one of these institutions.[70] What this study finds is that modernist enterprise in Britain during the first decades of the century helped to construct a scaffolding for what followed, and an institutional and financial framework for the post-war arts industry in Britain.

[70] See, for example, Mark Crinson and Claire Zimmerman (eds), *Neo-Avant-Garde and Postmodern: Postwar Architecture in Britain and Beyond* (New Haven, CT, and London: Yale University Press, 2011); Alexander Clement, *Brutalism: Post-War British Architecture* (Marlborough: The Crowood Press, 2011); Philip Rupprecht, *British Musical Modernism: The Manchester Group and their Contemporaries* (Cambridge: Cambridge University Press, 2015).

2

Postimpressionism™

'In so far as taste can be changed by one man, it was changed by Roger Fry.'[1]

Included in the 1923 New English Art Club exhibition, alongside much-lauded works by Augustus John and the Vorticist William Roberts, was a peculiar, small oil painting entitled *The Unknown God* by Henry Tonks, at the time the Professor of Fine Art at the Slade School (Figure 2.1). Tonks had taught, influenced and (in turn) been cast aside by any number of canonical experimental painters in the early decades of the 20th century, Wyndham Lewis, Mark Gertler, David Bomberg and Stanley Spencer among them. Paul Nash had found Tonks reactionary and old-fashioned, and it is clear from many of the contemporary descriptions of Tonks's opinions that he was no friend of most experimental art in the period.[2] Aldous Huxley's analysis of *The Unknown God* is better than any I could offer:

> For those who are sufficiently conversant with the world of art critics and of painters, this little picture is a work to be studied with infinite delight. For 'The Unknown God' is a caricature—and a little masterpiece of its kind. The picture represents Mr. Roger Fry preaching, as St. Paul preached to the Areopagites, the doctrine of the Unknown God. Pointing with an enthusiastic gesture towards a very plastic-looking piece of nigger-cum-cubist sculpture, he seems to be saying, in the words of the Apostle, 'Whom therefore ye ignorantly worship, him I declare unto you.' Playing Timothy to Mr. Fry's St. Paul, Mr. Clive Bell stands at the preacher's side and vigorously rings his eponymous instrument of music. From his mouth issues a label containing the pious exclamation 'Cézannah, Cézannah.' Among the audience of Areopagites we see many familiar faces. Mr. George Moore, Mr. Sickert, Mr. Maclagen, Mr. D. S. MacColl, Professor Rothenstein and many others sit listening to the new doctrine, some placidly, with a politeness that seems to mask an expression of boredom or of irony, some with a look of astonishment and horror. 'Whom therefore ye ignorantly worship, him I declare unto you.' Every propounder of

[1] Kenneth Clark, 'Introduction', in Roger Fry, *Last Lectures* (Cambridge: Cambridge University Press, 1939), ix.
[2] Paul Nash, *Outline* (London: Columbus, 1998), 102.

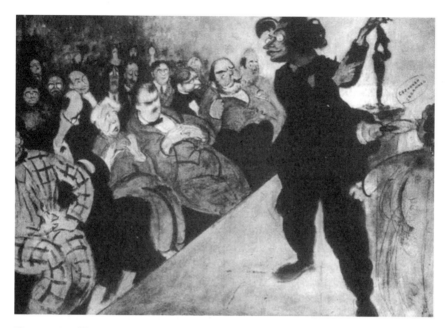

Figure 2.1. Henry Tonks, *The Unknown God*, 1923

a new theory of aesthetics is a St. Paul preaching to the Areopagites. Mr. Fry
happens to be the latest as well as one of the ablest of these apostles.[3]

There are a number of things to say about this caricature, and Huxley's
description. For one, the painting dates from 1923, but it clearly refers
back to 'Manet and the Post-Impressionists', which opened at the Grafton
Galleries in November 1910, where Fry first proclaimed Cézanne, Matisse,
Gauguin, Picasso and Van Gogh as the new modern masters. At such a
distance of time, it is perhaps difficult to believe that the work of these
artists was clearly still capable of dropping a few monocles. If anything,
Tonks's painting proves that the 1910 show still cast a long shadow in
1923. Figures in the crowd clearly represent a particular subset of British
art-going culture—Walter Sickert and George Moore are there, neither of
whom were supporters of Postimpressionism. Fry was caricatured often in
the period: *Punch* ran pointed satires in November 1910 directed towards
Fry—thinly disguised as 'Mr Rumbell Wetherham, an eminent Art critic'—
and quoted the exhibition catalogue against itself, with Fry's pontificating

[3] Aldous Huxley, 'The Unknown God: Being Notes on a Caricature and Some Pictures at
the Goupil Gallery by the Talented Young Landscape Painter, Gilbert Spencer', *Vogue*, 61, 2
(January 1923): 54–5; 54.

attitude the centrepiece of the attack.[4] Virginia Woolf painted a picture of a disinterested Fry amidst the melee. 'He was amused', she wrote, 'to find that his own reputation—the dim portrait that the public had drawn of him as a man of taste and learning—was replaced by a crude caricature of a man who, as the critics implied, probably from base motives, either to advertise himself, to make money, or from mere freakishness, had thrown overboard his culture and deserted his standards.'[5]

That an exhibition could leave such an afterglow, and the collective memory of it still resonate thirteen years after its doors closed, marks a new moment in the role art played in public life. The exhibition began with 'a wild hurricane of newspaper abuse from all quarters'.[6] Opening on 8 November, to howls of derision, 'Manet and the Post-Impressionists' has, for the last century, been seen as *the* index case of European modernism in Britain. This confrontation—in one corner a continental, formalist, elitist coterie and in the other a reactionary public that had elevated hostility to advanced art to the level of a virtue—has been consistently cited as a moment of changed relations, at least since Virginia Woolf made it so in 'Mr Bennett and Mrs Brown' (1925). This story is of course true—a volley of invective was directed towards the efforts of Roger Fry, Clive Bell and Desmond MacCarthy at the opening of an exhibition that marked, or has been used to mark, a fault line in British art history, when abstraction, experimentation and 'significant form' came to London. Described as a 'major incident in the history of taste' by Benedict Nicholson in 1951, the event has become a point of origin to describe so many of the fraught encounters between the public and artistic culture ever since.[7] Robert Ross, writing in the *Morning Post*, declared that the public would receive the paintings with 'permanent ridicule'—what was on display could be 'of no interest except to the student of pathology and the specialist in abnormality'.[8] The *Daily Express* ran with 'Paint Run Mad', the experience amounting to 'a violent bilious headache', while such luminaries as Charles Ricketts and Wilfrid Scawen Blunt felt the need to condemn Fry's exhibition in the most pejorative terms possible. For Blunt, there was no 'trace of sense or skill or taste, good or bad, or art or cleverness. Nothing but that gross puerility which scrawls indecencies

[4] 'The International Society of Plasterer Painters', *Punch*, 139 (30 November 1910): 386.

[5] Virginia Woolf, *Roger Fry: A Biography* (London: Hogarth Press, 1940), 157.

[6] Roger Fry to Sir Edward Fry (24 November 1910), in *The Letters of Roger Fry*, vol. 1, ed. Denys Sutton (London: Chatto and Windus, 1972), 338.

[7] Benedict Nicholson, 'Post-Impressionism and Roger Fry', *Burlington Magazine*, 93, 574 (January 1951): 10–15; 11.

[8] *Morning Post* (7 November 1910): 3.

on the walls of a privy.'[9] It is ironic that it took Ezra Pound's 'Mr. Nixon' himself, Arnold Bennett, to restore some sanity to the public discussion of the event: 'The mild tragedy of the thing', he wrote in the *New Age*, 'is that London is infinitely too self-complacent even to suspect that it is London and not the exhibition which is making itself look ridiculous.'[10] But if this story is true, is it complete? And if late 1910 was a watershed moment in British artistic culture, what changed? In this chapter, I want to suggest that the exhibition at the Grafton Galleries was indeed a moment of changed relations, but not in such hyperbolic terms as Woolf would have it (even though her comments were made tongue in cheek). The Postimpressionist moment in London did, however, alter the way in which modern art was displayed, exhibited and marketed to the public, and Fry's part in the exhibition marked out a new role for the art critic cum impresario in Britain. It also introduced the British public to European modernism, and the quick assimilation and acceptance of artists much derided in 1910—Matisse in particular—says much about the changing public taste in Britain in the ten or fifteen years after the exhibition, so much so that in his 'Retrospect' on the event written a decade later, Fry could confidently assert that 'Matisse has become a safe investment for persons of taste.'[11]

Though this chapter will touch on the aesthetic innovation of the works of art displayed in Fry's show in 1910, the focus here is very much on the strategies that a nascent Bloomsbury employed to enshrine a particular brand of modernist experimentation as its own—through Fry's own promotion of, and identity with, the exhibition's advanced aesthetics. It will also explore some of the more diffuse results of the Grafton Galleries show—in particular the swift canonisation of a number of those artists exhibited and the efforts to tour paintings from the show around Britain, and the legacies that Postimpressionist aesthetics left for British art and design. The central idea I want to advance here is that Postimpressionism developed as a complex term to denote both an art movement—though, as many commentators at the time noted, this was at best a nebulous group of artists and styles—*and* an educational and pedagogical rhetorical strategy. While Fry, Bell and MacCarthy may have had little other desire than

[9] [unsigned], 'Paint Run Mad: Post-Impressionists at Grafton Galleries', *Daily Express* (9 November 1910): 8; Charles Ricketts, 'Post-Impressionism', *Morning Post* (9 November 1910): 6.; Wilfrid Scawen Blunt, *My Diaries* [entry for 15 November 1910], rpt. in J. B. Bullen (ed.), *Post-Impressionists in England* (London: Routledge, 1988), 113.

[10] Jacob Tonson [Arnold Bennett], 'Books and Persons', *New Age*, 8 (December 1910): 135.

[11] Roger Fry, 'Retrospect' in *Vision and Design* (London: Chatto and Windus, 1920), 189–199; 198.

to excite the public taste (and to sell a few pictures), the close affinity between the exhibition and the development of a distinctive social and cultural concept of 'Bloomsbury' meant that—in terms of reception—the advanced aesthetics of the exhibition became bound up with a set of attitudes and class and social positions not intrinsic to the paintings on the wall.

The notion that 'Bloomsbury' might not just represent a group of intellectuals, writers and artists, nor indeed just a unified set of aesthetic, social or political attitudes, but also a marketable and desirable concept has been attended to by Jennifer Wicke. She argues persuasively that Bloomsbury represents 'an invented community, in intention almost a utopia of and for consumption' and 'a modernist imaginary indubitably associated with socioeconomics'.[12] The persistence of the mythology of Bloomsbury—its particular brand of visual and literary aesthetics and the liberal social and sexual attitudes of its most prominent members—has resulted in a kind of reification: Wicke talks insightfully about the commercialisation of the Bloomsbury brand in Laura Ashley wallpaper, Charleston ceramics and a recent revival of Omega-ware. This persistence, for Wicke, arises from the ways in which Bloomsbury offers a site of resistance to mass production: though its energies certainly find their origin in the aesthetic and social experiments of William Morris, the small scale and coterie philosophy behind many of Bloomsbury's artistic interventions work to deny the possibility of large-scale commercialisation, thereby creating a market niche that privileges the bespoke and the one-off original—what Wicke adroitly terms 'the beckoning image of coterie lifestyle'.[13] This coterie lifestyle, and its desirability in the decades that followed, drew much of its inspiration from the invention of a Postimpressionist aesthetic by Fry—primitivist (in fact, in important ways, non-Western), instinctual, abstract and attentive to form. It was also a democratising aesthetic, privileging individual, unlearned and instinctive responses in viewers over knowledge, erudition and connoisseurship. Clive Bell's *Art* (1914), and its introduction of the concept of significant form to scholarship, can be seen as the most robust contemporaneous defence of this attitude to the arts.

[12] Jennifer Wicke, 'Coterie Consumption: Bloomsbury, Keynes, and Modernist as Marketing', in Kevin J. H. Dettmar and Stephen Watt (eds), *Marketing Modernisms: Self-Promotion, Canonization, and Rereading* (Ann Arbor: The University of Michigan Press, 1996), 109–33; 111.

[13] Ibid., 116.

This chapter charts two related results of the Postimpressionist moment in Britain. In the first place, taking Postimpressionism as a kind of symptom of a much deeper malaise in British art, I want to argue that the Grafton Galleries show, and the subsequent Postimpressionist moment in Britain before the outbreak of the war, established a pedagogical dimension in British artistic culture that persevered throughout the first half of the 20th century and helped shape many of the initiatives that this study goes on to chart. Fry's anti-institutional stance, and his emerging attention to the teaching of art and to social engagement, meant that Postimpressionism was a tool used to create new institutions—most notably the CAS—and foster new ways of educating the public's taste in art. In the second, the foregrounding of Fry (and Bell and MacCarthy to a much lesser extent) as representative of a nascent modernism in British art altered the role played by the art critic or mediator, and ushered in permanent changes in the role of the 'expert' in British artistic life. Tangential to these two points, and in a longer arc across this book, I want to argue that the resultant embrace of Postimpressionist aesthetics in the form of decoration in the British art world functioned to create a desirable and marketable subculture. The subsequent canonisation of Bloomsbury style—bold colours and patterning, amateur finish and often exotic stylisation—brought into constellation an authentic modernism exploring primitive subjects and colour theory with the marketplace.

Recent work has sought to dissociate Fry from the lineage of socially minded critics that includes Ruskin and Morris, and to paint a portrait of a radically different intellectual. While the philosophy of his two forebears saw art and social life indelibly connected a priori, it is undoubtedly the case that Fry arrived much later in life at the applied role that art could play, his social conscience awakened in the years around the Grafton Galleries show and leading to a varied career as a promoter of art in schools, in the provinces, in universities—anywhere, in short, outside the bastions of the academies. His early critical career, up to the first years of the new century, was devoted to Renaissance art, and his writing dominated by an attentiveness to form. Yet even in his early works his aesthetic sensibility was stirred by artists whose works featured primitivist styles and bold colour and line, attributes that would help to formulate a definition for Postimpressionism in 1910. Elizabeth Prettejohn's study of Fry's early art criticism—in particular his nascent attention to primitive and oriental art forms—finds evidence for his attraction to non-classical forms in his very earliest published pieces, and likewise Christopher Green, in the same volume, offers a nuanced reading of Fry's work on 'savage' artists as a kind of precursor to his later attention

to Matisse, Cézanne, Van Gogh and Picasso.[14] Rachel Teukolsky is correct
to disturb the problematic correlation that Fry made between 'primitive' art
and the activities of a highly skilled and trained body of European artists,
arguing for a thorough historicising of the art world's subsequent canonisa-
tion of primitivism as a form of modernism, but it is clear that in Fry's
oeuvre a sensitivity to 'barbaric' forms was acquired early.[15] This eclectic
artistic background helps to explain his attraction to the bold colour, line
and forms of the work of many of the artists who would be exhibited at
'Manet and the Post-Impressionists' and the strategies Fry would use to
ground what appeared to be a new, shocking aesthetic in past artistic styles
and traditions with which he was most intimately familiar.

The public encounter with what became known after 1910 as Post-
impressionism was neither as brutal nor as instantaneous as is often
imagined. Public exposure in Britain to artists such as Matisse and
Cézanne had already begun in 1908, with the exhibition of French art
held in Brighton. Robert Dell, writing in the prospectus for that exhibi-
tion, had already begun the work of connecting artists such as Matisse,
Redon and Gauguin with earlier traditions. The response, however, to
the exhibition (and to the continental aesthetics that it represented) was
almost wholeheartedly negative: of the exhibition at Brighton, the reviewer
for the *Burlington Magazine* pointed to the 'infantile' work of Matisse and
celebrated—by contrast—British art, which had 'avoided the senile puerili-
ties' working in France.[16] Everywhere, the response to the work of Matisse,
Gauguin, Picasso and others was derided, not only for its aesthetics but
also often more for its cynical attempt to be new, shocking and a break with
any artistic tradition. *The Nation* admonished this cynicism: 'in trying to
be new', their art critic opined, 'they now see everything in acid blue and
black, fondly believing themselves original, and above all "new"'.[17] It was
these early attempts at bringing modern art into Britain that spurred Fry
into action. Indeed, he wrote a response to the *Burlington Magazine* review

[14] Elizabeth Prettejohn, 'Out of the Nineteenth Century: Roger Fry's Early Art Criticism',
in Christopher Green (ed.), *Art Made Modern: Roger Fry's Vision of Art* (London: Merrell
Holberton and The Courtauld Gallery, 1999), 31–44; Christopher Green, ''Expanding the
Canon: Roger Fry's Evaluations of the "Civilized" and the "Savage"'' in Green, *Art Made
Modern*, 119–34.

[15] Rachel Teukolsky, *The Literate Eye: Victorian Art Writing and Modernist Aesthetics* (Oxford:
Oxford University Press, 2009), especially ch. 5: 'Primitives and Post-Impressionists: Roger
Fry's Anthropological Modernism', 192–233.

[16] [unsigned], 'The Last Phase of Impressionism', *Burlington Magazine for Connoisseurs*, 12,
59 (February 1908): 272–3; 272; 273.

[17] 'Art: Autumn The Salon', *Nation* (7 November 1908): 221.

of Dell's exhibition and defended the work on show. In it, he pointed not only to the value of the work on the walls, but also to its place in artistic traditions—particularly those that existed before the turn towards the pictorial in the 17th century in Europe and those outside the Western canon—beginning a strategy of authenticating the work of these artists that would continue during the 1910 exhibition and beyond. Matisse, Gauguin, Signac—they were seen as the natural inheritors of Byzantinism: 'M.M. Cézanne and Paul Gauguin are not really Impressionists at all. They are proto-Byzantines rather than neo-Impressionists.'[18]

This strategy, of bringing reprobate artists into the fold, was one Fry would continue in 1910. One of the difficulties the organisers faced in defending the show was the preponderance of foreign work. Indeed, many of the reviews tied together the show's deranged styles with a kind of foreign infection. Fluctuations in nationalist and internationalist rhetoric undoubtedly played a part in both the reception of continental Postimpressionist art and sculpture and the home-grown artistic responses to its challenges. Paul Peppis has explored the role that nationalist rhetoric and politics played in the development of a British avant-garde in the years after 1910, particularly so far as the rise of Vorticist aesthetics is tied to a twin growth in anti-internationalist sentiment directed towards continental artistic movements.[19] Peppis's study helps to decode the imperialist strategies and processes that lie behind the development of a politically attuned avant-garde in Britain in the years before the First World War. Without a doubt, the same tensions pervade the response to Fry's Francophile exhibition in 1910. The metaphor of violence—either perpetrated on Western canons of art by radical continentals or dispensed by an enraged public on such scandalous works—is pervasive in the early responses to the exhibition. The reviewer in *The Times* opined that like 'anarchism in politics, [Postimpressionist art] is the rejection of all that civilization has done, the good with the bad', while a review in *The Spectator* laid the blame at the feet of the French political tradition, where 'a reform movement always has its section who are for the barricades, the guillotine, and the Anarchist's bomb'.[20] The political dimension in criticism was hard to ignore: E. Wake Cook, writing in the

[18] Roger Fry, letter to *Burlington Magazine for Connoisseurs*, 12, 60 (March 1908): 374–6; 375.

[19] Paul Peppis, *Literature, Politics and the English Avant-Garde* (Cambridge: Cambridge University Press, 2000).

[20] Quoted in Peter Stansky, *On or About December 1910: Early Bloomsbury and Its Intimate World* (Cambridge MA: Harvard University Press, 1997), 214; *The Spectator* (12 November 1910): 798.

Pall Mall Gazette, saw the art of Van Gogh and Gauguin as political inflam-
mation, the 'exact analogue' to 'criminal Anarchism which accompanies
Socialism like its shadow'.[21]

Fry sought to neuter this artistic and political othering of the work
included in the Grafton Galleries show by stressing the continuities rather
than the ruptures. In his 'Retrospect' essay on the show written in 1920,
he records his failure to convince the viewing public that Matisse, Cézanne
and Picasso represented not an advance, nor even a split from their
Impressionist 'parent stock', but 'a return to the ideas of formal design
which had almost been lost sight of in the fervid pursuit of naturalistic
representation'.[22] Rather than unleashing the experiments of Van Gogh,
Matisse and Picasso onto an unsuspecting public, the organisers worked to
create narratives around the exhibition and to generate an aura of authen-
ticity and a back-history about works that would cause public consterna-
tion. The term 'Post-Impressionist'—and those artists grouped under that
banner by Fry and Bell—was a neologism in 1910, dreamed up by Fry in
the weeks before the show. The term proved more useful than perhaps
Fry could have foreseen, connecting Manet—who was by 1910 already
well known to the British public as an Impressionist—with a number of
other artists who were still obscure in Britain at the time. Indeed, some
contemporary commentators saw the attempt to usher the excesses of Van
Gogh and Matisse under the safe canopy of Impressionism as a cynical
ploy: Walter Sickert wondered, in the *Fortnightly Review*, whether the fact
that the exhibition was called 'Manet and the Post-Impressionists' was in
fact 'a detail of advertisement'.[23] However ,the narrative constructed by Fry
and Desmond MacCarthy—in the 'Preface' to the exhibition catalogue—to
explain the sources of inspiration and heritage of Postimpressionism cer-
tainly did reveal a deep commitment to authorising the movement within
canons of Impressionism, all the while stressing connections with primitiv-
ist, Renaissance, Byzantine and Far-Eastern art. Manet's centrality to the
exhibition is stressed repeatedly—Cézanne's 'art is derived directly from
him', and Manet is 'the father of Impressionism'—but each artist repre-
sented in the show 'is pushing their ideas further and further'.[24] Fry's own

[21] E. Wake Cook, letter to the *Pall Mall Gazette* (10 November 1910): 7.

[22] Fry, 'Retrospect', in *Vision and Design* (London: Chatto and Windus, 1920), 188–99; 193.

[23] Walter Sickert, 'Post-Impressionists', *Fortnightly Review* (new series), XCV (January 1911):
79–89; 79.

[24] Desmond MacCarthy, 'The Post-Impressionists' [Introduction to the Catalogue of 'Manet
and the Post-Impressionists'], in J. B. Bullen (ed.), *Post-Impressionists in England* (New York:
Routledge, 1988), 94–9; 95; 98.

public declamations about the exhibition help to demonstrate the connec-
tions between Postimpressionism and past artistic styles. He was at pains—
in reviews, in public lectures, in responses to critics—to find continuities
between the artistic experiments of Van Gogh, Matisse and Cézanne and
non-figurative forebears. In an essay in the *Fortnightly Review* of May 1911,
he went some way to undermining one of the grounds upon which the exhi-
bition was attacked—its regressive or degenerative aesthetics. For Cézanne,
he found affinities with Piero della Francesca, he united Matisse with
Leonardo in their shared search for 'the rhythm of the figure as a whole',
and he viewed Gauguin as an inheritor of Cimabue's 'primitivism'.[25]

This attempt to ground the works included in 'Manet and the Post-
Impressionists', and to show connections where other critics saw only rup-
ture and artifice, was part of a strategy to imbue the works on the walls with
a narrative, a strategy mirrored in the layout of the rooms at the Grafton
Galleries in 1910. While the exhibited paintings and other decorative art
pieces on show have been documented with as much accuracy as the recon-
struction of the catalogues and sales records of the show will allow, less
attention has been paid to the story Fry tried to tell with the design of
the exhibition space. Anna Gruetzner Robins has undertaken significant
work towards producing a complete checklist of the exhibits, and her study
offers detailed information about the mechanics involved in producing the
show.[26] The elements of the exhibition that remain—photographs of the
hanging of paintings and the plan of the layout of the exhibition, along with
Fry's own comments about its design—reveal an under-discussed peda-
gogical dimension to the Grafton Galleries show. Fry was at the vanguard
of the transatlantic reshaping of exhibition culture that took place in the
early 20th century and helped to produce the modern gallery space. Fry's
familiarity not only with European galleries and curatorial practice but
also those in the United States—after his time spent at the Metropolitan
Museum in New York—ushered in changes to the way in which modern art
was displayed for its publics. His understanding of the gallery as an educa-
tional space, and not just one where the public could while away a few idle
hours, was instrumental in his designs for a new salon at the Metropolitan
Museum in 1906, where he was curator of paintings for a short time. He
wrote in March of that year that instrumental to his plans for the Met was

[25] Roger Fry, 'Post-Impressionism', *Fortnightly Review* (new series), XCV (May 1911):
856–67; 862, 864.
[26] See Anna Gruetzner Robins, '"Manet and the Post-Impressionists": A Checklist of
Exhibits', *Burlington Magazine*, 152, 1293 (December 2010): 782–93.

the issue of what 'the man in the street' looked for from his encounter with art, but of more central concern to Fry was the educational journey undertaken by an ideal viewer. The public should, he believed, 'acquire definite notions about the historical sequence of artistic expression'.[27] Yet the pedagogical dimensions of his techniques of display were strongly in evidence: 'We must', he wrote, 'so arrange the galleries that it shall be apparent to each and all that some things are more worthy than others of prolonged and serious attention.'[28]

The design of 'Manet and the Post-Impressionists' employed both of these techniques—the construction of a narrative journey in period or style and the focus on one or two pieces as emblematic of the exhibition's purpose—to encourage a holistic sense of the aesthetic principles of Postimpressionism. Fry was 'entirely absorbed', according to May Morris, 'in deciding which picture would look best next to another', and his attentiveness to the design of the space offered to him by the Grafton Galleries demonstrates clearly the narrative he wished to create.[29] Cézanne and Manet anchored the exhibition in the Octagonal Gallery, through which viewers entered the exhibition. Manet was the missing link, for Fry and MacCarthy, between an Impressionism that had been finally accepted in Britain and the work of Matisse, Picasso, Van Gogh and others that would follow in subsequent rooms. For Anna Gruetzner Robins, Fry's use of Manet as a departure point is driven home by the hanging of the now well-known *Un bar aux Folies-Bergère* next to Cézanne's *Mme Cézanne in a Striped Skirt*, thus demonstrating through the female form the move from the broadly representational and imitative Manet to the more abstract Cézanne.[30] Leaving this space, the visitor entered the Large Gallery—on display here were Gauguin and Van Gogh. Gauguin, MacCarthy's 'Preface' explained, was a primitive and a 'decorator', working on the edges of a representational aesthetic with 'extreme simplification' of gesture and movement. Van Gogh, too, for all the extreme emotion his paintings contain, 'accepts in the main the general appearance of nature'.[31] The culmination of the viewer's journey was in Picasso and finally Matisse. Both left representational style

[27] Roger Fry, 'Ideals for a Picture Gallery', *The Bulletin of the Metropolitan Museum*, I (March 1906): 59.

[28] Ibid.

[29] May Morris to John Quinn (7 December 1910), quoted in B. I. Read, *The Man from New York: John Quinn and his Friends* (Oxford: Oxford University Press, 1968), 95.

[30] See Anna Gruetzner Robins (ed.), *Modern Art in Britain 1910–1914* (London: Merrell Holberton, 1997), 21.

[31] MacCarthy, 'The Post-Impressionists', 98.

behind, even in their early work, and MacCarthy emphasised that both were in 'search of an abstract harmony [...] which often deprive the figure of all appearance of nature'.[32] The story the exhibition told, in other words, charted a path from representational to abstract aesthetics, showing how the development of an aesthetic begun in Manet reached its apotheosis in these more obviously experimental successors. This narrative is important for two reasons: it helped to legitimise and explain the more abstract pictures on display, stressing their continuity with past artistic traditions, while also helping to legitimise decoration (which Fry came to celebrate in Matisse, in particular) as an important facet of modernism. Of all of the artists included in the 1910 exhibition, it was Matisse who became most associated with 'Bloomsbury' modernism. While in 1910 Fry saw Matisse as an important member of a group of artists devoted to the effect of line and colour, he came to stress the singular importance of Matisse in later years, especially as his work might lend itself to decoration. Matisse (and Picasso, to a lesser extent) grew in importance to Fry's conception of what Postimpressionism was—they were 'two men', he wrote in *The Nation* after the second Postimpressionist show in 1912, that 'stand out at the present moment as leaders'.[33] While not overly represented in the 1910 exhibition—there were four Matisses and two Picassos—both artists were more than just representatives of the movement, and the number of paintings included by each at the show two years later in London increased markedly: nineteen from Matisse and eleven from Picasso. In some ways, the reception of both artists' work in Britain acts as a barometer for the private and public reception of Fry's Postimpressionist brand. Indeed, the records of display and purchase of works by Matisse and Picasso in Britain in the next few decades goes some way to demonstrating the importance of the narratives that were constructed around both by Fry in 1910.

In the years immediately following the exhibitions at the Grafton Galleries, more paintings by Matisse and Picasso were bought in Britain than in any other country except France. Madeleine Korn has detailed exhaustively the collections of both artists that existed in Britain in the early 20th century, her survey revealing a diversity of purchasers as well as some significant trends in popularity.[34] The earliest collectors of both Matisse and Picasso—Korn's analysis reveals—were unsurprisingly those

[32] Ibid.
[33] Roger Fry, 'The Grafton Gallery: An Apologia', *The Nation* (9 November 1912): 250.
[34] Madeleine Korn, 'Collecting Paintings by Matisse and by Picasso in Britain before the Second World War', *Journal of the History of Collections*, 16, 1 (2004): 111–29.

with significant connections to Bloomsbury or to the artists themselves: Fry bought some himself too, as did Clive Bell. Yet very quickly purchasers came from outside. Cyril K. Butler, one of the founders of the CAS, bought Matisse's *Marocaine en jaune* (1912) in the year it was painted, and a year later Herbert Coleman, a merchant from Manchester, bought the same artist's *L'Ilysus du Parthénon* (1908).[35] He also bought some of Matisse's sculpture and a ceramic plaque in the same year. Korn argues that the significant actors in Britain in the 1920s and 1930s collected works by Matisse and Picasso not out of a belief that they were getting a bargain, nor indeed that they would be able to sell on for a significant profit, but rather because they were motivated by what Margrit Hahnloser-Ingold called 'the adventurous championing of a small, misunderstood avant-garde'.[36] For Korn, collectors 'saw the purchase of this art not as an economic investment or a representation of their socio-economic position but as a way of showing their individuality and originality through their refusal to follow the general taste of the day'.[37] Buyers bought because 'they still believed that its ownership identified them as adventurous pioneers of the avant-garde'.[38] Their collection practices bore little resemblance to those being practised on the other side of the Atlantic Ocean: while wealthy buyers such as Alfred Barnes, Duncan Phillips or John Quinn could form movement-defining collections and enshrine artists' reputations by amassing huge stores of their work, the habits of most British buyers were small-batch and piecemeal. If they were less interested in the future financial uptick that might result from a savvy purchase, they were also less concerned with the kind of canon-forming acquisitions that resulted in the Barnes Foundation's collections or those of the Museum of Modern Art in New York. Korn's research shows that their purchases were not necessarily 'institutional' ones—their decisions were not guided by the future museum or gallery locations, nor indeed the future prices, of the paintings—but rather by aesthetic curiosity and, importantly, possession of a coterie identity.

Identifying the collections of the most prominent Postimpressionists at Fry's exhibitions that were obtained by collectors is, for this reason, a difficult task. Even in the case of Matisse and Picasso, the task is harder than

[35] Ibid.: 114.

[36] Margrit Hahnloser-Ingold, 'Collecting Matisses of the 1920s in the 1920s', in Jack Cowart (ed.), *Henri Matisse: The Early Years in Nice, 1916–1930* (Washington DC: The National Gallery of Art, 1986), 235–74; 235.

[37] Korn, 'Collecting Paintings': 116.

[38] Ibid.: 120.

might be imagined. Part of the problem is undoubtedly the fact that no *catalogue raisonné* exists for Picasso's work after 1916, and what is known about the whereabouts of Matisse's work is largely pieced together from exhibition catalogues. But Korn's work still shows the huge uptake of paintings and sculptures by both artists in the 1920s and 1930s: 130 paintings by Picasso and 120 by Matisse were in British hands by 1940, mainly held singly or in very small collections. Matisse's significant popularity in Britain in the 1910s and 1920s—almost seven times more paintings by Matisse were bought in the 1920s than Picassos in Britain—hints perhaps at the comfort buyers found in his decorative style, and more widely at the enshrinement of decorative aesthetics at the heart of artistic modernism in Britain by Fry. Certainly, Matisse's visibility in Britain was enhanced by a one-man show at the Leicester Galleries in 1919, the total sales of which amounted to over £5,000.[39] But hidden behind these sales figures is the prevailing taste among collectors for *a certain kind* of Matisse. Most of the Matisse paintings bought in Britain in the 1910s and 1920s were from his post-Paris workshop—they were not of the same style as those exhibited by Fry in 1910 and 1912 in London, and were mainly drawn from his period in Nice. Less radically colourised than his Fauvist and Parisian work, his works from this period are undeniably prettier: more decorative, redolent of Mediterranean openness and light more than Parisian interiors, they appealed to buyers who wanted to hang them in their homes. There was the odd exception—David Tennant bought *Red Studio* and *L'Atelier du Quai Saint-Michel*, both from Matisse's more controversial earlier period, and hung them in the Gargoyle Club. Even there, though, they were used for decorative effect, used to accent the mirrored mosaic walls. Matisse visited Britain in 1919 for the first time with an exhibition at the Leicester Galleries and, though neither Fry nor Bell were in the country, his presence—and the fact that he undertook two commissions in Britain in subsequent visits, painting Maud Russell and Mary Hutchinson—seems to confirm at least a tacit acceptance in the art world. Undoubtedly, his involvement with the ballet in London helped to cement this acceptance, as did the patronage of influential arbiters of taste such as Osbert and Sacheverell Sitwell and Léopold Zborowski. His involvement with the Ballets Russes—beginning in 1919 with his designs for *Rossignol*, introduced his work to a much wider audience. Moreover, the decorative sense that had so condemned him in 1910 was applauded when translated to the stage.

[39] Oliver Brown, *Exhibitions: The Memoirs of Oliver Brown* (London: Evelyn, Adams & Mackay, 1968), 66.

From the most divisive of the figures at the 1910 show, Matisse developed into a safe, 'quotable' modernist artist quite quickly. R. H. Wilenski noted wryly in 1919 the 'prettiness' of Matisse's *Chapeau à plumes*, and that it 'would take Miss Helen Dryden only about ten minutes to convert it into a typical cover for *Vogue*' (a magazine that would pick out Matisse for its 'Hall of Fame' in 1925).[40] It is worth dwelling on the assimilation of Matisse in particular because, of all the artists exhibited in 1910 and 1912, he became central to Fry's conception of the decorative potential of modern art. In Chapter 4, I discuss some of the ways in which the Omega Workshops, set up by Fry in the immediate aftermath of the Postimpressionist moment in Britain to marketise a Bloomsbury aesthetic, transformed modernist aesthetics into objects for home decor. The relationship between the aesthetic and pedagogical elements of the show and the obvious commercial interests of its organisers is a complicated one. Undoubtedly, one of Fry's aims was to sell paintings, and the packaging and reification of a distinct aesthetic style helped to foster a sense of an artistic movement that might constitute a profitable investment. Desmond MacCarthy, writing the catalogue, suggested that Matisse aimed 'at synthesis in design [...] he is prepared to subordinate consciously his power of representing the parts of his picture as plausibly as possible, to the expressiveness of the whole design'.[41] Fry would write later, in 1912, that the only truly revolutionary aspect of Postimpressionist painting was its 'return to the strict laws of design'.[42] In fact, Matisse's decorative aesthetic—already advanced in 1910, but continuing to develop throughout his works of the 1910s and 1920s—was, for Fry, the logical endpoint of the shift from realism to abstraction. Fry's focus on Matisse's colour intelligence grew: of Matisse's works included in the 'Second Post-Impressionist Exhibition' in 1912, he wrote that 'the same identical colour may be used to express a number of distinct planes [...] thanks to the increased amplitude and simplicity of the design'.[43] The suitability of Postimpressionist design for the three dimensions of craft objects derives, in part, from its flatness and geometric—and often repeating—forms. Flat design, which incidentally

[40] R. H. Wilenski, 'Art Matters', *Athenaeum* (19 November 1919): 1402. Richard Shone points out some of the affinities between Matisse's work and *Vogue*'s cover illustration: see Shone, 'Matisse in England and Two English Sitters', *Burlington Magazine*, 135, 1084 (July 1993): 479–84; 481.

[41] Desmond MacCarthy, *Manet and the Post Impressionists* (London: Grafton Galleries, 1910), 12.

[42] Fry, 'The Grafton Gallery', 250.

[43] Ibid.

was one of the markers of primitive and medieval art that Fry consistently championed in his writings of the 1910s, offered the craftsman and producer of wares an opportunity to transpose bold lines, colours and forms onto three dimensional objects. Fry's own home, Durbins, in Guildford, Surrey, became an almost perfect showcase for the ways in which this Postimpressionist Bloomsbury aesthetic became a marketable lifestyle. Durbins, for all its pale walls, open spaces and bare floors, was exquisitely and eclectically decorated. *Vogue*'s photo-essay of Fry's home in March 1918 shows a space filled with Postimpressionist works—several by Bell and Grant, of course, and many by other modernists such as sculptures by Henri Gaudier-Brzeska and Eric Gill. Indeed, *Vogue*, as Jane Garrity has demonstrated, provided one forum for the reification and marketisation of a Bloomsbury–Omega–Postimpressionist lifestyle: that magazine 'provides evidence that the "Bloomsbury industry" can be traced to the years of high modernist production'.[44] The eclecticism of Fry's home did not result in Victorian nick-nackery, but something altogether more proportional. Virginia Woolf found it 'Bloomsbury' par excellence: 'Every sort of style and object seemed to be mixed, but harmoniously. It was a stored, but not a congested, house, a place to live in, not a museum.'[45]

Undoubtedly, the commercial appeal of Postimpressionist design were obvious. By 1934, Herbert Read could persuasively make the case in his *Art and Industry* that the formalist values Fry had enshrined in the conceptualisation of Postimpressionism, naturally spilled over into the world of practical design', and that whenever 'the final product of the machine is designed or determined by anyone sensitive enough formal values, that product can and does become an abstract work in the subtle sense of the term'.[46] Frank Rutter's retrospective study *Evolution in Modern Art: A Study of Modern Painting 1870–1925* argued persuasively that the true legacies of Postimpressionism were in design. 'Not only in public buildings, but in many private dwellings, isolated cabinet pictures—having no relation to each other—are gradually being ousted in favour of a suite of panels by the same artist, or by groups of artists in sympathy with each other. On the evidence we may fairly assume that decorative rather than illustrative ideals

[44] Jane Garrity, 'Selling Culture to the "Civilized": Bloomsbury, British *Vogue*, and the Marketing of National Identity', *Modernism/modernity*, 6, 2 (April 1999): 29–48: 30.

[45] Quoted in Christopher Reed, *Bloomsbury Rooms: Modernism, Subculture and Domesticity* (New Haven, CT: Yale University Press, 2004), 44.

[46] Herbert Read, *Art and Industry: The Principles of Industrial Design* (London: Faber and Faber, 1934), 37.

prevail to-day in the pictorial arts.'[47] For Rutter, advances in design mark the biggest change in aesthetics between the 1890s and the work of the 1920s, and such advances led to the spilling over of the flat design so celebrated by Fry in Matisse into the applied arts: ceramics, furniture—even woodcuts: 'In one small gallery alone over seven hundred wood-engravings were sold during a twelvemonth. This sudden popularity of an art that is far more intellectual than sensuousness surely indicates a certain change in the public taste and a revived interest in design.'[48] Fry's role in cultivating this revived interest stemmed from his sense of the decorative element in Postimpressionist art, and his firm belief that art had a role to play in the world meant a legacy for Postimpressionism beyond the four walls of the gallery.

In important ways, Fry's art criticism and sense of pedagogic mission interacted with this desire to increase exposure to modernist art. The home would become a legitimate target of Postimpressionist aesthetics in the years following the 1910 exhibition, but there were other sites that Fry hoped to refresh with modern art. The arts institution—the art objects it possessed, its selection and exhibition procedures, the stories it told about itself, the role it played in everyday life—were also shaped by Fry's exhibition and, importantly, in his art criticism too. One long arc in Fry's gradual shift from criticism of the Old Masters to championing modernism was an increasing disillusionment with the relationship that the public had with art and its institutions, and, in particular, the role that the art critic played in that nexus. In this next section, I want to suggest that the Fry of the Postimpressionist moment was a major figure in the transformation of the role of the art critic and was, in turn, a transformational figure on the institutional basis for the visual arts in Britain, a recurring theme in subsequent chapters.

The relationship between art and its critics has a deep history in the 19th century.[49] The rise of art criticism in the later 19th century was accelerated by cheap and voluminous print. Every major publication had an arts critic, and the circulation of many titles far outstripped gallery attendance

[47] Frank Rutter, *Evolution in Modern Art: A Study of Modern Painting 1870–1925* (London: Harrap and Co., 1926), 151.

[48] Ibid., 150.

[49] See, for example, Kate Flint, *The Victorians and the Visual Imagination* (Cambridge: Cambridge University Press, 2000), 167–96; Teukolsky, *The Literate Eye*; Jonah Siegel, *Desire and Excess: The Nineteenth-Century Culture of Art* (Princeton, NJ: Princeton University Press, 2000).

figures. The role that such critics were to play in the dissemination of ideas about art began to attract debate later in the century. The true subject of Whistler's angry post-trial diatribe, 'Whistler vs. Ruskin: Art and Art Critics' (1878), was the invidious influence of this new body of commentators—'the war', he opined, 'of which the opening skirmish was fought the other day in Westminster, is really one between the brush and the pen; and involves literally, as the Attorney-General himself hinted, the absolute *raison d'être* of the critic'.[50] Whistler's bigger objection, though, was against the kind of moral arbitration that art criticism came to represent in public culture—that commentators on art gave themselves free licence to connect aesthetic compositions with moral, social and political means and motives. Whistler's call for the separateness of artistic appreciation, its radical difference from the other activities of life, marks a change in the role that art criticism was to play in British life. As Kate Flint suggests, the 'various forms of response' that constitute art criticism were, for Whistler, 'inseparable from both vulgarisation and popular pretension. They foster the illusion that the mysteries of art are easily accessible.'[51] The notion that the arts were for the public at large—supported by galleries that opened until later in the evening, free exhibitions and public lectures, and the development of the cheap, reproducible image—went hand in hand, for Whistler, with the rise of an insidious class of critics and commentators to lead them by the nose, motivated by prudery, dogma or—worse—commercial interests.

The burgeoning art-critical field was marked by a significant rise in the number of art critics and journals dedicated to the study of art. The ability to mass-produce images of art—in photographs, lithographs, prints and advertisements—helped take art to wider audiences and meant that the art critic had significantly more exposure. What Victorian art criticism constituted was often not analysis of art objects in and of themselves, but a range of subjects including artist biographies, studies of subject matter and analysis of the didactic purpose of art. For Jonah Siegel, the Victorian art institution was 'scripted' with social, biographical, moral and religious meanings overlaying the viewing experience, and Rachel Teukolsky argues that the Victorian gallery-goer faced 'a host of extrinsic factors, the most significant of which was the language used to characterise the arts [which was] at times unrecognizable in connection with the

[50] James McNeill Whistler, *The Gentle Art of Making Enemies* (London: Heinemann, 1892), 25.
[51] Flint, *The Victorians*, 172.

art it was meant to describe'.[52] In this system, the role of the art critic was often not to interpret the arrangement of the work, but to encircle it with a learned discourse of history, religion, politics and methods of attribution. The 'learning' that such criticism disseminated was, then, not exterior to the work itself. The focus on the object itself was crucial to this shift in art criticism in the years after 1910. Central to Fry's writing on Postimpressionism is a new attentiveness to formal arrangement, and with it one of the totemic concepts in artistic modernism in Britain: significant form. Elizabeth Prettejohn suggests that the art-critical world that existed in Britain before November 1910 depended on what were essentially Victorian 'structures of discrimination'; that is, a relatively liberal consensus about the autonomy of the art work—however nebulous or woolly this may have been in its Paterian or Wildean iterations—accompanied by a holistic and harmonious belief in the relationship between form and moral or spiritual content.[53] Fry's separation of structural analysis from everything else in the interpretation of art—subject matter, the 'intention' of the artist, ethics, religion and so forth—was perhaps the first flowering of a true formalism in British art criticism, but it also began the work of democratising the interpretation of complex works of art by privileging individual intuition over everything else. Though it took Clive Bell's *Art* (1914) to concretise the concept, and although true formalism in art had been developed on the continent in the later 19th century and had been more assuredly outlined by Heinrich Wölfflin in a range of publications including *Renaissance und Barock* (1888) and *Die Klassische Kunst* (1898), Fry's understanding of the demands modernist art placed on the viewer, and the need for that viewer to develop a rational, objective and quasi-scientific method to interpret the work, helped to establish a more professional attitude to art criticism in Britain, and one founded on egalitarian and democratic principles.

Bell's study is hardly art-historical—he was vague about the features he discussed and the absence of a method in his analytical framework is striking: appreciation of the art object requires 'nothing but a sense of form and colour and a knowledge of three-dimensional space' and demands nothing more of the viewer than 'a turn for clear thinking'.[54] Other critics attempted to define the same indefinable feeling, mood or emotional complex that the viewer received in front of the art work. John Rodker, writing on the

[52] Siegel, *Desire and Excess*, xxvi; Teukolsky, *The Literate Eye*, 16.
[53] Elizabeth Prettejohn, 'Out of the Nineteenth Century', 34.
[54] Clive Bell, *Art* (New York: Frederick Stokes, 1914), 23; 5.

outbreak of war, was perhaps a little more specific in his description of the effect of form in modernist art:

> It may be that the public is developing a new sense—or, rather, reverting to an old one—that of intuition; for the 'new' art is primarily a thing from which intellect must, as much as possible, be excluded. We are then left with our senses merely, which include that one not yet pinned and labelled by scientists as such, but which we know, nevertheless, exists, and is called intuition. This, then, explains many things. A perfect quiescence in the presence of a work of the 'new' art is more likely to result in appreciation, and that aesthetic pleasure which inevitably accompanies these works, than the most strenuous brain-racking, for the senses will immediately seize upon that rhythm of line, harmony of conception, and striking colour which are their greatness. Looked at in this way there is no reason whatever why these pictures should give rise to laughter instead of a deep insight, or why they should remain the caviare they have remained.[55]

'Intuition' is perhaps closer to Fry's understanding of the process of formal analysis. While Bell's study is rightly lauded as an accessible handbook to unpacking Postimpressionist aesthetics, and was crucial in disseminating the idea of a pure, formal analysis in British art criticism, it remains a frustrating explication of what Fry imagined the new aesthetic analysis might accomplish. For one, the stress on a non-educated, innate and unthinking response to the art object in Bell's study does harm to Fry's enlarged sense of what a deeper understanding of non-representational art might do in the world. Bell's description of the 'aesthetic emotion' in front of great art was just that—it served no social role or purpose and could easily be mistaken for seeing the work of art as a pleasure in and of itself (a position dangerously close to an art for art's sake philosophy). In Fry's writings on formal analysis, it becomes clear that he was not advocating an uneducated response to the work but, rather, a better understanding of what specifically was to be studied in the artwork and what was to be gained in the analysis. The methodology is anything but relative and subjective: 'The view of the ordinary educated man', he wrote in 1904, 'is that in matters of taste one man's opinion is as good as another's [...] Nevertheless, it may be well to point out that this idea of the subjectivity of the aesthetic judgement has not always been held: it is merely an outcome of the present chaotic condition of the arts.'[56] Such insight required the rigour of a method and some grounds for empirical testing. Indeed, his writings on his own methodology

[55] John Rodker, 'The "New" Movement in Art', *Dial Monthly* (May 1914): 185–6.
[56] Roger Fry, 'The Chantrey Bequest' [I], in Christopher Reed (ed.), *A Roger Fry Reader* (Chicago and London: University of Chicago Press, 1996), 252–3; 252.

used the language of scientific analysis: in an unpublished lecture from 1908, he claimed to have flown the shackles of metaphysics:

> [m]y attitude to aesthetics is essentially a practical and empirical one [...] In carrying out [the] work of comparison I find myself from time to time to sum up my results in a theory of aesthetic which I always regard as provisional and of the nature of a scientific hypothesis, to be held until some new phenomenon arises [...][57]

As late as 1930, Fry declared that 'the scientific discipline' is 'of immense value [...] It is essential that the art-historian should be able to contemplate any object which can claim in any way to be a work of art with the same alert and attentive inquisition as one which has already been, as it were, canonized.'[58]

Significant form and its attendant concepts of aesthetic emotion or intuition have been much derided for their extreme solipsism and relativism, dependent on the cultivation of an amorphous sense for unpacking a painting. And while there is much fuzziness around the concept in Clive Bell's explication, Fry was always clear on rigour, integrity and an almost architectonic sense of forms at work. Moreover, though the individual was the sole repository of taste and discrimination, and a sense of discernment was to be grown from exposure to a range of great art, the end result of the process of art-gazing was not merely an enlarged sense of self, but an enlarged sense of the self *in the world*. Once a capacity for sensitive engagement with the arts was thus developed, the perceiver's role was a social one. Fry's sense of what role art played in the world has been explored by a number of critics, and though he was already alert to the ways in which art might interrupt or heighten quotidian life by the time of the Grafton Galleries show, it was the ill-informed, vitriolic and emotive response to it that led him to champion the development of art writing along a scientific path. A set of formalist principles—a process—demanded a methodology, one that could be replicated and taught, and it is no surprise to see Fry's conception of this new art-analytical toolkit spill over into thoughts about education. In subsequent chapters, I will explore the ways in which a modernist pedagogy developed in writers such as Fry and Herbert Read, but Fry's vision of the professionalisation of art criticism was crucial to his understanding of the importance of Postimpressionist work, and the democratisation—and

[57] Roger Fry, 'Expression and Representation in the Graphic Arts' [unpublished lecture], in Reed, *A Roger Fry Reader* , 61–75; 61.
[58] Roger Fry, 'The Courtauld Institute of Art', *Burlington Magazine for Connoisseurs*, 57, 333 (December 1930): 317–18; 317.

decentralisation—of the arts in Britain. A nation not slavishly dependent on the opinions of a few snobbish dilettantes resident in a few square miles of London would be quicker to see the social benefits of modernist art. He pursued the education of art critics intermittently throughout the decades after 1910, but always argued for impartiality, diligence and—above all— an anti-institutional stance in art criticism. More and more, his writings stressed a need for the art critic to be an active, public figure, engaging the public—as far as possible—with lively discourse and democratising comment. This is no academic role: it is a roving intellectual at large, polemical, suspicious of vested interests and ready to defend the indefensible. In a letter to the *Burlington Magazine* in December 1930, he reflected on the changes to the study of art history from a quarter of a century before, when 'the Burlington struggled painfully for its existence', to a time where there was to be a real social and cultural good in art criticism.[59] 'I think we may fairly pride ourselves', he said, 'on having done much to bring about that changed attitude towards art history of which the establishment of an art-historical faculty in London University is a culminating proof.'[60]

A key part of this change was the new role in public life afforded to the art critic, a prominence established by the events in 1910 and after. In the same letter, Fry continued to advocate for an enlarged role for the art critic. Noting that both the democratisation of taste, of which he had been chief architect, and the opportunity that university education in art history and criticism might afford a greater number of people, Fry saw a future for the discipline outside the narrow confines of attribution and connoisseurship. He also reflected that the study of art in an academic setting, not tinged by the networks of capital in the art market and gallery trade, would help foster disinterested, formalist criticism devoid of moralistic or quasi-religious baggage. Even more importantly, a professional training in the arts would encourage changes to the structure of arts organisations nationally: Art history in the universities would have 'in the long run, a considerable effect. There are in England a number of posts which might be and should be filled by highly trained professional art-historians. I am thinking particularly of the curatorships of our provincial museums.' Noting that few trained professionals would venture forth out of the capital at that time, largely because the governing bodies of such institutions were filled with moneyed know-nothings, he looked forward to a changed dynamic in the future:

[59] Ibid.
[60] Ibid.

The mere existence of a University degree in art-history would have mar-
vellously sobering effect on these public-spirited, but over-inspired patrons.
They would feel something of the same hesitation in overriding the opinion
of such a professional authority as they many now feel about neglecting the
advice of their doctor. In the long run this might lead to our provincial galler-
ies becoming centres of artistic influence comparable to the great provincial
galleries of Germany and America. The difference that this would make in the
cultural life of England is incalculable.[61]

In his brutal critique of the mismanagement of the Chantrey Bequest, Fry
pointed to the need for the development of an 'objective standard' of art
that relied on those who understood the mechanics of the discipline: such
a standard is 'attainable the moment one has a consensus of authorita-
tive opinion [...] In the Middle Ages and early Renaissance the contract
between a patron and an artist was drawn with a clause that the work was
to be done to the satisfaction of competent masters in the art, not, it be
noticed, to the satisfaction of the patron.'[62] The original bequest, made
in the will of Francis Leggatt Chantrey, was to enable the state to encour-
age the work of British artists and to provide funds to purchase such work
for the nation. By the turn of the century, however, the Royal Academy was
acting neither transparently nor democratically with these funds—it was
instead buying up the works of senior Royal Academicians whose artistic
skill was clearly limited.

As early as 1904, then, Fry was deeply suspicious of the taste and abili-
ties of the men who found themselves in charge of the nation's main reposi-
tories of art and of the ways in which those institutions canonised certain
styles and artists. It is undoubtedly possible to read the development of
his social theories of art in the decade before the First World War as one
marked by a growing anti-institutionalism, and many facets of the 1910
show and its aftermath are evidence of Fry's radical opposition to the more
institutionalised art spaces in London—in particular Burlington House
and the National Gallery. Certainly, Fry's opposition to Academy art was
patent by the turn of the century. 'The Academy', he wrote in *Pilot* in 1900,
'becomes every year a more and more colossal joke played with inimitable
gravity on a public which is too much the creature of habit to show that it
is no longer taken in.'[63] Few critical studies have focused on Fry's attacks
on the institutions of art in Britain in the years leading up to 'Manet and

61 Ibid.
62 Fry, 'Chantrey Bequest' [I], 252–3.
63 Roger Fry, 'Royal Academy', *Pilot* (12 May 1900): 321.

the Post-Impressionists', but there are so many hints—in his letters and his public writings—that Fry was primed, in 1910, for a fiery encounter with the artistic establishment. His ire at both the prevailing structures of the British art world and at existing concepts of taste and discrimination in public life coalesced on the Royal Academy. Possessed of so much of the artistic capital—in every sense of that word—of the nation, the Royal Academy had long attracted the criticism of experimental artists and critics of the art establishment. By the turn of the century, its shows became the bête noire of almost every innovative artist in Britain: indeed, many artists' organisations (including the New English Art Club and the Allied Artists Association) were founded on the principle that they would oppose the Royal Academy's selection and purchase of works, and it was one of Wyndham Lewis's targets in *Blast*. Yet for David Bomberg the Academy still represented, to the public at least, 'what art should be in England'.[64] In 'Fine-Art Gossip' in *The Athenaeum*, Fry wrote applaudingly of the 'indefatigable' D. S. MacColl and 'his attempts to reform the administration of official patronage of modern art'.[65] His outrage at the administration of the Chantrey Bequest spilled over into a much wider diatribe about the management of the arts in Britain. For Fry, the situation was akin to 'a theatre, endowed by the State for the production of classical drama, which pocketed its annual grant and proceeded to have thousand-night runs of "Charley's Aunt"'.[66] The debate that ensued once the spending was made public reached the House of Lords, where an investigating committee found that the Chantrey collection, 'while containing some fine works of art, is lacking in variety and interest' and 'contains too many pictures of a purely popular character, and too few which reach the degree of artistic distinction evidently aimed at by Sir Francis Chantrey'.[67]

The Lords' report suggested wholesale changes to the structure of the Royal Academy and to the way in which pictures were purchased. Fry was sceptical about any long-term changes to the institutional art policy in Britain—'it is well not to have extravagant hopes', he wrote, 'and there is good precedent for supposing that after a few years of better administration things will return to their former condition'.[68] The Royal Academy's

[64] Quoted in William C. Wees, *Vorticism and the English Avant-Garde* (Toronto: Toronto University Press, 1972), 10.

[65] Roger Fry, 'Fine-Art Gossip', *The Athenaeum* (23 May 1903): 665.

[66] Fry, 'The Chantrey Bequest' [I], 252–5; 254.

[67] Quoted by Fry in 'The Chantrey Bequest' [II] in Reed, *A Roger Fry Reader*, 255–8.

[68] Ibid.

desire, to offend as few people as possible, had resulted in an insipid exhibition culture. Its selection of works by committee went against the grain of Fry's appeal to the conviction of taste that should be expressed by the individual. In an article from 1902 on the National Gallery, he wrote that such selection procedures would only result in 'works of feeble and flaccid personalities' that would provoke no response other than boredom in the gallery-going public. What also lay behind these pre-1910 missives was a profound concern for the health of the nation's art. Fry was animated on the foreign acquisition of masterpieces—both Renaissance and modern—while the National Gallery was obsessed with one or two narrow formal styles and the Royal Academy was self-servingly buying the works of its own senior members. The national repository of fine art—in the National Gallery in particular—was at an all-time low, and its management 'will definitely prevent any hope of our keeping pace with the German public and American private enterprise'.[69]

This questioning of the extant institutional basis for art in Britain, and Fry's worries about a home-grown artistic culture being eclipsed abroad, also led directly to the founding of the CAS. Set up in 1910 as a society dedicated to 'acquiring works of art by living or recently deceased artists, to be presented to London or Provincial galleries', the CAS was an anti-institutional arts organisation and one committed to encouraging an authentic British modernism.[70] While other collecting organisations had been set up in the years before, such as the National Art Collections Fund (of which Fry was also a founder member), none had been devoted to the cultivation of a home-grown avant-garde. Over the course of the next few years, the CAS subsidised a huge number of young artists in Britain, and it helped to foster a British response to Postimpressionism. While the CAS benefited from a huge range of critics, patrons and art-educators—Phillip and Ottoline Morrell, D. S. MacColl, Charles Aitken and Edward Marsh among them—its *raison d'être* drew from Fry's criticisms of the art world as it stood before 1910. Fry's assertion that taste could not be expressed, nor cultivated, by committee, for instance, found its way into CAS policy quite quickly. A different member of the executive committee bought works of art each year, so that committee standards did not result in anodyne acquisitions. The first annual report of the CAS offered a mission

[69] Roger Fry, 'The Administration of the National Gallery', *The Athenaeum* (2 August 1902): 165.
[70] Contemporary Art Society, 'First Annual Report', Tate Gallery Archive, TGA9215/2/1, n.p.

statement that offered implied criticism of the wider collecting practices of some of the major institutions in London, and this echoed Fry's words in the preceding years: 'From the conviction that some of the finer artistic talent of our time is imperfectly or not at all represented in the National or Municipal Galleries', the report bemoaned the fact that 'during the last century little or no attempt was made to secure for the nation any vital contemporary painting which has stood the test of time' and that '[t]he CAS hoped to obviate a similar reproach being made against the present age'.[71] One of the problems was that, when the larger galleries refused to buy contemporary or experimental work, it was snapped up by private patrons and disappeared from public view. Indeed, the crisis moment that initiated the committee that formed the CAS was the private purchase of Augustus John's *The Smiling Woman*, of which Fry had written glowingly in 1909 in the *Burlington Magazine*. Eventually, the CAS rescued it from private hands for the nation for the sum of £225, and then displayed it in Newcastle before it was donated to the Tate in 1917. Purchases were loaned out to a range of institutions, beginning with a show at the Kingston on Thames gallery in 1911. Early exhibitions were extremely well attended, for relatively short events. In 1912, the Manchester exhibition brought in over 45,000 visitors, and those at Leeds and Bradford over 30,000 each, while in its first years there were also sizeable modernist exhibitions at provincial galleries in Liverpool, Aberdeen, Rochdale, Leicester and Newcastle. Indeed, provinciality was an important driving principle in the construction of the CAS: the committee felt in 1912 that it was 'desirable to appoint Correspondents in important provincial centres who should rank as Consultative members of the Executive Committee', with such correspondents tasked with 'stimulat[ing] public opinion where it is apathetic or ill-informed, and incite their fellow citizens to increased generosity'.[72] Such nodes were to be based in Manchester, Liverpool, Birmingham, Bristol, Leeds, Scarborough, Bradford, Brighton and Lincolnshire. While the CAS became one of the main champions of British modern art in the first part of the 20th century, the purchases it made, along with the tastes it collectively displayed, were throughout its first years overwhelmingly Postimpressionist. Influenced quite significantly by the tastes of Fry, but also major collectors such as Michael Sadler and Edward Marsh, it avoided buying the work of British artists who strayed too far beyond the bounds of Postimpressionism. A subsequent generation of British artists working in

[71] Ibid., n.p.
[72] 'Executive Committee' notes, 3 August 1912, TGA 9215/2/3, n.p.

strong non-representation and abstract styles, including Wyndham Lewis, Paul Nash and Edward Wadsworth, were somewhat disenfranchised by the collecting habits of the early CAS, but the institution helped to disseminate the work of the inheritors of Postimpressionism in Britain, such as Duncan Grant and Vanessa Bell. In doing so, its exhibitions and its purchasing habits in the years up to the First World War owed a huge debt to Roger Fry's vision of Postimpressionism.

While organisations such as the CAS represented one form of decentralisation in the arts, in a similar way private galleries, such as the Grafton, also played a role in taking financial and cultural power away from the larger institutions of art, and were able to blend commerce and pedagogy in supple new ways. The techniques of 'Manet and the Post-Impressionists'—a show that opened with a coterie, invitational and press view, an exhibition catalogue that offered a narrative about the event and the use of a private, commercial gallery to concretise an entirely fabricated aesthetic—were all elements of the marketer as much as the educator. What is revealed in Fry's art criticism in the years surrounding 1910 is that he was aware of the institutional vacuum that existed in Britain at the time—that of a gallery that could be a space of cultural, social and economic capital. If the Grafton Galleries were not perhaps the site of a political context in late 1910, it was nonetheless a new kind of cultural space and marketplace, what Anna Gruetzner Robins describes as 'an institutionalized space and time of apparent freedom from the insidious forms of Victorian convention and control'.[73] The 1910 exhibition and its successors were part of a nascent market culture of modernist art that took root in the smaller, private gallery spaces across London and, in subsequent years, in regional and provincial locations in Britain. Anne Helmreich and Ysanne Holt usefully demonstrate the ways in which the institutional apparatus of a small, commercial gallery—its reputation, its patronage and management, and its market power—condition the works displayed within and shape their reception; as a space, in other words, where 'modernism and the market confronted each other in a necessary but paradoxical relationship'.[74] These galleries might also be marked out as a site of modernist pedagogy as well as modernist aesthetics: Jeremy Braddock argues that private galleries, or the collections they eventually fostered, produced both 'the most deeply idiosyncratic of

[73] Anna Gruetzner Robins, 'Fathers and Sons: Walter Sickert and Roger Fry', in Robins, *Modern Art in Britain*, 49.
[74] Anne Helmreich and Ysanne Holt, 'Marketing Bohemia: The Chenil Gallery in Chelsea, 1905–1926', *Oxford Art Journal*, 33, 1 (2010): 43–61; 43.

modernist collections and also the most systematic educational and inter-
pretive program on that collection's behalf'.[75] These hybrid spaces helped
to develop canons of modernist art and simultaneously provide a curatorial
and educational apparatus to help explain the significance of, and connec-
tions between, the works on the walls. D. S. MacColl reflected, in 1931,
that the private and quasi-commercial spaces that grew in importance in
the dissemination of modernist art in Britain represented 'an intermediary,
a suspended state of being [...] a Purgatory of art before the Paradise of
national collections is reached'.[76] Such counter-spaces, Braddock argues,
were 'provisional institutions': they were 'a mode of public engagement
modelling future—and often more democratic (although the meaning of
this word would be contentious)—relationships between audience and
artwork'.[77] Braddock's thesis—though focused on the formation of mod-
ernist collections and anthologies in the United States rather than Britain—
demonstrates just how important these private collections were, at a time
'when the cultural value of modernist art was acknowledged but the mode
of its institutionalization, its canon, and its relationship to society were
undecided'.[78]

Fry's role as a commentator and public intellectual, his vehement belief
in the democracy of taste and his actions to foster new methods of collect-
ing and exhibiting modernist work represent a new age of the art critic. For
Rachel Teukolsky, 'the art critic was no longer a retiring Paterian presence,
ensconced within a closed circle of aesthetic young men, but was instead
a powerful and visible player in the writing of high culture'.[79] The media-
tion of the principles of modernist art and literature—a focus on formal
construction, a celebration of non-representational practices, a dispensing
of discussion about the morality of art objects or texts—has shaped the
practices of art criticism to this day. Kate Flint argues persuasively that the
moral dimension of English art writing changed considerably with the rise
of critics such as Frank Rutter, D. S. MacColl and Roger Fry. While art
criticism in England had been dominated by questions about didacticism
and the morality of the artist in the fifty years after Ruskin, Flint argues, the
change that occurred in the early 20th century refocused discussion onto

[75] Jeremy Braddock, *Collecting as Modernist Practice* (Baltimore, MD: Johns Hopkins University Press, 2012), 111.
[76] D. S. MacColl, *Confessions of a Keeper and Other Papers* (London: Alexander Maclehose & Co., 1931), 31.
[77] Braddock, *Collecting*, 3.
[78] Ibid. 4.
[79] Teukolsky, *The Literate Eye*, 199.

the art object: whereas 'overtly moralising criticism [...] centre[s] around the responsibility of the artist', in this new form of criticism 'the finished work itself is constructed as the subject. It is conceived of as a body, possessor of mental and physical attributes and defects.'[80] This is an important shift in the ways in which the experimental art forms discussed in this book were treated in critical discourse, for Flint, because it stresses the autonomy of the art object and its potential to exist in a state of radical otherness, separated from its creator, in the public sphere. When such art is 'scorned, railed against, and made into a spectacle of humiliation, it achieves a sense of its own oppositional identity'.[81] Discussion of the art object as subject, in other words, shifted the focus of aesthetic criticism towards a recognition of the intrinsic nature of the work itself, and led to the increased presence of discourses of 'form', 'structure' and 'style' in the presence of mainstream art criticism. It was this shift in tone that led to what we now might recognise as a profound era of discussion in early 20th-century art criticism, one that eventually allowed 'the wayward art-subject' to be 'legitimised, and brought, with great caution, within the mainstream culture of bourgeois society'.[82]

The legacy of 'Manet and the Post-Impressionists' is hard to overstate. While so many commentators have explored the effect of the pictures on the walls of the Grafton Galleries in late 1910—especially in the context of subsequent exhibitions of note such as the Futurist exhibition of 1912, the first Vorticist shows in 1914 and the subsequent blossoming of an energised and often polarised British modernist aesthetic—fewer studies have noted the institutional and pedagogical dimensions of the show and its aftermath. While Fry often played the straw man in subsequent debates around the role of art in public life, and while he was often a reactionary voice in his response to later continental artistic innovation in the years before his death, he helped to mediate not only a new aesthetic, but a changed relationship between advanced art and its public in the years after the 1910 show. He was not the first pedagogical critic of the arts, but he was undoubtedly the first to truly attempt a democratisation of the experience of advanced and non-representational art. Though significant form remained a nebulous (and indeed a rather niche) concept in art history in the early decades of

[80] Kate Flint, 'Moral Judgement and the Language of English Art Criticism, 1870–1910', *Oxford Art Journal*, 6, 2 (1983): 59–66; 60.
[81] Ibid., 65.
[82] Ibid.

the 20th century, at its heart lay a truly revolutionary attitude to modernist art: that it was not an esoteric and alien aesthetic, comprehensible to the few, but that a cultivation of the senses and a response that relied on innate rather than learned faculties would yield an enriched relationship to art in the individual, and might help to materially change the role that art played in the world. It would be wrong to argue that the material conditions of the art market changed in the years after 1910. To borrow from the language of Huxley, one set of gods replaced another, and the quick assimilation of a Postimpressionist brand was attended by, as we have seen and will continue to see, a resultant marketisation of its aesthetics in the next decades. Decoration became, despite subsequent attempts to purge it from the language of art criticism, indelibly linked with a certain kind of modernism, one packaged and reified by Fry as Postimpressionism, and one that embraced and profited from its (at least initial) subcultural character. However, what I argue *did* change as a result of 'Manet and the Post-Impressionists' was the grounds for art appreciation and its dissemination in Britain. The language and purpose of art criticism (and the art critic), the techniques of exhibition design and narrative, the role of the independent gallery and the mobile collection as a locus for the avant-garde and the attempt to decentralise the arts—all were bound up with the 1910 show and its critical aftermath. Not all of these changes are, of course, attributable to Fry; there was already a developing attempt to regionalise modernism in Britain in other exhibiting societies and in institutions such as the Leeds Art Club, and Fry was only one voice among other critics of the arts who embraced continental modernism for its transformative potential on the art world—John Rodker and Frank Rutter, for instance, were loud supporters of the work that Fry championed. However, it was the 1910 show, and Fry's (albeit probably unwanted) public persona, that helped to bring modernist art to the front pages in Britain, and helped to ultimately effect the assimilation of modernist art into British cultural life. 'It is difficult', Woolf wrote in her biography of Fry, 'when a great hospital is benefiting from a centenary exhibition of Cézanne's works, and the gallery is daily crowded with devout and submissive worshippers, to realise what violent emotions those pictures excited less than thirty years ago. The pictures are the same; it is the public that has changed.'[83]

[83] Woolf, *Roger Fry*, 138.

3

'A revolution of incalculable effect': modernism and the teaching of art in schools

A certain Miss. Richardson, chubby, red-faced, very nice-looking, turned up at the Omega, having come up to London with a portfolio of her children's drawings to try to get a post in London. The Education authorities, whoever they are, had turned her down at once as no good and having heard of our show she came on and luckily found me. I was absolutely amazed at the things she brought; she knew quite well how good they were. Well, I've made a fuss about them and nearly everyone has come to see that they are very important. Finally, I organized an interview with another friend of yours, Fisher [H. A. L. Fisher, Minister of Education], who was duly and most encouragingly impressed [...] and may even work out some scheme with me for teaching art on a big scale on her lines [...] If we've any luck we may make a huge change in the future of a good many English children.[1]

Roger Fry's dual claims to his sister Margery, that schoolchildren's art was important in an aesthetic as well as an educational context and that the right kind of art teaching had the power to transform the English children's lives, might at first seem a little grandiose. Fry had a fairly well-earned reputation for being fleetingly passionate, and it would be easy to dismiss his enthusiasm for children's art had it only lasted a few months, but in one way or another it endured for the rest of his life. He wrote significant articles on art and education, and curated exhibitions of children's drawings at the Omega Workshops on a number of occasions (which, if the reviews are anything to go by, were generally better received than the work in the rest of the showrooms).[2] The connection between advanced design and children's

[1] Roger Fry to Margery Fry (2 May 1917), *The Letters of Roger Fry*, vol. 2, ed. Denys Sutton (London: Chatto and Windus, 1972), 409–10.
[2] See, for instance: Roger Fry, 'Children's Drawings', *Burlington Magazine for Connoisseurs*, 30, 171 (June 1917): 225–7; 'Children's Drawings', *Burlington Magazine for Connoisseurs*, 44, 250 (January 1924): 35–7, 41; 'Teaching Art', *The Athenaeum* (12 September 1919): 882–3.

art was more than spatial at Omega. If the impetus to refine the artistic sense of the nation was, philosophically at least, behind the experiments in Fry's workshops, then his desire to display the best of what children could achieve was part of the same drive—to show that any revolution in the standards of taste in Britain had to start not on the walls of its major galleries but in the daily lives of its population. While Fry's voice was loud on the subject, he was far from the only critic or commentator concerned with the way in which children were being taught to practise and to appreciate art. In fact, the teaching of art in schools became a minor cause célèbre during the early decades of the 20th century—one side concerned for the moral and intellectual character of children exposed to experimental art and new methods of teaching it, the other assured in its belief in the social potential and transformative power of the encounter. Until the turn of the 20th century, the teaching of art in schools had been considered at most a diversion in the mainly pragmatic curricula that the majority of children followed, which was divided markedly on gender lines. The changes made to the British educational landscape in a series of policy changes in government, along with the industrious efforts of a number of individuals, revolutionised the way in which art was taught to children, and assigned an importance to the teaching of art far beyond its tangible results.

Child art had already been drawn into a constellation with modernist work elsewhere in the world. Two exhibitions—one in Europe and another in America—placed the imaginative paintings made by children in the context of avant-garde experimentation. In May 1911, the Futurists had included children's work alongside their own at 'La Mostra d'Arte Libera' (Exhibition of Free Art) in Milan, and in 1912 Alfred Stieglitz displayed children's art at an exhibition at his Gallery 291 in New York, in the same space soon to be occupied by exhibits of Picasso, Matisse and Brancusi.[3] At the same time, Wassily Kandinsky and Franz Marc included a number of paintings and drawings by children in their eclectic *Blaue Reiter* almanac: for Kandinsky, the artist had to rediscover the simplicity of representation and the purity of vision that children's art demonstrated in order to produce vital work.[4] Analogously, child art was often subsumed within the more

Fry began a book entitled *Children's Pictures and the Teaching of Art* but, although advance advertisements were placed by Chatto and Windus in November 1917, it did not appear.
[3] Sarah Greenough, *Modern Art and America: Alfred Stieglitz and His New York Galleries* (Washington DC: Little, Brown and Co., 2001), 265–6.
[4] See particularly Wassily Kandinsky, *The Art of Spiritual Harmony* [*Über das Geistige in der Kunst*], trans. Michael Sadler (London: Constable and Co., 1914 [1911]), 36–43. For more on Kandinsky's relationship with child art, see Barbara Wörwag, "'There Is an Unconscious,

familiar (and more robustly documented) relationship between avant-garde art and primitive aesthetics.[5] In the introduction to his 1914 translation of Kandinsky's *Über das Geistige in der Kunst* [*Concerning the Spiritual in Art*], Michael Sadler—an early champion of Kandinsky's work in Britain—noted 'the analogy drawn by friends of the new movement between the neo-primitive vision and that of a child', an analogy that permeated many of the public discussions of the aesthetic 'value' of child art.[6] Roger Fry declared that the paintings at the 1917 exhibition were a 'real primitive art—not the greatest or purest art, but real art,' and he sought to relate untaught representation to an aesthetics of authenticity:

> For the adult in our modern self-conscious civilisation, the primitive attitude is no longer possible. Whether this is due to the fading of the emotions of wonder and delight in objects or not I cannot say, but it is certain that no modern adult can retain the freshness of vision, the surprise and shock, the intimacy and sharpness of notation, the *imprevu* quality of primitive art. And it is just here that untaught children have an enormous superiority.[7]

Kenneth Clark, in the introduction to Marion Richardson's posthumously published *Art and the Child*, connects Richardson's 'revolution' with 'the philosophic movement which revealed the art of primitive peoples'.[8] Whether or not the modernist discoveries of child art and primitive art are the same in kind is, in a sense, immaterial—the primary, elemental and authentic nature of both reflected perfectly the desires of avant-gardistes who sought an ideal artistic vision unencumbered by skill, habit or training, and any number of innovators drew on child art to develop new attitudes to colour, perspective and line.[9] However, if the purloining of primitivist figuration by Cubism, Futurism and Expressionism—and indeed the whole

Vast Power in the Child": Notes on Kandinsky, Münter and Children's Drawings', in Jonathan Fineberg (ed.), *Discovering Child Art: Essays on Childhood, Primitivism, Modernism* (Princeton, NJ: Princeton University Press, 2001), 68–94.

[5] For more extensive analysis of the relationship between primitivism and modern art, see Robert Goldwater, *Primitivism in Modern Art (Paperbacks in Art History)* (Cambridge, MA: Belknap Press, 1986); Charles Harrison, Francis Frascina and Gill Perry, *Primitivism, Cubism, Abstraction: The Early Twentieth Century (Modern Art: Practices and Debates)* (New Haven, CT: Yale University Press, 1993).

[6] Kandinsky, *Spiritual Harmony*, iii.

[7] Roger Fry to Margery Fry (2 May 1917). *Letters of Roger Fry*, vol. 2, 410; Fry, 'Children's Drawings' (1917), 226.

[8] Sir Kenneth Clark, 'Introduction', in Marion Richardson, *Art and the Child* (London: University of London Press, 1948), 2–13; 7.

[9] For more on the ways in which child art influenced individual artists, see Jonathan Fineberg, *The Innocent Eye: Children's Art and the Modern Artist* (Princeton, NJ: Princeton University Press, 1997).

notion of 'primitive art'—has been problematised by much recent criticism, the connection between modernist experimentation and children's art has been theorised largely as a one-way street, with modernist artists unproblematically raiding imagined, idealised childhood styles to revitalise their own aesthetic. This has had the effect of relegating child art to mere source material for modernism, along with reinforcing the assumption that child art is homogeneous and static—a collection of immutable tropes from which the artist can select. What is often missed in the discussion of this relationship are the ways in which children's art (and the way in which it was taught) drew energy, inspiration and direction from modernist experimentation. This chapter focuses on how the analytical, technical and imaginative precepts of modern art were brought into the classroom in Britain, so as to chart the ways in which children's art education was enriched and shaped by modernist art.

The Miss Richardson who had dazzled Fry with her efforts in 1917 was Marion Richardson, then teacher of art at Dudley High School for Girls in the West Midlands, and the future Art Inspector for the schools under the control of the London County Council (LCC). Richardson was born in 1892 in Kent and moved to Oxford, and to Milham Ford School, with her family at the age of fourteen. The school was far ahead of its time in terms of teaching practices and educational innovation, and it was the art mistress there who encouraged Richardson, who displayed no shortage of talent herself, to enter the Birmingham Municipal School of Arts and Crafts to train as an art teacher. There she came under the tutelage of Robert Catterson-Smith, who had worked for William Morris in the later years of the 19th century and had helped edit Edward Burne-Jones's designs for the Kelmscott edition of Chaucer. Catterson-Smith privileged an approach to the teaching of art that recognised and gave precedence to the validity of children's modes of expression. He encouraged the dissemination of a teaching method founded on direct visual and imaginative treatment of the thing, in contrast with many of his peers who believed that drawing and painting were species of scientific observation.[10] Though she did not shine as brightly as the leading lights of that school in terms of creative output, Richardson's desire to teach was awoken. A fortuitous meeting with Margery Fry helped her into a teaching job even before she had finished her course at Birmingham. Fry had taught some classes at Dudley

[10] See Robert Catterson-Smith, *Drawing from Memory and Mind-Picturing* (London: Pitman, 1921).

High School for Girls, a school lost among the slag-heaps and factories of the Black Country, and was a member of the Staffordshire Education Committee. Richardson met her at one of the evening classes Fry ran from a boarding house for young female students in Birmingham, and Fry was clearly impressed. An interview, and the offer of the post of art mistress at Dudley, came in 1909, a position she would keep until 1930.

The history of artistic education in Britain was a fairly short one by the time Richardson arrived in Dudley, but attempts to change the way in which art was taught at British schools gathered pace during her time there. When compulsory schooling was introduced in Britain with the Elementary Education Act of 1870, the teaching of art was largely absent from it and any subsequent parliamentary acts, their purpose being to simply secure uniform, utilitarian schooling. The measures taken in parliament over the next few decades sought to ensure that all children received a non-denominational education from the age of five.[11] While these efforts broadened and deepened children's education, it was only during the First World War that any efforts to change the philosophy of post-elementary education began on a large scale, beginning in earnest with H. A. L. Fisher's Education Act of 1918. This did not demarcate a clear plan for arts teaching in schools, but Fisher believed strongly in the potential for artistic education to benefit society as well as the individual, and was responsible for setting up new committees to oversee educational change.[12] The Hadow Reports, six studies undertaken on the state of education in England and Wales between 1923 and 1933 by Sir William Henry Hadow and his committee, were one legacy of Fisher's endeavours, and included many new progressive proposals for the improvement of teaching in the arts. As well as more pragmatic suggestions, such as recommending the raising of the school leaving age and more clearly demarcating primary and secondary education, the reports espoused a more liberal attitude to education in the arts, and outlined a series of broad changes that needed to take place if schoolchildren were going to have a balanced education. The report of 1923, entitled *Differentiation of the Curriculum for Boys and Girls Respectively in Secondary Schools*, for instance, outlined the sex stratification of education in the United Kingdom. Boys' timetables were filled with the Classics, with a smattering of divinity, geography and history, while girls tended to

[11] The age at which children could leave school was raised in amendments and successive bills from ten in 1870 to twelve in 1899, to fourteen or fifteen by 1918.

[12] *Education Act*, 1918: 8 & 9 GEO. 5. CH. 39. See http://www.legislation.gov.uk/ukpga/Geo5/8-9/39, for the full text of the Act.

study what might be called 'accomplishments': literature, drawing, painting and needlework. The imbalance in aesthetic education needed redress, according to Hadow, and a section expressing the '[d]esirability of developing the Aesthetic side of Secondary Education for both sexes' outlined some strategies for raising the profile of arts teaching in secondary schools:

> Several of our most authoritative witnesses, basing their opinions partly on the results of psychological research, and partly on experience gained in co-educational schools, thought that the response of the two sexes in Music and Art was probably equal, if equal opportunities were provided, and that in consequence a more serious development of aesthetic training was very necessary in the whole of our system of Secondary Education. Others laid much stress on the value of the fine Arts, when properly taught, in developing concentration of mind, accuracy of observation, and a genuine appreciation of natural beauty and artistic achievement, and in stimulating the growth of the imaginative, critical, and creative faculties. It was pointed out that, in the past, technical skill had been too much regarded as the only measure of successful achievement in these subjects. Only a small proportion of the pupils could probably attain to high technical skill, but the great majority could be trained to appreciate good Art and good Music.[13]

The duty of educational establishments to nurture the aesthetic sensibilities of children went beyond simply improving artistic ability—for Hadow, the desired goal was an enlivened sense of taste and a more developed faculty for critical discernment. And the way to encourage children to cultivate this sense was through imaginative exploration. The 1931 Hadow report into primary education reflected on the need to shift away from rote learning to imaginative and creative encouragement, recognising that 'owing to the bookish trend of modern instruction, mental images, so concrete and so vivid in the younger child, tend to atrophy from disuse'.[14] Arthur M. Hind agreed, arguing that an artistic education enriched thoughts and opinions far removed from the art-room easel. '[T]he one aim to be kept in view', Hind said, is that the child 'with creative instinct should be allowed such freedom as will best develop his real gifts, imparting at the same time such discipline and training in other things as will open his mind to life in the broadest and most generous sense.'[15] While all these modifications in the

[13] Board of Education, *The Differentiation of the Curriculum for Boys and Girls Respectively in Secondary Schools* (The Hadow Report) (London: HMSO, 1923), 67–8.
[14] Board of Education, *The Primary School* (The Hadow Report) (London: HMSO, 1931), 45.
[15] Arthur M. Hind, 'Art in a Liberal Education: The Substance of a Paper Read before the Ascham Club, Oxford', *Burlington Magazine for Connoisseurs*, 47, 269 (August 1925): 81–7; p. 84.

philosophy of arts education went some way to changing attitudes to arts teaching, they offered few concrete policy decisions that recognised the aesthetic as well as practical value of art in school. Most of the changes to arts teaching were made in a piecemeal fashion by individuals and on a local basis, but over time such changes became enshrined in wider educational strategy. Richardson's work at Dudley was pioneering, and very quickly attracted regional and national attention.

Her early experiences of teaching art at Dudley, and the philosophy that arose out of those experiences, is recounted in her posthumously published memoir, *Art and the Child* (1948). Refusing to give her students objects to study, and demanding nothing from their representations in terms of likeness, Richardson invited them to create 'mind-pictures' that they could recreate in paint.[16] The original idea often came from her own mind: she would describe a scene—very often a painting—or read a poem, and her students would be asked to reproduce what they saw in their mind's eye. Any early reserve the children had evaporated, and they quickly began to produce pictures of their memories of scenes drawn from their daily lives— dimly lit shops, cafés and huge grey factories figure strongly in the work that still exists in Richardson's archive. This was no simple free-play of the imagination; Richardson promoted a more developed sense of observation of what was art-worthy in her students by encouraging them to study the world around them with an artist's eye. 'They would then see pictures everywhere,' she wrote, 'in poor plain places as well as lovely ones: in fried-fish and other little shops, market stalls, chimney stacks, watchmen's huts, eating houses, slag-heaps, salt carts, cinderbanks, canal barges, pit mounts, and waste grounds.'[17]

The teaching techniques worked equally well for adolescents as they did for younger children: Roger Fry had noted that in most of the images he saw there was a 'falling off' in authentic vision at around the age of fifteen in most cases, but in Richardson's students none was seen.[18] Students were also encouraged to develop skills in abstract pattern-making alongside their compositional work. Herbert Read argued that this resulted in their becoming less susceptible to adult prejudices of representation:

> Personally I believe that the results obtained by Miss Richardson in her drawing classes are just as important as those already mentioned [in her handwriting

[16] Richardson, *Art and the Child*, 19.
[17] Ibid., 15.
[18] Roger Fry, 'Introduction' to 1919 Exhibition Catalogue, Marion Richardson Archive (hereafter *MRA*) (Birmingham City University), item 3207.

and pattern-making classes]. In the first place, the sense of colour harmony, freely developed in pattern-making, is carried over into picture-making, and it requires an extreme distortion of the child's natural instincts to impose an abstract standard of natural appearances. The child 'naturally' prefers its own colour sensations to any extraneous standard. Secondly, the sense of rhythm, both as linear flow and as sequence of shapes, so fully practised in pattern-making, is also carried over into the other activity. For with these two elements fully developed—rhythm and colour—we have the foundations of every kind of artistic activity.[19]

By exposing her students to different media, too—masks, busts, jewellery, sculpture, painting and textiles—Richardson increased both the students' inventiveness and practical knowledge. 'In searching for the painted interpretation of the image', Richardson later recounted, 'the children explored to the utmost the technical resources of their materials, and gained experience which would stand them in good stead when a complete idea came along.'[20] In fact, she noted, their technical skills began to grow organically, in response to the demands of their imagination. She recollected taking away the children's paints in one lesson, before giving them more rustic materials—beetroot juice, curry powder and so on—to give them a greater appreciation for the vibrancy of the colours they had on their palettes. She found that if she showed them the power of their own imaginative capacity, they were happy to improvise with whatever material was at hand—a useful skill for children whose families could not, for the most part, afford paints and brushes.[21] The privileging of imaginative construction over technical observation and a more fluid attitude to colour and material may seem almost commonplace today, but Richardson's techniques marked a significant change in the way in which art was taught to the child, and the products of these demands on intuitive imagination are still as surprising today (Colour Plates 2 and 3). It is easy to see the qualities that marked these paintings as being different to other children's work. Many of the pieces demonstrate a more intuitively gestalt conception of art; the scenes are painted in an holistic way which draws attention to the rhythm between the different elements of the painting, rather than the more common, almost anatomical studies encouraged at most schools at the time. The prominence of gestalt ideas

[19] Herbert Read, 'Art and Education—1—Teaching Art to Children', unpublished and undated manuscript, MRA), item 2107. Though unpublished in its form in the MRA, this manuscript seems to have been written before 1935, as it includes sections from Read's article 'Art and Education', The Listener (19 June 1935).

[20] Richardson, Art and the Child, 19.

[21] Ibid., 27.

in early 20th-century studies of visual perception is widely documented, but many of the earliest gestalt thinkers had at least a passing interest in the expressivity of the child's artistic act.[22] Certainly, Richardson's students painted in a way that would be immediately recognised by associationist psychologists as empathetic, and they share an emotional kinship with the expressive works of Gauguin or Van Gogh.

The comparison with high Postimpressionist work is not a trite one. Indeed, what surprises most in Richardson's programme of art education are the sources of inspiration she drew on to energise her students' minds. Though many influential art-educators, taking a lead perhaps from Franz Cižek in Switzerland, who insisted that self-expression in children had to develop in a vacuum away from artistic influence, Richardson was happy to introduce her students to contemporary art.[23] Early prints of Matisse and Picasso were displayed on the walls of the art room, and children were given subjects from the pantheon of modern art and culture (such as the Ballets Russes; Colour Plate 4)—the cupboard doors in the art room were even copied from those painted and hung by Vanessa Bell at her home at Charleston.[24] Richardson used pointillist prints to demonstrate colour techniques as early as 1916, and an original painting by Roger Fry hung in the school hall.[25]

For Richardson, the children responded positively to the exposure to high art, and in particular to modern forms, and she saw no discontinuity between her children's work and the tenets of Postimpressionism—in fact, she found the same dependence on direct construction, boldness of line and colour, and imaginative freedom on display in a visit to the Grafton Galleries in 1910:

> We were on our way from a visit to Burlington House when we passed the Grafton Galleries, where the first Post-Impressionist Exhibition was being held [...] It was hung with pictures which in some strange way were familiar and yet new to me. I had no choice but to go in. Impertinent and fantastic though the idea may seem, I can only say that to me a common denominator

[22] For more on the role of gestalt theory in psychology, and a general survey of the relevant literature, see Steven M. Silverstein and Peter J. Uhlhaas, 'Gestalt Psychology: The Forgotten Paradigm in Abnormal Psychology', *The American Journal of Psychology*, 117, 2 (Summer 2004): 259–77.

[23] Cižek was a pre-eminent advocate for child art education—see Wilhelm Viola, *Child Art and Franz Cižek* (Vienna: Austrian Junior Red Cross, 1936), 3–34 for a distillation of his techniques.

[24] Rosemary Sassoon, *Marion Richardson: Her Life and Her Contribution to Handwriting* (Bristol: Intellect Books, 2011), 34.

[25] Peter Smith, 'Another Vision of Progressivism: Marion Richardson's Triumph and Tragedy', *Studies in Art Education*, 37, 3 (Spring 1996): 170–83; 180.

was evident between the children's infinitely humble intimations of artistic experience and the mighty statements of these great modern masters. In the happiest of the children's work I had learned to recognise a vital something; but with my limited knowledge of art I had not, up till then, been fully conscious of having seen it elsewhere. Now, for the first time, it blazed at me [...] I have not, however, for fear of being misunderstood, ever spoken of this experience before now.[26]

Richardson's reticence to relate the much-maligned European art of Cézanne, Gauguin and Van Gogh to the products of her own classroom was probably sensible, given the pervasive notion of degeneracy that, as I explored in Chapter 2, surrounded that exhibition. Many commentators did not only question the artistic quality of the works on display at the Grafton Galleries—and the taste of the organiser—but also charged them with the corrosion of decency and the corruption of minds. Charles Harrison lists some of the epithets used in the contemporary reviews—'madness', 'infection', 'sickness of the soul', 'putrescence', 'pornography' and 'anarchy'.[27]

Richardson may have been doubly sensitive to such a comparison because, in much contemporary opinion on the subject, children were the most susceptible to the corrupting influence of deviant art. Theories on the development of the aesthetic sense in children abounded in the early 20th century. Ranging from a purely theoretical concern with image acquisition and the psychology of the artistic impulse, to more practical aspects of child art such as subject matter, mental and social development, and pedagogy, a large body of work developed to relate artistic development to intelligence and individual psychological well-being.[28] Art for children, according to many of these scholars, was both an escape from reality and a reinforcement of the real world—a subjective release from the eidetic images of the objective world and social orientation in the prevailing modes of cultural representation; or, in other words, both an imaginative and imitative activity.

[26] Richardson, *Art and the Child*, 14.
[27] See Charles Harrison, *English Art and Modernism, 1900–1939*, 2nd edn (New Haven, CT: Yale University Press, 1994), 47.
[28] See Gordon W. Allport, 'Eidetic Imagery', *British Journal of Psychology*, 15, 2 (1924–5): 99–120; F. C. Bartlett, 'Experimental Study of Some Problems of Perceiving and Imaging', *British Journal of Psychology*, 8 (1916): 222–66; Helga Eng, *The Psychology of Children's Drawings*, trans. H. Stafford Hatfield (London: Kegan Paul, 1931); Margaret McMillan, *Education Through the Imagination* (London: Swann, Sonnenschein & Co., 1904); P. B. Ballard, 'What London Children Like to Draw', *Journal of Experimental Pedagogy*, 1 (1911–12): 185–97; Katherine M. Banham Bridge, *The Social and Emotional Development of the Pre-School Child* (London: Kegan Paul, Trench, Trubner & Co., 1931); Margaret H. Bulley, 'An Enquiry as to the Aesthetic Judgments of Children', *British Journal of Educational Psychology*, 4 (1934): 162–82; Evelyn Gibbs, *The Teaching of Art in Schools* (London: Williams and Norgate, 1934).

In the work of behaviourally orientated commentators such as Jean Piaget or Margaret Bulley, the educator's role was vital in mediating between the child's imaginative sense and the role that drawing and painting needed to play in socialisation. Art, taught in the wrong way or allowed to develop unchecked, presented a significant danger to the mental development of the child. 'Artistic "imagination" or "vision" appears', Hadow's 1931 report noted, 'to be closely allied with the emotional nature and for this reason is obviously of vital importance in the education of the young [...] but it may easily become perverted, and feed a mere craving for the garish and sensational and even the sensual.'[29] Such a perversion, so worryingly connected to all the psychological deviancies associated with a descent into the 'sensual', left the art-educator trading a fine line between snuffing out the aesthetic sense in his or her charges completely and allowing too much of an indulgence in the products of the imagination to ensure that the child would be orientated on the proper, healthy course of life.

Taking a cue from Richardson's experiences (which he references liberally), Herbert Read explicitly connected the development of a child's aesthetic sense with the psychological evolution of the superego. For Read, puberty (and the associated victory of the logical over the instinctive faculties) marked the point where 'that conscious and critical super-ego which in all its aspects is a censor and suppressor of the instincts' begins its domination of the ego—it is no coincidence that this is 'not only the age at which the instinctive aesthetic impulses of the child tend to become atrophied or suppressed, but also the age at which the moral consciousness of the child makes its first appearance'. The 'gifted-child', however, does not suppress the aesthetic instinct—he or she can in fact maintain a 'compromise with reality' and allow art to function as the healthy outflow of the pleasure principle.[30] Read was happy to associate this desired preservation of aesthetic sensibility in such 'gifted' children, with its felicitous and fertile slippage between id, ego and superego, with the more advanced art of the day. 'If reality is to be our aim,' he said, 'then we must include all aspects of human experience, not excluding those elements of imaginative, sub-conscious life which are revealed in dreams, day-dreams, trances and hallucinations. Such is the quite logical claim of Surrealism.'[31] The right aesthetic development would correlate with a change for the better in the real world—as Read noted, 'if in the upbringing of our children we preserved, by methods

[29] Board of Education, *Primary School*, 68.

[30] Herbert Read, *Art and Society* (London: Faber and Faber, 1967 [1936]), 97, 98.

[31] Ibid., 120.

which I have indicated, the vividness of their sensations, we might succeed in relating action to feeling, and even a reality to our ideals'.[32] Richardson's belief in the holistic nature of aesthetic experience while she was at Dudley chimed with Read's analysis, which was congruent in many ways with a growing body of work that emphasised that a child's healthy attitude to art might benefit wider society.[33]

Certainly, Roger Fry felt, on first seeing the work of Richardson's students, that a revolution in the standards of taste might be effected. Richardson met Fry for the first time in 1917, at his first exhibition for children's art at Omega. Mostly filled with the pictures of artists' children, and a few of Duncan Grant's youthful paintings, the exhibition was, for Richard Carline, 'the first attempt to stage a display of children's paintings as real works of art in their own right, entirely different in concept from the exhibitions of the Royal Drawing Society, which showed how near children could get to adult work'.[34] Though the exhibition 'revealed unexpected marvels' to Fry, the pictures being 'simply too lovely for anything', it revealed some stark differences in the quality of art teaching around the country.[35] 'It appeared evidently', he said in an editorial on the exhibition, 'that the ordinary teaching destroyed completely the children's peculiar gifts of representation and design, replacing them with feeble imitations of some contemporary convention.'[36] Down for an unsuccessful interview with the LCC—at which the products of her children's hands had met with the disapproval of the selection committee—Richardson passed by Omega and ventured to show her paintings to Fry. Fry, clearly impressed, asked to hold onto them. 'Everything he said was so serious, so unsentimental, and so sane. Without praising, still less flattering, us he made me feel that we were included in the wide range of his interests, and even part of the modern movement in art of which he was so great a leader.'[37] Fry singled out the children's work under Richardson as something different: 'the

[32] Herbert Read, *Education Through Art* (London: Faber and Faber, 1956 [1943]), 302.

[33] See, for instance, Gertrude Hartman and Ann Shumaker, *Creative Expression: The Development of Children in Art, Music, Literature and Dramatics* (New York: John Day, 1932); Susan Isaacs, *Intellectual Growth in Young Children* (London: Routledge, 1944 [1932]); R. R. Tomlinson, *Picture Making by Children* (London: Studio Ltd, 1934); 'Children's Drawings and Designs', in *Annual Report of London County Council*, vol. 5 (1936), 3–6; K. Doubleday, 'The Creative Mind in Education', *New Era*, 17, 2 (February 1936): 19–24; E. H. Styhr, 'A Summary of Art Teaching', *Athene*, 1, 1 (1939): 6–12.

[34] Richard Carline, *Draw They Must* (London: Edward Arnold, 1968): 167.

[35] Roger Fry to Rose Vildrac (4 April 1917), *Letters of Roger Fry*, vol. 2, 408, 406.

[36] Fry, 'Children's Drawings' (1917): 225.

[37] Richardson, *Art and the Child*, 32.

quantity and quality of the inventive design revealed in this one school is so surprising that I cannot doubt that if children were stimulated to create instead of being inhibited by instruction we should no longer need to complain as we do to-day of the want of creative imagination'.[38] Keeping as many of the drawings and paintings as he could, he redesigned the exhibition with the aim of making some changes to art education policy—'I am anxious to keep yr. Children's drawings here for a few days,' he wrote to Richardson. 'I've got at H. Fisher [Minister for Education] and I don't want to miss the chance of his seeing the lot. I don't know what luck I shall have with him but I hope something good will come of it.'[39] Fisher was obviously impressed: 'He was most sympathetic and quite understood how remarkable the drawings were. He has promised to see what can be done for you. I shall try to keep him up to the scratch. [...] If only I can get you to start a big school in London.'[40] The 1917 exhibition had been a rather mixed experience for Fry, confirming that if there was something primitive and elemental in children's work, education along the lines of technical composition and scientific observation did its best to grind out that vital spark. Richardson's pictures were, however, a tonic, and he continued to ask for more and more examples. By 1919, there was enough material to hold a show devoted to the work of Richardson's pupils. Held at Omega, it included over a hundred paintings and drawings, and Fry contributed an introduction to the catalogue:

> Some years ago the Omega Workshops invited schools and private people to send examples of children's drawings. Those invited were asked to say whether the children had been taught or not. It was then found that most of those children who had had the ordinary drawing lessons where [*sic*] inhibited from any power of expression whatever [...] A curious exception to this rule was however found in the work of Miss Marion Richardson's pupils at Dudley High School. In their case no falling off was visible up to the ages of 16 and 17 when they left school. Miss Richardson has developed a special system of training without ever giving instruction or interfering with the free development of the individual vision. She has found how to keep the children's attention fixed and their purpose lively without setting them given tasks or modifying their methods of expression [...] It is not of course great art [... but] there is however enough promise here to make it a matter of national importance that such an experiment should be tried under the most favourable circumstances possible.[41]

[38] Fry, 'Children's Drawings' (1917): 227.
[39] Letter from Fry (undated but probably late March 1917), *MRA*, item 855.
[40] Letter from Fry (4 April 1917), *MRA*, item 865.
[41] Fry, 'Introduction' to 1919 Exhibition Catalogue.

Responses to the exhibition, and Fry's catalogue of the paintings on display, were varied. *The Observer* clearly thought Fry's claims were overwrought. Calling the pictures 'innocent of perspective, faulty in proportion, and childishly naive', while opining that the 'drawings by the Dudley High School girls are, at any rate, more enjoyable than the sophisticated cubist marionettes by M. M. Larionow [*sic*] in the adjoining room', it felt that Fry's denigration of the teaching of technical composition in schools was:

> a grave exaggeration. There are few, very few, among the leading expressionist artists, who have not undergone thorough training on conventional lines and benefitted vastly by such training even though in their later struggle for self-expression they often broke away from the rules and precepts of their early training. It is not the illiterate who can take liberties with, and give new forceful expression to, language, but the man who has mastered its conventional use.[42]

Other reviews were strongly positive, including Frank Rutter's in the *Sunday Times*, which praised the 'free development of her pupils' individual vision'.[43]

By the early 1920s, with the exposure of the 1919 exhibition, Richardson was becoming increasingly known as a pioneer in art education. Appointed to a lectureship at London Day College, she went to London in 1923, and her portrait was included in *Vogue*'s Hall of Fame in January 1924. Without severing her position at Dudley, she spent a term living with Fry and his sister, giving private lessons in London and travelling back to teach the girls in the West Midlands. Subsequent exhibitions of the work of the children under her tutelage attracted a mixed reaction in the periodical press. The *Daily Express* seemed worried about the influence of an insidious modernist aesthetic on the children:

> Cubism in art seems to have its disciples among school children, if one may judge by the singular exhibition of work by child artists which is now being held at the Mansard Gallery, Tottenham Court Road. Those who 'dabble in art' talk much about the 'excellence of form' and the 'depth of feeling' that the children whose ages range from eight to fourteen years show in their methods and treatment of ordinary subjects. The average individual, however, just stands in front of them and wonders if the modern child is being taught to see everyday objects as they are not and never will be.[44]

[42] 'Art and Artists: The Omega Workshops', *The Observer* (2 March 1919): 7.
[43] *Sunday Times* (2 March 1919): 22.
[44] 'Child Artists as Cubists—Puzzling Pictures in an Exhibition—Square Figures', *Daily Express* (26 June 1928): 17.

Others reported the bemused reactions to the exhibits by visitors:

> There was one fond parent with a neighbour, who was being led round the corridors by her small son to see his picture. Loyally, she was belittling all the other pictures. 'Wait till you see my Alfie's', she kept repeating. They stopped in front of a picture containing apparently, two dark squares and two lighter ovals, and entitled 'My Music Lesson'. 'There y'are Ma,' said Alfie proudly. There was an awful silence, then 'Ma' shrugged her shoulders and turned away saying 'Oh, Alfie. I always thought you liked your music'.[45]

In most cases, however, the reviews reflected on what the shows meant for the future of appreciation, discrimination and standards of taste in Britain. The *Westminster Gazette* described the '[r]emarkable pictures' of a show at the Independent Gallery in 1924. 'The idea of works of art being turned out by secondary school-girls of the Dudley High School, living amid the soot and grime of the industrial districts, may appear incongruous. It is noteworthy that the paintings, if not exactly cubist in design, are nevertheless very "modernist".'[46] P. G. Konody wrote in the *Daily Mail* that 'Honest expression takes precedence of technical accomplishment. [...] Presumably few, if any, of the High School girls will take up art as a profession; but they will enter life fully equipped with taste and the capacity of aesthetic enjoyment which will be reflected in their homes and transmitted to the next generation.'[47] Reflecting on the show in *The Observer* a few days later, Konody drew attention to the trickle-down effects that the show might represent: 'The art practice of the Dudley High School girls is not a preparation for a professional career, but it will help these girls, who even now find beauty and poetry in the drabness of the Black Country, to introduce beauty into their homes and to bring brightness into their lives and the lives of those around them.'[48] Richardson had clearly recognised the potential for her teaching to enact a transformation of the artistic taste of her students. In an early, abortive attempt to construct a syllabus at Dudley, she noted that her chief aims were to 'enable as many of the children as possible to find a means of expression in drawing' and to 'build up, chiefly through creative work, a standard of taste (by training people to recognise the genuine from the sham)'.[49]

This creative work extended beyond the art room. An early meeting between Richardson and Fry led to an invitation to see the rehearsals

[45] *South London Press* (16 June 1933): n.p.

[46] 'Art in the Black Country—Futurist Works by School Children', *Westminster Gazette* (28 December 1923): 17.

[47] *Daily Mail* (1 January 1924): 33.

[48] *Observer* (6 January 1924): n.p.

[49] Untitled Item [Draft Syllabus] *MRA*, item 3156.

of the Ballets Russes: 'I saw Picasso himself rehearsing *Parade* and *The Three-Cornered Hat*, and wrestling with the dressmakers, poor souls, who were trying to interpret his designs.'[50] Going back to Dudley, Richardson endeavoured to put on a performance of her own. The sets were designed by the pupils with inspiration from what Richardson had seen of Diaghilev's production in London. 'After the play was over, orders began to pour in for our painted furniture. All the staff, and their friends [and pupils] were becoming conscious of the look of their own home surroundings, and planning to improve them.'[51] If the quality of the art her pupils produced was improving, so too was the quality of their appreciation:

> Hitherto they had accepted quite uncritically the horrors of many mass-produced furnishings [... Now] it was not a case of being able to recognise the label, 'good taste,' on a thing and therefore approving it. Through their own painting, to themselves unmistakably sincere or otherwise, these girls had an internal test, a diviner's rod by which to discover the common denominator of art.[52]

Fry had already noted that what distinguished Richardson most from other art educators was that her students began to develop a critical and discriminatory sense alongside their technical and expressive skills. Students in her classes were always expected to make 'a written valuation, even if only a word or two, on every drawing they did'.[53] Fry saw such critical self-awareness in historical terms, likening what was going on in Dudley to the 'kind of common tradition somewhat analogous to the local traditions of art of the Italian towns in the Renaissance'.[54] Not every student would be an artist, but all could possess an appreciative instinct and a finer sense of the aesthetic—and social—value of the cultural and decorative objects that surrounded them in their quotidian existence. For Herbert Read, who felt that if a 'number of those who are to be trained as painters, sculptors and "creative" artists generally should be restricted, [... then] the number of those to be trained in the appreciation of the arts should be vastly increased', Richardson's work clearly aspired to an improvement in taste as well as technical skill.[55]

The 1938 LCC exhibition of children's drawings was probably the largest that Richardson ever curated. By that time, Richardson was overseeing

[50] Richardson, *Art and the Child*, 33.
[51] Ibid., 34.
[52] Ibid., 34–5.
[53] Ibid., 41.
[54] Fry, 1919 Exhibition Catalogue, *MRA*, item 3207.
[55] Read, *Art and Society*, 107–8.

the art teaching in 7,000 schools as art inspector for the LCC. Her new position afforded her a greater audience, and by 1938 many schools across Greater London had implemented her teaching philosophy. The exhibition was hugely successful: Kenneth Clark opened a show of 600 pictures, and during the eight weeks it was open 26,000 people visited. 'It is most appropriate that the Director of the National Gallery should have opened the Exhibition of Children's drawings at the County Hall,' said the *New Statesman and Nation*, 'for the reorganisation of art-teaching in the LCC schools is a public benefit of inestimable value [...] Intelligent art-teaching not only increases vastly the happiness and equilibrium of the young painters, but may be expected to effect a very important improvement in public taste.'[56] The art produced under Richardson's tutelage and support was not just a critical success, but also a commercial one. In 1928, at the Whitworth Gallery in Manchester, an exhibition of some of the patterns produced by her pupils caught the eye of a number of industrialists. By 1930, Adam Murray Ltd, a member of the Calico Printers Association, had begun to print textiles to the children's designs, in a range called Maid Marian.[57]

The effects of Richardson's work were clearly felt both educationally and socially, but her work also acted to introduce modernist art into areas it had not previously broached. Her work with children was, in many respects, a mediation and distillation of the formal aspects of Postimpressionist design; it embraced colour experimentation and gestalt synthesis, and privileged authentic psychological expression over anatomical observation. Moreover, it encouraged children (and, through shows and performances, their parents) that art was not merely a technical skill but a vital part of social life, and that good taste could be cultivated through the creative process. Though the claims made by some reviewers might be extravagant, Richardson's work reasserted the social potential of art education by incorporating and translating a modernist aesthetic into a significant set of pragmatic applications.

If Marion Richardson's endeavours marked a very definite attempt to educate not only the artistic skills of children but also their aesthetic sensibilities, there were other piecemeal efforts to bring pupils into contact with the more avant-garde art of the day. Schemes to introduce art to schoolchildren were not new, but a number of initiatives aimed solely at engaging

[56] *New Statesman and Nation* (16 July 1938): 7.
[57] See 'Industry Buys Children's Designs', *Christian Science Monitor* (11 January 1930): 6; 'Spring Designs in Cottons and Rayons', *The Drapers Organiser* (January 1930): n.p.

the attention of younger eyes began in the 1930s. Because most schools simply could not afford original artworks, several commercial enterprises set up to design and print lithographs and woodcuts commercially found an almost accidental market in schools and other educational establishments. The Empire Marketing Board, set up in 1926 to help maintain trade across the British Empire, produced a number of posters and prints that instantly became desirable to schools, despite their rather eclectic subject matter. By 1929, they were producing prints for sale to schools (an almost unbelievable 27,000 schools by 1933). The Post Office, too, produced a number of prints in the early 1930s illustrating its services. They were an instant hit with schools, to the point that the Department of Education arranged for the free issue of the prints—on tougher paper, more durable in the hands of schoolchildren—to educational establishments from 1934. It was the Post Office that created what was probably the first print series aimed directly at schoolchildren. Kenneth Clark and Clive Bell acted as advisors on the scheme, commissioned by H. S. Williamson, the principal of Chelsea College of Art. Williamson knew he was producing something different in kind and scope to regular, informational posters. 'Normally a poster delivers its message instantaneously,' he remarked, 'and thereafter its appeal weakens until it ultimately bores. In the present case some greater deal of elaboration seems to be called for.'[58] But Williamson was no experimental artist, and he held a firm belief in the need for 'a maximum of factual content [while] the artistic treatment must be a secondary concern'. The prints in the series were all focused on the historical activities of the Post Office—*Relays Carrying the King's Messages, 1482, Mails for the Packets Arriving at Falmouth, 1833, Loading Air Mails for the Empire, Croydon, 1934* and so on—and each was supplemented by a clarifying leaflet.

There were more ground-breaking initiatives than those of the Post Office, however. Contemporary Lithographs was started in 1936 by Robert Wellington, art dealer at Zwemmer's Gallery in Litchfield Street in London, John Piper, artist and printmaker, and Henry Morris, County Education Secretary for Cambridgeshire; this was a scheme aimed at commissioning living artists to produce prints that would be marketed to schools. Morris, who held rather advanced educational views for the 1930s, believed that introducing schoolchildren to advanced art could only increase aesthetic standards. He engaged Walter Gropius, then a refugee in Britain from the Nazis' Bauhaus purge, to help design and build Impington Village College

[58] Quoted in Ruth Artmonsky, *The School Prints: A Romantic Project* (London: Artmonsky Arts, 2006), 14.

near Cambridge, and contracted the colour scheme at Linton Village College to László Moholy-Nagy, also temporarily resident in Britain. Morris met Wellington at Zwemmer's, and it was Wellington's connections with artists that helped polish Morris's aesthetic standards. Wellington and Morris involved Piper who, with his experience in lithography, would help a number of the contributors with technical and design issues. The Curwen Press, run by Oliver Simon and Harold Curwen, printed the first series of ten lithographs, and artists including Piper himself, Paul Nash, Eric Ravilious, Graham Sutherland, Vanessa Bell and Edward Wadsworth, all made visits to Curwen to draw directly onto the stones. In the first prospectus for the prints, Wellington and Piper declared that they wanted 'to discourage the feeling that good pictures are exclusively museum objects: things which were no longer produced after 1800 or 1900' and that they wanted to connect the art that children produced with 'such present day paintings as may come their way'.[59]

To this end, these were no reproductions, nor did they serve some promotional purpose. The subject matter of each lithograph was not pre-determined and, in most cases, reflected the style and substance of the work that each artist was engaged with at the time in their wider *oeuvre*. Paul Nash's contribution, for instance (Colour Plate 5), shared not only a similar setting to his other works of the period but also the same title as an oil painting and two watercolours he completed at about the same time, and owed much to his interest in the relationship between abstract forms and the British landscape. Edward Bawden's *Cattle Market* (Colour Plate 6) was very much in the style of his prints for Fortnum & Mason, Shell-Mex and Faber & Faber: the flat colouration contributes to a stylised, decorative patterned print that, for all it portrays a familiar event, makes a significant compromise with realism. Most of the prints in the first series depicted 'English' scenes, but nowhere is there a dominating nostalgia, nor is there a pervasive use of the pastoral. While the Post Office prints, and others before them, had offered an historical and narrative perspective on British commerce, industry and landscape, Contemporary Lithographs drew attention first and foremost to form and colour.

The first series was launched at the Curwen Press gallery in January 1937, but only attracted a smattering of interest.[60] *The Times* opined that, if advanced English art was being produced, then it was the first the public

[59] Quoted in Artmonsky, *The School Prints*, 104.
[60] Only three reviews are recorded: *The Times* (22 January 1937): 18; Clive Bell, *New Statesman and Nation* (23 January 1937): 37; J. E. Barton, *Architectural Review* (January 1937): 16.

had probably heard of it, and recognised the importance of this series in terms of its potential to disseminate modern English work:

> Of the value of this enterprise there can be no question. As may have been observed in the collection of pictures for schools included in the recent 'Design in Education' exhibition at the County Hall, while more or less good reproductions in colour of masterpieces of the past are available, there is not the same opportunity in the case of contemporary art—English art in particular.[61]

Headmasters were less than interested, however; Wellington reported that the first sales tour he made was 'an abysmal failure. We failed to interest anyone. We tried Leicester, Birmingham, Manchester and Worcester without success. The idea and the artists were too novel, and considered too advanced.'[62] The second series, produced in 1938, was aimed at both schools and at the wider public, and was even more advanced in design. While some of the collection still represented typically English scenes, many of the prints dispensed with the notion of representation entirely: Frances Hodgkins (who was elected to the 7 & 5 Society, an *avant garde* exhibiting society, in 1929 and spent a brief time at Paul Nash and Herbert Read's group, Unit One) submitted a still life (Colour Plate 7) in which an arrangement of jugs is rendered in a flat plane, dispensing entirely of perspective, drawing attention, rather, to its primary colouration and vertical lines. Piper's own contribution to this series involved two 'Nursery Friezes' (Colour Plate 8) that followed suit, though they give a strong impression of collage and, despite their lack of perspective, have an unusual depth. Reflecting Piper's non-figurative interests at the time, they depict a seascape and a landscape, and both include a lot of representative activities (lobster pots, lighthouses, trains, pavilions, agriculture) that would hold the young eye interested for quite some time.[63]

Whether it was the alienating abstraction of some of the prints or the poor marketing and distribution of the collections, neither series flourished. A number of schools bought up quite a few full sets, but generally sales were poor. Jan Gordon laid the blame largely at the foot of print retailers: 'There can be but little doubt, that some of the poor response of the normal Briton to art must be found in the incredibly low quality of art appreciation

[61] *The Times* (22 January 1936): 17.

[62] Ruth Artmonsky, *Art for Everyone: Contemporary Lithography Ltd* (London: Artmonsky Arts, 2010), 104.

[63] Frances Spalding notes that 'in at least one London house they were pasted onto the wall at a height with which small people could engage'. Frances Spalding, *John Piper, Myfanwy Piper: Lives in Art* (Oxford: Oxford University Press, 2009), 96.

shown by the general distributors [...] and yet this is the filter through which Contemporary Lithographs must pass before they can reach the public on anything like an effective scale.'[64] But the subject matter was often difficult, and the series demanded a new attitude to art on the part of schools—buying original prints of contemporary art amounted to a closer connection between artist and audience than that achieved by displaying a machine reproduction of an old master. The latter enacted an unbreachable distance between the child and the art object and represented all the formidable, inaccessible aspects of high art. The rhetoric of the advance notices of Contemporary Lithographs, on the other hand, reflected at length on the democratic philosophy behind the series:

> [T]here is a large enough potential public for contemporary art. The trouble is that only a fractional minority have the opportunity of seeing any original examples themselves, much less of hanging them on their own walls. There is practically no machinery for 'getting pictures across' to a public [...] To make original modern pictures available to a wide public in some cheaper form is clearly necessary.[65]

Another similar venture was The School Prints series. Begun by Derek Rawnsley in 1935 as a picture hire firm, lending out prints to schools from a library of 150 reproductions, the series was taken over by his wife Brenda on his death on active service in Africa in 1943. Brenda Rawnsley met Herbert Read sometime after returning home from duty herself, and began in earnest a more ambitious scheme to commission art for primary schools. Read contracted an advisory panel consisting of Phillip James (Arts Council), R. R. Tomlinson (Marion Richardson's successor as art inspector at the LCC) and several art masters from schools around the country. Many of the commissioned artists for the first two series consisted of watercolourists (many of whom had worked on the wartime 'Recording Britain' scheme set up by the Pilgrim Trust) and children's book illustrators, a fact reflected in the provincial, nostalgic and tame subject matter of a number of the early prints. Read's presence behind the selections, however, can be detected in examples such as John Tunnard's surrealist *Holiday* (Colour Plate 9). Phantasms skip off arm in arm towards a distant red and blue sun, representing what Read described as 'the order of art, which is an analogy of the mystical mathematics of the City of Heaven'.[66]

[64] Jan Gordon, 'Contemporary Lithographs', *Penrose Annual*, 41 (1939): 42–9; 48.
[65] *Original Prints by Living Artists*, Contemporary Lithographs Ltd, Victoria and Albert Art Library (Box 194BB).
[66] Quoted in Artmonsky, *The School Prints*, 76.

Some schools clearly found the overarching modernity of some of the prints too much, with one headmaster complaining to Rawnsley that 'I personally do not enjoy looking at boys without limbs, fat ugly women and impossible situations. Maybe I haven't grasped the "inner meanings" or maybe I ought to be more childlike.'[67] Being more childlike might have been the answer, according to Michael Ayrton, who found the prints to be far too conventional: 'If I might make a suggestion to the committee, it would be that they should not restrict themselves exclusively to what they think children should like [...] Young children experience very little difficulty before what seems esoteric to adults, cubism and surrealism included. Good, rather than good-mannered, modern pictures might also do teachers good.'[68]

Perhaps because of its more affordable cost (£4 for each of the first two series, both consisting of twelve prints), or the active commercial interest and expertise Rawnsley brought to the company, the launch of the first two series attracted a good deal of attention in the press, which led to not only more interest from schools but also to wider public exposure: *Vogue*, *Good Housekeeping* and *Ideal Home* all included prints from the first two series in photo spreads of fashionable interiors during the coming years.[69] Rawnsley and Read clearly listened to the advice of Ayrton, and began commissioning a European series in 1946. Using a new process that produced prints using plastic sheets, Rawnsley discovered a more durable (and readily transportable) way to make inexpensive runs of prints. Read brought in Henry Moore to experiment with the process, and his own print, *Sculptural Objects*, was included in the series. Rawnsley determinedly set about recruiting some of the leading modernist artists still working in Europe, securing the services of Picasso, Matisse, Léger and Braque. Gone was the charming provincialism of the earlier works, and with it the support of the educational authorities and the print media. *The Recorder* ran a review under the title 'Modern "Horrors" Go to School', and the *Evening Standard* singled out Picasso's *Composition* for most derision: 'Of the educationalists who have visited the exhibition at School Prints Studio one said it was a bird drinking, a second said it was Picasso himself lying in a hammock, a third said a woman in an aeroplane. Picasso refuses to explain the drawing and says, "The children will understand."'[70]

[67] Quoted in ibid., 94.

[68] Michael Ayrton, *The Spectator* (19 October 1945): 17.

[69] See Artmonsky, *The School Prints*, 93, for more details on periodicals that included the prints in a design capacity.

[70] *Recorder* (7 May 1949): 7; *Evening Standard* (10 May 1949): 18.

The stacks of unsold prints left when Rawnsley moved on to new pastures probably confirms that the educational authorities were in no way ready to accept modern art for the classrooms and school halls of Britain in 1949. But the ultimate failure of these two schemes, largely, it seems, on the basis of their more experimental inclusions, belies a more silent and clandestine invasion of modernist aesthetics into the art classrooms of Britain in the early 20th century. Figures so central to the promotion of modern art—Fry, Read and Piper in particular—saw no distinction between their efforts to broadcast avant-garde work to the wider public and to educate children, in a progressive fashion, to embrace and practise art in their daily lives; both were part of the same desire to improve the appreciation of the arts in Britain. By demanding changes in the fairly self-enclosed world of education, where a revolution of sorts could be more readily accomplished, standards of taste could be enhanced by encouraging a different attitude to artistic culture. The rhetoric of social improvement at the core of these programmes also tapped into a wider, avant-garde charge that art, as a social practice, should drive right at the heart of quotidian life. The Ministry of Education's report entitled *Art Education*, which declared that, owing to the efforts of passionate individuals, 'art has ceased to be simply a frill and holds its place as an essential element, in some form or another, of a sound education' demonstrated a lasting success in this area.[71] While outrage was heaped on the deviant (and largely European) art that brutally confronted the public in the short, sharp shocks of outrageous exhibitions, formal experimentation and abstraction were being practised on easels in thousands of art classrooms in Britain, many of which were decorated with the work of artists vilified in London galleries. By improving the understanding of modern art in schools and fostering a different relationship between the student and the work of art, some of the more pioneering schemes—though their success was often limited at the time—enacted a sea change in educational attitudes to art that perseveres today. It was, according to Eric Newton, no longer 'a question of making the child produce better "art": it [was] a question of the practise of art producing a better kind of child.'[72]

[71] Quoted in 'Editorial: Art Education', *Burlington Magazine for Connoisseurs*, 89, 529 (April 1947): 85.
[72] Eric Newton, 'The Public Schools Exhibition', *The Times* (17 July 1938): 14.

4

'But is it possible to live in such a motley setting?' The modernist interior in Britain

> In the ground floor showrooms are some examples of gaily painted Omega furniture, with decorated designs ranging from asymmetric, irregular patches of bright colours to geometric designs and even to actual representation of the human figure. The effect is enlivening and stimulating—but is it possible to live in such a motley setting?[1]

Such was the opinion expressed in *The Observer* in a review of an exhibition of Omega-ware at Roger Fry's Fitzroy Square showroom and workshop, in the year Omega was to formally close. While bold, innovative, non-representational art had started to earn its place on the walls of the nation's galleries by 1919, the domestic interior still remained a contested space for advanced design because of the challenges it mounted to ideas of domesticity. Coloured strongly by ideas of religion, morality and virtue, the layout and decoration of the Victorian and Edwardian living space signified so much more than a taste for certain patterns, colours and objects, and the often brutal changes meted out by modernist artists and designers were attacks on bourgeois complacencies and on the sublimations of the psyche as much as they were on the design of the sideboard or sofa. For Jean Badovici, interior design 'not only reflects [the homeowner's] way of living and his preoccupations, it also helps him get a clearer picture of himself. Interior decoration helps him to strike the necessary balance between his most sacred and hidden desires and the outside world of his daily activities.'[2] In an age of mass production, cheap goods, and increased spending power for the middle classes, the home became a testing ground for new ideas about health, class, and gender identity, a locus

[1] 'Art and Artists: The Omega Workshops', *The Observer* (2 March 1919): 13.
[2] Peter Adam, *Eileen Gray, Architect/Designer: A Biography* (New York: Harry N. Abrams, Inc., 2000), 165.

for expressions of taste and refinement and a site of debate about the relationship between private and public spheres. Major aesthetic movements across Europe and the United States—from Art Nouveau to Jugendstil to Streamline Moderne—concerned themselves with the design and decoration of the living space, and many avant-garde artists took commissions to make the home artistic. Despite this, many historians of the period define modernism as the opposite of the domestic. Christopher Reed argues that high modernism had 'no time to spare for the mundane details of home life and housekeeping' and that 'the domestic, perpetually invoked in order to be denied, remains throughout the course of modernism a crucial site of anxiety and subversion'.[3]

In this sense, Max Weber's thesis—that modernity amounts to the rationalisation of everyday life and a corresponding dissolution of older ways of living dependent on religious or quasi-religious concepts of virtue and order—is a useful one to describe some broad shifts towards modernist living in Britain during the early decades of the 20th century. But, of course, the Victorian interior did not disappear. One of the connecting threads in this study, between what were disparate artistic and decorative endeavours in Britain, is the mollification and transformation of European avant-gardiste principles by more moderate (and softer) aesthetics. If Le Corbusier was busy declaring the house a site of rational process, modernist designers and decorators in Britain were blending functionalist philosophy with their own ideas of the tasteful. The modernist interior in Britain was therefore a site of contest between competing ideas of rational living, functionality, comfort and cost, and this chapter explores some of the ways in which modernist innovation in Britain offered solutions that attempted to negotiate these tensions. Kent Kleinman, Joanna Merwood-Salisbury and Lois Weinthal argue that '[t]he repudiation of taste as a category by which to make and judge design is a defining trope of modern design criticism, and interior design is one of its primary targets'.[4] If this is the case, how might we frame those aesthetic negotiations about the design of the interior space in the early years of the 20th century that centre almost solely on what is and is not tasteful? If we can reclaim taste as a legitimate category of judgement that depends not only on aesthetic data but on social, sexual and

[3] Christopher Reed, 'Introduction', in Christopher Reed (ed.), *Not at Home: The Suppression of Domesticity in Modern Art and Architecture* (London: Thames and Hudson, 1996), 15–16.
[4] 'Introduction', in Kent Kleinman, Joanna Merwood-Salisbury and Lois Weinthal (eds), *After Taste: Expanded Practices in Interior Design* (Princeton, NJ: Princeton Architectural Press, 2012), 9.

political criteria too, then we can start to unpick what was at stake in the design and decoration of the living space. This chapter explores a number of different initiatives to modify the domestic sphere, from the philosophical and artistic strategies underpinning the Omega Workshops to a number of different interpretations of functional living in the design and decoration of the Lawn Road Flats (the Isokon Building) in Hampstead and in the work of the Design and Industries Association (DIA). These three groups are partly chosen here because they cover a spectrum of interior design activities—from the decorative to the practical to the architectural. In each case, I want to trace out the influences on these initiatives—both foreign and domestic—and to try to map out the ways in which each broached the issue of tasteful living in the modern age. The same amelioratory philosophy lies behind all of these enterprises, I argue: by improving the taste of the homeowner, practitioners of modernist interior decoration in Britain hoped that some abstract improvement in collective life would be achieved.

Many British attempts to engender change in the design and decoration of the home were short-lived affairs. Even Omega, by far the most prominent design initiative of the early 20th century—and most prominently critiqued—lasted just six years and had limited contemporary public influence. My discussion here of the attempts to integrate advanced aesthetics and interior design in Britain in the early 20th century is full of failures in a sense. None of the initiatives I discuss led directly to any wide-scale change in living standards in Britain, nor did any really capture the imagination of the purchasing public. But a history of such attempts, however, reveals much about the dissemination of ideas of taste in British society in the early 20th century and about the reification of the home in the period as a site for the production of Pierre Bourdieu's interpretation of the term *habitus*. Bourdieu's term is a useful one in this context, because what lies behind many of the designs discussed here was not simply a redefinition of domestic aesthetics but a refinement of 'living': what was signified by the home space and how it shaped individual and collective identity. Unconscious though such an impulse might have been, the connection between avant-garde aesthetics and socialisation—particularly in domestic design aimed at revitalising the living conditions of the urban poor in Britain—is noticeable in the promotion and advertisement of some of the schemes I discuss, which often imagined new modes of living alongside the products and spaces they were marketing. What my case studies expose, then, are the utopian attempts made by architects and designers in Britain to reinvent the individual and the public through the design and decoration of the home. At the heart of many of these initiatives was the fervent desire

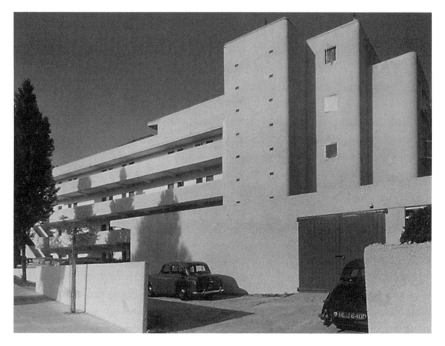

Figure 4.1. The Isokon Building: Lawn Road Flats, Hampstead (courtesy of Pritchard Papers, University of East Anglia)

to shape public taste: at a moment when mass production and cheap goods threatened a new age of clutter and bric-a-brac, a number of architects and designers in Britain were devoting themselves to design education for the public—through exhibitions, through advertisements and through sales. And behind each initiative was a firm belief that by advancing public taste an improvement in social conditions could be effected.

The Isokon Building (Figure 4.1), for example, an experiment in communal living on Lawn Road in Hampstead, was designed by the architect Wells Coates to be 'modern among the moderns, a monument to the pious aspiration of salvation through good design and social consciousness which was the key signature of English avant-garde thought in the thirties'.[5] The DIA, a group founded in 1915 but arguably most active, and with most influence, in the 1930s, dedicated itself to the same end: to 'influence and guide public taste' in Britain.[6] The activities of this group, and its

[5] From a draft editorial for the *Architectural Review*, 1955, Pritchard Papers at University of East Anglia (hereafter PP), 16/2/28/5/2.

[6] 'Aims of the DIA', unpublished document (11 August 1931), PP/28/1.

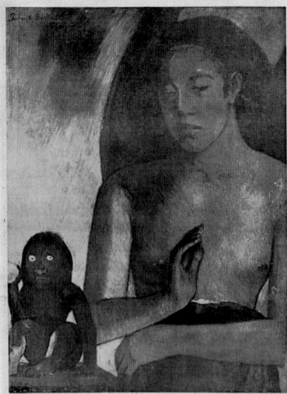

Plate 1 Advertisement for the Grafton Galleries Show
(with permission from Tate Gallery Archive)

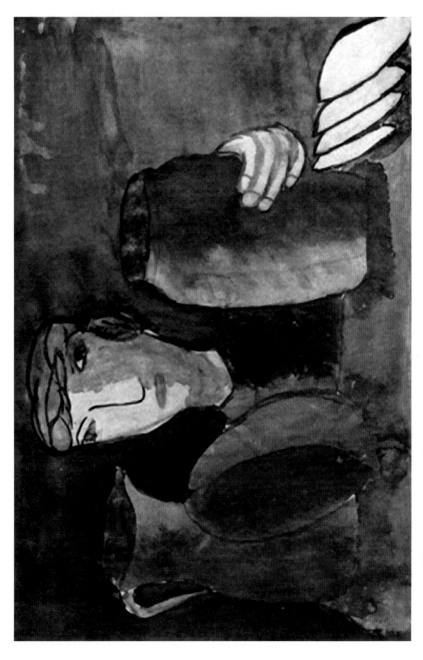

Plate 2 Florrie Howell (aged thirteen), *Serving Maid (after Velasquez)* (with permission from *MRA*)

Plate 3 Doris Richards (aged fifteen), *Evening Newspaper* (with permission from *MRA*)

Plate 4 Murial Church (aged thirteen), *Russian Ballet* (with permission from *MRA*)

Plate 5 Paul Nash, *Landscape of the Megaliths* (Contemporary Lithographs, Series One) (© Victoria and Albert Museum, London)

Plate 6 Edward Bawden, *Cattle Market* (Contemporary Lithographs, Series One)
(© Victoria and Albert Museum, London)

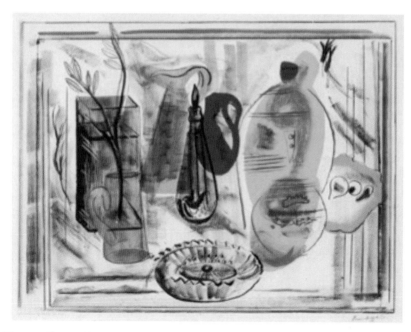

Plate 7 Frances Hodgkins, *Arrangement of Jugs* (Contemporary Lithographs, Series Two)
(© Victoria and Albert Museum, London)

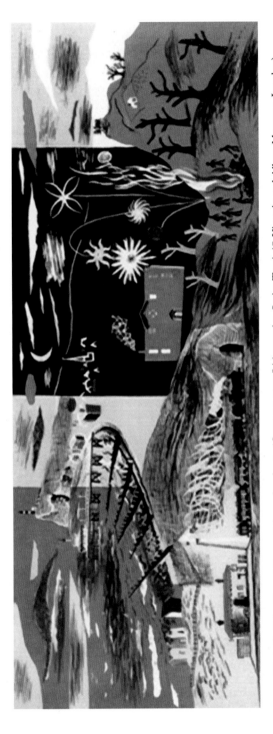

Plate 8 John Piper, *Nursery Frieze—Landscape* (Contemporary Lithographs, Series Two) (© Victoria and Albert Museum, London)

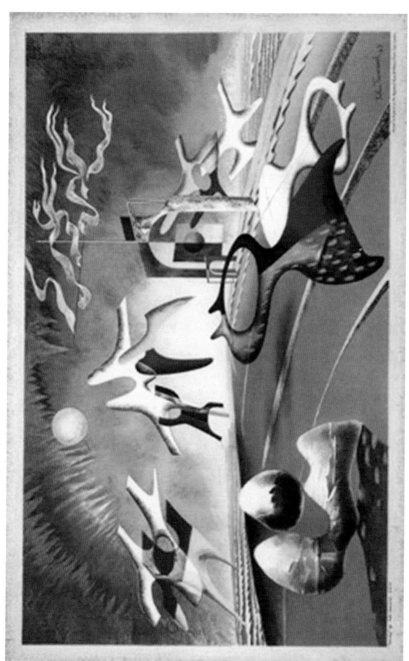

Plate 9 John Tunnard, *Holiday* (The School Prints, Second Series, No. 18) (with permission from Tate Gallery Archive)

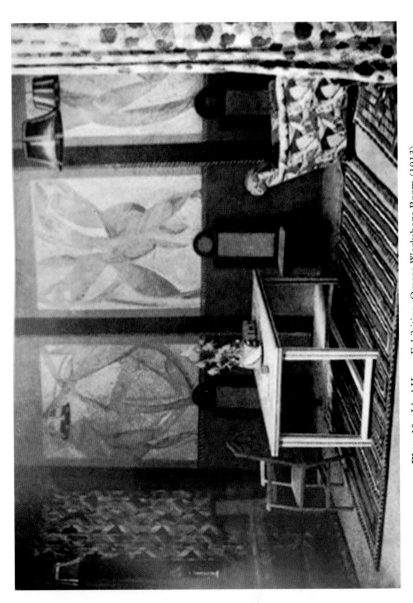

Plate 10 Ideal Home Exhibition, Omega Workshops Room (1913)
(© Victoria and Albert Museum, London: Archive of Art and Design)

philosophical principle that 'Nothing Need Be Ugly', draw obvious parallels with the Arts and Crafts movement, but its attempts to negotiate the differences between the often extreme aesthetics of designers and the demands of the marketplace mark it out as a key mediator in debates around public taste in the 1930s. And there are any number of other private, ad hoc and voluntary ventures across Britain in the 1930s whose achievements have been discussed in isolation but whose influence and value for later British domestic design practices en masse are less well understood.[7] What has been particularly ill explored in the history of British domestic design of the 1930s are the productive connections between designers, patrons and quasi-state sponsored groups that helped to shape and condition the production, advertising, marketing and selling of modernist design aesthetics to the British public. What I draw out here are some of the ways in which modernist domestic design was supported by new exhibition strategies and new modes of advertising, and how the gradual infiltration of design groups by modernists helped to mould British domestic and urban design into the 20th century.

If Wells Coates was correct—that his flats on Lawn Road and other initiatives like it mark out a dialogue between good design and social awareness unique to the 1930s—the legacy of these ventures might not lie purely in the design principles they left behind, but in the social and philosophical imperative that good domestic architecture and interior design might lead towards both an improvement in the quotidian activities of the public and towards an amelioration in standards of taste in Britain. As precursors to much more visible and policy-backed initiatives that flourished after the Second World War—such as the Council of Industrial Design, which was formed in 1944 and was the driver for the 'Britain Can Make It' exhibition held at the Victoria and Albert Museum in 1946—many of these ventures were piecemeal, short lived and poorly funded.[8] They did, however, firmly assert the need for a revolution in domestic design and

[7] Elizabeth Darling discusses, among others, Maxwell Fry's Kensal House in Ladbroke Grove and the Pioneer Health Centre in Peckham in *Re-Forming Britain: Narratives of Modernity before Reconstruction* (London: Routledge, 2006); Dennis Sharp and Sally Rendell discuss the designs of Connell, Ward and Lucas—particularly noteworthy among their designs was Kent House in Camden—in *Connell Ward and Lucas: Modern Movement Architects in England 1929–39* (London: Frances Lincoln, 2008), 154–9.

[8] The history of the 'Britain Can Make It' exhibition is admirably recorded by Jonathan M. Woodham, 'The Politics of Persuasion: State, Industry and Good Design at the *Britain Can Make It* Exhibition', in Patrick J. Maguire and Jonathan M. Woodham (eds), *Design and Cultural Politics in Postwar Britain* (Leicester: Leicester University Press, 1997), 45–66.

architecture that would have profound and wide-reaching consequences for urban planning, social housing and public health in the decades after the war. In the context of the difficult economic climate of the 1930s, they suggested responses and solutions to the problems of poor living in Britain, arguing that aesthetic improvements in the domestic space would lead to improvements—however nebulous these might be—in standards of living. Such improvements shaped the aesthetic qualities of British modernist interior design in the early 20th century and were important considerations, in particular, in the formative debates about working-class housing and about the role of women in the home. The modernist interior in Britain was therefore a site of contest between competing ideas of rational living, functionality, comfort and cost, and I want to explore here some of the ways in which modernist innovation in Britain offered solutions that attempted to negotiate these tensions. As Cheryl Buckley argues, the home 'could be modern, modernist and "English" at the same time'.[9]

The notion that interior design can be aligned with avant-garde experimentation runs counter to one narrative of artistic modernism in Britain, which polarises radical aesthetics and the domestic space. As Colin Painter argues, 'the home was characterized as comfortable and reassuring while modernism stood for challenge and progress'.[10] Many of the leading exponents of abstraction targeted the domestic interior as the site of all that was wrong with the role that art was allowed to play in the social world. Arguing, in essence, that no other space was so representative of that hated Victorian socialisation of art, Mark Rothko and Adolph Gottlieb said that their art, first and foremost, 'must insult anyone who is spiritually attuned to interior decoration; pictures for the home; pictures for over the

[9] Cheryl Buckley, *Designing Modern Britain* (London: Reaktion, 2007), 86. Much attention has been paid to the difficult relationship between modernism and national identity in Britain—see, for instance, Jeremy Lewison, 'Going Modern and Being British: The Challenge of the 1930s', in Henry Meyric Hughes and Gijs van Tuyl (eds), *Blast to Freeze: British Art in the Twentieth Century* (Amsterdam: Ostfildern-Ruit, 2002), 66–72; Sue Malvern, *Modern Art, Britain and the Great War* (New Haven, CT: Yale University Press, 2004); Standish Meacham, *Regaining Paradise: Englishness and the Early Garden City Movement* (New Haven, CT: Yale University Press, 1999); Mark Crinson, 'Architecture and "National Projection" between the Wars', in Dana Arnold (ed.), *Cultural Identities and the Aesthetics of Britishness* (Manchester: Manchester University Press, 2004), 182–200; William Whyte, 'The Englishness of English Architecture: Modernism and the Making of a National International Style, 1927–1957', *Journal of British Studies*, 48, 2 (April 2009): 441–65.
[10] Colin Painter, 'Introduction', in Colin Painter (ed.), *Contemporary Art and the Home* (Oxford and New York: Berg, 2002), 1.

mantel'.[11] For Clement Greenberg, the art forms being produced in the 1940s and 1950s by figures such as Rothko, Robert Motherwell and others, represented the antithesis of 'kitsch', a term in every sense belonging to the middle-class home.[12] 'Decoration', Greenberg warned, 'is the specter that haunts modernist painting.'[13] This opposition to the decorative spectrum is one defining characteristic of avant-garde aesthetics, and one that makes it superficially more difficult to read interior decoration and design through the lens of modernist studies. If modernism reached its formalist apotheosis in architecture—analytical, rational and exterior—then for its architect-philosophers it was no time for the jumbled confusion of space and function that is the world of the interior. Moreover, the idea that the home might be the final destination for art was treated with disgust by many avant-gardistes. For Wyndham Lewis, man was split by his dual existences at work and at rest. The 'modern city man', he said, 'is probably a very fine fellow—very alert, combative, and capable of straight, hard thinking', but at home in his 'villa in the suburbs' he is an 'invalid bag of mediocre nerves, a silly child'. The artist, Lewis goes on, should 'give expression to the more energetic part of that City man's life [...] than manufacture sentimental and lazy images [...] for his wretched vegetable home existence'.[14]

But modernism's relationship with the domestic decorative or design commodity is more complicated than one of mere antithesis. On the one hand, modernism signifies an attempt to halt and interrogate the object-as-commodity fetishism that drives commercial modernity. The artistic object (and we may as well include painting and sculpture here, as well as decorative items) taken out of its commercial setting and reformulated is saved from the ravages of mass-production, utilitarianism and use. Its very separateness from the world of things is what modernism stresses. At the same time, more recent studies of modernism shed light on the material entanglements of objects in their milieu. Theorists such as Bill Brown have been working to unpack such entanglements in recent years.[15] Thing theory, and other related methodological attempts to re-embed the decorative and the ornamental within experimental modernist aesthetics,

[11] Adolph Gottlieb and Mark Rothko, 'Letter to *The New York Times*', in E. H. Johnson (ed.), *American Artists on Art from 1940 to 1980* (New York: Harper and Row, 1982), 14.

[12] For Greenberg's definition of kitsch, see 'Avant-Garde and Kitsch', *Partisan Review*, 6, 5 (1939): 34–49.

[13] Clement Greenberg, *Art and Culture* (Boston, MA: Beacon, 1961), 200.

[14] Wyndham Lewis, 'Rebel Art in Modern Life', *Daily News and Leader* (7 April 1914), n.p.

[15] See in particular Bill Brown, *A Sense of Things* (Chicago: Chicago University Press, 2003), 1–19.

have helped shape new object-focused critical fields alive to the interplay between the consumer, the home and the marketplace, and also have helped to foreground the materialist preoccupations of many modernist writers and artists. One effect of such work has been to see the home—and the ways in which the home is decorated—as a site in which advanced ideas about art (often ideas that are antagonistic to the home as a place where advanced art might find refuge) are confronted by the quotidian demands of eating, sleeping and relaxing.

Corrupting or otherwise problematising the everyday was the declared aim of many of the key movements in modernist art and design, with many artists saving the most savage twists and distortions for the sanctity and safety of the home environment. Decoration and design—weighed down by ornamentations that preserved all the class, sex and race hierarchies and made and maintained a 19th-century domestic world view—were the declared enemy of modernist design in architecture. The International Style, named for the exhibition of advanced architectural and design aesthetics held at the Museum of Modern Art in New York in 1932, still marks—in interior design circles at least—the paradigmatic manifestation of modernist design. Finding repugnance in ornament, architect-designers such as Le Corbusier, Mies van der Rohe, Raymond Hood and Richard Neutra adopted steel, glass and the new possibilities afforded by concrete to create minimal, airy, seemingly weightless, transparent and mass-reproducible exteriors. Devoid of clutter, stripped of decorative embellishment, the home enshrined in Le Corbusier's *Vers une Architecture* (1923) and made manifest in his Villa Savoye (1929–31) placed form over function and relegated the interior to a bit part. The elision of the interior is, however, the elision of any taste at all—minimalism in the home, so associated with the Le Corbusier legacy, is nothing more than the refusal to exhibit taste. True utilitarian architecture, devoid of any considerations of taste, would arrive in Buckminster Fuller's designs for the Dymaxion House (1927). Born from the streamlined process of mass production, the lexicon of performance spilled over from the design of the house to its aesthetic footprint. To 'perform' well as a house, Dymaxion would be rented by its inhabitants from the company who would repair it or replace obsolete contents with newer versions. The house itself—or 'living unit', as Fuller preferred—built of metal, could be thrown away and exchanged for something new. For many modernist architects, the language of technological precision spilled over into the interior. Le Corbusier's Modulor system, the anthropometric scale of proportions designed and refined by the architect in the 1940s, is nothing less than a technologisation of quotidian life, while Christine Frederick's step-saving

method, outlined in her 1914 work *You and Your Kitchen*, extended work-flow management and efficiency into the private home. The relegation of form to function emphasised the underlying principle of this style: that the exterior was in every way to be the manifestation of the intent of the architect and the interior of the modernist home was a space marked by absence. It should be uncluttered, clean, light and not impede views outward.

If, in one form of architectonic modernism, the interior was made submissive to exterior design, a number of contemporary critics began to theorise the relationship between the modern subject and the interior he inhabited. The modern interior, Anthony Vidler says, 'comes into being with the invention [...] of the self-conscious individual modern subject [...] So it is that we have no interior in the modern sense, until we have an interior subjectivity in the modern sense.'[16] Moreover, for Victoria Rosner, the modernist novel 'draws a conceptual vocabulary from the lexicons on domestic architecture and interior design, elaborating a notion of psychic interiority [...] that rests on specific ideas about architectural interiors'.[17] Interiority, as a cognitive concept, has long been central to critical understanding of literary and artistic modernism, but it is only relatively recently that the early 20th-century interior has taken its rightful place as one of the generative and formative sites for the production and consumption of modernist art and literature. For so long, narratives of modernism focused on interiority only so far as to describe the autotelic, immaterial and centripetal self that existed on a different plane to anything so mundane and quotidian as the living space. For Walter Benjamin, the entry of the private interior into history is one of the markers of the rise of modern capitalist economy in the 19th century. The separation of work space and living space resulted in a separation of the functional and the decorative:

> The private individual, who in the office has to deal with realities, needs the domestic interior to sustain him in his illusions. This necessity is all the more pressing since he has no intention of grafting onto his business interests a clear perception of his social function [...] From this derive the phantasmagoria of the interior—which, for the private individual, represents the universe. [...] His living room is a box in the theater of the world.[18]

[16] Anthony Vidler, 'Outside In/Inside Out: A Short History of (Modern) Interiority', in Kleinman, Merwood-Salisbury and Weinthal, *After Taste*, 67.

[17] Victoria Rosner, *Modernism and the Architecture of Private Life* (New York: Columbia University Press, 2005), 12.

[18] Walter Benjamin, 'Paris, Capital of the Nineteenth Century: Exposé of 1939', in *The Arcades Project*, trans. Howard Eiland and Kevin McLaughlin (Cambridge, MA, and London: Belknap/Harvard University Press, 1999), 19.

The cult of collection in the 19th century is psychologised by Benjamin. The retreat into the sanctuary of the living space, awash with heavy drapes, fabrics, colours and patterns and filled with mementos, nick-nacks and bibelots was a retreat into the unconscious self. The heavy, plush interiors of the 19th-century salon were the focus of the assault made on the home by figures such as Le Corbusier and Siegfried Giedion. For Le Corbusier, 'this taste for decorating everything around one is a false taste, an abominable little perversion'.[19] For Giedion, 19th-century society 'gradually killed any creative impulse with the poison of its ruling taste'.[20] Hegemonic bourgeois interior design amounted to an extension of the comfortable, unthinking lives of the European middle classes, and the stripping away of decoration and ornament by modernist designers was a clear assault on middlebrow values. The canvas of the modern living space, I would like to suggest, is a subject for the study of taste par excellence, because it represents a set of imagined collective standards constantly refreshed by the threat of homogeneity. The stale, the old, the déclassé, all haunt the domestic interior more than any other space, and are burdened more than any other visual form with social and class baggage. For Kent Kleinman, nowhere is the issue of what constitutes taste so fully realised than in ephemeral interior fashion. 'Fashion [...] is to interior design what style is to architecture (in Adolf Loos's terms, fashion is the ephemeral ballroom gown and style is the timeless tuxedo)', he says. 'Fashion issues forth subjective declarations that demand an imagined common community and the community thus issued forth never materializes but is always present. Like Lyotard's cloud communities, communities of fashion are in a constant state of becoming without ever solidifying.'[21] The communal aspect of elite taste formation is something we have seen, and will continue to see, across this study: the creation of modernist styles and institutional frameworks to encourage and foster communities—however nebulous, momentary and successful— devoted to the improvement of public and private life. Recent work has gone some way to exploring the ways in which the home was reconceptu-alised in early 20th-century Britain.[22] Most of this work has focused on the

[19] Le Corbusier, *The Decorative Art of Today*, trans. James Dunnett (Cambridge, MA: MIT Press, 1987 [1925]), 90.

[20] Siegfried Giedion, *Space, Time and Architecture: The Growth of a New Tradition* (Cambridge, MA: Harvard University Press, 1982 [1941]), 277.

[21] Kent Kleinman, 'Taste, After All', in Kleinman, Merwood-Salisbury and Weinthal, *After Taste*, 40.

[22] See, for example, Christopher Reed, *Bloomsbury Rooms: Modernism, Subculture, and Domesticity* (New Haven, CT: Yale University Press, 2004); Rosner, *Modernism*.

styles and fashions of the living space, and the domestication of modernism across the period, without necessarily being as attendant to the pedagogical and ameliorative dimensions of the lifestyles being promoted. In my discussion of some very different case studies of British interior modernist design, I want to explore some of these dimensions—the ways in which design initiatives, private and quasi-governmental, developed and adapted continental modernism for the British home and attempted to educate the taste of the purchasing public at the same time.

The centrality of the Omega Workshops in discussions about British modernist interior design has been cemented by decades of work on Roger Fry's short-lived initiative.[23] In 1913, in a difficult economic climate, Fry, with the backing of several prominent cultural figures including George Bernard Shaw, E. M. Forster and Walter Sickert, opened Omega in Fitzroy Square. There, for six years, Fry and a workshop of artist-designers and craftsmen produced furnishings, pottery, clothing for women, screens and wall decorations. Drawing on a broadly Postimpressionist aesthetic, Fry's workshop completed commissions for a great many liberal-minded benefactors and connoisseurs, transforming Georgian interiors across well-heeled London into celebrations of bold colour, line and texture. Its aesthetics are less my concern here, however, than its philosophical principles of education and amelioration. In a range of critical writings during and after the years the workshops were active, Fry was keen to stress its radical departure from previous British efforts to connect the design and decoration of the interior with educational or social development, and it is towards the theory behind Omega that this section turns. The impetus behind the Omega Workshops was without a doubt the same democratic principle of taste that Fry, Bell and MacCarthy had laboured under with 'Manet and the Post-Impressionists'. Not just concerned with the improvement of the taste of consumers, Omega also sought to transform the conditions of the production of crafts in Britain. If it is obvious that Fry cared a great deal about the filtering down of the principles of advanced museum art into quotidian life, he also worried about the conditions under which everyday objects were produced. In 'Art and Socialism', an essay full of derision for the decoration of public spaces, included in *The Great State* (1912), Fry concerned himself mostly with the plight of those whose job it was to create such abominations, 'those men whose life-work it is to stimulate this

[23] By far the most detailed studies of Omega are Reed's *Bloomsbury Rooms*, and Judith Collins, *The Omega Workshops* (London: Secker and Warburg, 1984).

eczematous eruption of pattern on the surface of modern manufactures'.[24] The kinship with Arts and Crafts philosophy is hard to ignore here, and elsewhere in this book, but, as I want to demonstrate, Fry sought to distance Omega from the theories of Ruskin and Morris, to use his experiment as an attempt to establish a new relationship between modernist art and the public and between artists and crafts.

The furore over the Grafton Galleries show had subsided by the time Omega was founded. There had been, as we have seen, a number of other Postimpressionist shows—in London and in other cities across Britain as well—which all had the effect of authenticating the aesthetics of continental art and grounding them within British artistic traditions, because of the inclusion of so many home-grown artists in those later shows, such as Bell, Grant, Winifred Gill, Nina Hamnett and William Roberts. With the art-quake coming to a standstill, Fry wrote to his mother in 1912 that 'the British Public has dozed off again since ['Manet and the Post-Impressionists'] and needs another electric shock. I hope I shall be able to provide it.'[25] Before 1913, Fry had written about the ways in which contemporary art might find a place outside the walls of the museum. In 'Art and Socialism', an essay devoted to some blue-sky thinking about the future relationships between the state, art and the public, Fry argued that applied art and craft might act as a bridge to help carry over the transformative effect of modern art to a wider audience. A 'new order' might be established if

> the whole practice of applied art could once more become rational and purposeful. In a world where the objects of daily use and ornament were made with practical common sense, the aesthetic sense would need far less to seek consolation and repose in works of pure art [...] Ultimately, of course, when art had been purified of its present unreality by a prolonged contact with the crafts, society would gain a new confidence in its collective artistic judgment.[26]

This appreciation for the role that homewares and crafts might play in the development of the artistic taste of the nation was central to the development of Omega, and Fry realised its centrality. In a letter to his mother, he wrote of Omega: 'I shall I think have done something to make art possible in England. It would be of course almost to accomplish a miracle, but I

[24] Roger Fry, 'Art and Socialism', in *Vision and Design* (New York: Dover, 1998), 39–54; 52.

[25] Roger Fry to Lady Fry (12 November 1913), in *The Letters of Roger Fry*, vol. 1, ed. Denys Sutton (London: Chatto and Windus, 1972), 139.

[26] Fry, 'Art and Socialism', 53–4.

have hopes [...] There's no doubt that it is a difficult thing to do and perhaps that is why almost all manufacturers give it up[...].'[27]

Fry's worries about the difficulty of what lay ahead were proved prescient quite quickly. He had set out to construct a kind of artist collective, not dissimilar to what Morris had envisaged originally for his workshops before they succumbed to the demands of the consumer. Yet the relationship between producer and consumer, and indeed the relationship between artist and Omega, was difficult for Fry to manage, and his attempt reveals some of the fault lines in the social project of art in early 20th-century Britain. The much-discussed secession of Wyndham Lewis, Frederick Etchells, Edward Wadsworth and Cuthbert Hamilton to the pointedly named Rebel Art Centre in late 1913, over a dispute about the design and decoration for Omega's submission to the Ideal Home Exhibition of that year, exposes some of the philosophical difficulties Fry had with conceiving of Omega's purpose. The details of the dispute are common knowledge and, by and large, petty.[28] What was revealed in the split, and in Lewis's letter to the patrons and supporters of Omega, drives right to the heart of much larger issues for Fry. For Lewis, writing with no little fire in his belly over the issue, 'The Idol [at Omega] is still Prettiness, with its mid-Victorian languish of the neck, and its skin is "greenery-yallery", despite the Post-What-Not fashionableness of its draperies. This party of strayed and Dissenting Aesthetes, however, were compelled to call in as much modern talent as they could find, to do the rough and masculine work [...].'[29]

Lewis' conceptualisation of the 'masculine' elements of the work discloses a gender bias in the conception of decorative design in the early 20th century. 'European and American progressive architects and designers of the early decades of the twentieth century,' writes Penny Sparke, '[...] associated the concept of taste with feminine modernity, bourgeois domesticity, fashion, decoration, and conspicuous consumption.'[30] In short, they identified the tasteful interior with something vaguely Victorian. Lurking within this definition is a worrying association between design and consumerism: that good taste could be bought and sold, reduced to 'fashion' and dictated

[27] Roger Fry to Lady Fry (14 June 1913), in *The Letters of Roger Fry*, vol. 2, ed. Denys Sutton (London: Chatto and Windus, 1972), 370.

[28] For a full discussion of this event, see Collins, *Omega Workshops*, 54–7.

[29] There is a copy of Lewis's letter in Fry's Papers, King's College Archives, Cambridge. Some of the contents of the letter are cited in Collins, *Omega Workshops*, 60–1.

[30] Penny Sparke, *The Modern Interior* (London: Reaktion, 2008), 75.

by the market. Relatedly, Lewis's conflation of Omega's Postimpressionist aesthetics with Victorian standards of 'prettiness' also questions the difference between Fry's endeavour and the work of the Arts and Crafts organisations that had, by 1913, been subsumed into bourgeois taste. Fry had always sought to maintain a distance from the Arts and Crafts tradition: in the prospectus for Omega, he had argued that he was 'less ambitious than William Morris' and that his workshops 'do not hope to solve the social problems of production at the same time as the artistic'.[31] Yet in both, Fry found the relationship with Arts and Crafts, and the weighty legacy of Morris, difficult to slough off.

In Lewis's defence, Omega shared much with the Arts and Crafts tradition, and the closeness of the relationship has been considered by Christopher Reed.[32] For early 20th-century artistic and social reformers, the fusing of social values with artistic ones in the work of John Ruskin and William Morris was still the dominant principle in interior design. Moreover, the entire system was built upon a change in the dynamics of labour and production, based upon an artisanal workshop model. By the early 20th century, though, Ruskin or Morris style had become subsumed into establishment taste, commercialised, mass-produced and entirely distanced from the workshop philosophy underpinning its original purpose. Even more obvious antecedents of Omega are the various Arts and Crafts workshops and guilds that developed in response to the teachings of Ruskin and Morris in the late 19th century. In 1882, the Century Guild of Artists was formed by Arthur Mackmurdo, this group in many ways pre-empting Fry's vision with Omega: its artists were to produce wares under the condition of anonymity. The aim of the group was 'to render all branches of art the sphere no longer of the tradesman but the artist', an aim stated in each edition of their quarterly magazine, *The Hobby Horse* (1884–92). In a similar vein, the Art-Worker's Guild (founded 1884) and the Guild and School of Handicraft (founded 1888) were artist associations in Britain devoted to raising craft-based work above its increasingly debased image in an age of mechanical reproduction. All these groups were tied—explicitly in most cases—to Morris's philosophy and to a nascent guild socialism. Artist-workers would oversee the entire creative process, working together and sharing the rewards of labour. Workers would also learn new skills

[31] Roger Fry, 'Prospectus for the Omega Workshops' [1913] in Christopher Reed (ed.), *A Roger Fry Reader* (Chicago and London: University of Chicago Press, 1996), 198–200; 199.

[32] See Reed, *Bloomsbury Rooms*, 113–16.

in being part of a co-operative, and their individual and collective lives enriched by the *jouissance* of productivity.

By the 1910s, however, the Arts and Crafts legacy was tainted some-what by the fact that any utopian philosophy in Morris's movement had been diluted by practical and commercial concerns. Many of Fry's circle felt that all that was left of Morris's collectivism was an empty, capitalist husk; for example, Eric Gill wrote critically of the movement in an essay in 1909, accusing Morris of 'putting the world on a false track' because it so readily became 'a fashion to be exploited'.[33] Moreover, as Lewis's tirade demonstrated, the division between pure art and applied craft in the 20th century was growing wider, gendering the latter as feminine, pretty and the anathema to the masculine drive of the artist-ego. The effect, for Fry, was a debasing of applied art—he lamented that 'a man can still remain a gentleman if he paints bad pictures, but must forfeit the conventional right to his Esquire is he makes good pots or serviceable furniture'.[34] The com-mercialisation of Arts and Crafts style had, in other words, divided pure art from its applied cousin. Abstract design and bold colour, the features of Postimpressionist art, were the perfect vehicle through which to bring modern styles into the home, and the time was now propitious to bring the applied arts back into the fold. As Fry wrote in his prospectus for Omega,

> Between [Morris's] time and the present, it was vain to attempt the recon-ciliation of art and industry, because the more serious and enterprising artists, absorbed in the study of natural appearances, were comparatively uninterested in abstract design. But the more recent movement in art [...] has brought the artist back to the problems of design so that he is once more in a position to grasp sympathetically the conditions of applied art.[35]

Applied arts now offered a form through which modern art could attain its revolutionary goals. It could meet its public head on, in their living room or bedroom, offering them a way to make sense of the vitality of abstract art by encouraging them to live among it. 'Untold harm has been done to art', Fry wrote in 1917, 'by the rigid distinction between picture making and applied art', and it was only by embracing household forms that that distinction could be effaced.[36] Ceramics, in his opinion the most degraded art form in Britain in the early 20th century, was particularly important in

[33] Eric Gill, 'The Failure of the Arts and Crafts Movement', *The Socialist Review*, 4, 22 (December 1909): 289–300.
[34] Roger Fry, 'A Modern Jeweller', *Burlington Magazine for Connoisseurs*, 17, 87 (June 1910): 169–74; 173.
[35] Fry, 'Prospectus', 198.
[36] Roger Fry, 'The Artist as Decorator', in Reed, *Roger Fry Reader*, 207–11; 207.

conveying the principles of fine art, translating them to tangible material goods that would find pride of place in the home. In March 1914, Fry wrote an article for the *Burlington Magazine* entitled 'The Art of Pottery in England' in which he outlined the possibilities for combining modern art with homeware:

> Pottery is of all the arts the most intimately connected with life, and therefore the one in which some sort of connexion between the artist's mood and the life of his contemporaries may be most readily allowed. A poet or even a painter may live apart from his age, and may create for a hypothetical posterity; but the potter cannot, or certainly does not, go on indefinitely creating pots that no one will use. He must come to some sort of terms with his fellow man.[37]

Until the early modern era, Fry explained, pottery was 'of one kind', but by the 18th century, there was a pottery of the people and another for the well to do. Both are 'so immeasurably inferior' to their holistic medieval counterpart, the former full of a 'cheerful brutality' and the latter displaying an 'empty elegance', neither connected at all to the shared democratic and utilitarian value of the form but instead betraying 'the profound division between the culture of the people and the upper classes'.[38] The continuing schism between artistry and function of household wares was only widened, indeed, by mass-produced perfection in the 19th century, encouraged by the dogmatic teaching of technique by Arts and Crafts institutions. The Central School of Arts and Crafts in Camden, headed by W. R. Lethaby, was one such place, where students were encouraged to develop skills in pottery, woodwork and metalwork to produce an art in which 'order, construction, beauty and efficiency are one'.[39] Fry's abhorrence of rote technique—and the kind of teaching system that existed to perpetuate these skills—was a constant in his writing throughout the Omega years.

Fry would remark in his prospectus for Omega that he was 'less ambitious than William Morris' and '[did] not hope to solve the social problems of production at the same time as the artistic'.[40] Part of the problem, for him, was that Arts and Crafts conflated social and aesthetic improvement into mass, utopian, programmatic thinking. The pedagogical philosophy of

[37] Roger Fry, 'The Art of Pottery in England', *Burlington Magazine for Connoisseurs*, 24, 132 (March 1914): 330–5; 330.

[38] Ibid.: 334.

[39] Quoted in Peter Fuller, 'William Lethaby, Keeping Art Ship-Shape', in Sylvia Backmeyer and Theresa Gronberg (eds), *W. R. Lethaby: 1857–1931: Architecture, Design and Education* (London: Lund Humphries, 1984), 32.

[40] Fry, 'Prospectus', 199.

the Arts and Crafts movement involved educative and taste-making work on a macro-scale, with social activism targeted—conceptually at least—at the masses. The change in the consumption of art that Fry demanded in his writings about Postimpressionism and his criticism of existing cultural and institutional structures, examined here in Chapter 2, were also central to his vision for the role of modern art in the home. Autonomy and freedom were repeated refrains in Fry's discussion of Omega, both in terms of his understanding of the role of the artist in the workshop and the role of the consumer. Such a focus on individuality as the most important index of production and consumption cuts against the macro-utopianism found in Ruskin and Morris. The establishment of a Postimpressionist taste was carried over to Omega. The artist's role was to execute his or her vision entirely, fully and without compromise. The viewer or consumer of art was to develop an appreciation for this kind of artistic vision, to sensitively understand its forms and structures, and to cultivate an internalised, individualised taste. Omega's pedagogy was built, in other words, on the foundations of Postimpressionism and significant form—that the individual was the sole repository of taste and discernment; and a cultivated sense of both would lead to a rejection of the tyranny of the imposed, the authoritarian and the conventional. In 'The Artist as Decorator', Fry stressed the autonomy of the artist within the living space:

> A word of warning is, however, necessary to the public, if ever they should take to employing artists in this way. It is no use to hope that artists will do just what they are told [...]. In the actual details the artist must be free to use his own invention. He can only do what he sees, not what someone else has seen. It is a grave defect in the artist, distinguishing him from the more serviceable machine—but I fear it is ineradicable.[41]

From the point of view of the consumer, Omega's democratising impulse, described as 'socialist' by Fry in his essay 'Art and Socialism', always privileged the individual taste over the collective. Woolf suggested that, for Fry, 'the herd is the adversary, swollen immensely in size and increased in brute power. The herd on one side, the individual on the other—hatred of one, belief in the other—that is the rhythm, to use his favourite word, that vibrates beneath the surface.'[42]

Omega grounded its artistic style in the language of significant form and the aesthetics of Postimpressionism—it built upon a pedagogy concerned with cultivation of individual taste in a vacuum away from traditional

[41] Fry, 'Artist as Decorator', 211.
[42] Virginia Woolf, *Roger Fry* (London: Hogarth Press, 1940), 232.

hierarchies of artistic knowledge. 'The starting point for all systems of aesthetics must be the personal experience of peculiar emotion', Clive Bell claimed in *Art*, and Fry's philosophical project in Omega was built on the same principles.[43] Even Fry's later criticism of the International Style in architecture and decoration was not on aesthetic grounds, but because it promoted an interior devoid of individual expression. In a later, rejected article for *Vanity Fair*, Fry elaborated that his main argument against Le Corbusier's vision of a streamlined and sanitised modernity was precisely this. A vision of an interior hard, flat and bare meant an anti-individualist world view, predicated on reproducibility and verisimilitude, the result of which was a 'home [...] swept and ungarnished [...] to a bare clean efficiency'. It is not hard to see Omega as a rejection of such 'monastic asceticism, [...] a reaction against the bleak austerity of the modern home'.[44]

The promotion of an individual vision over technique or the demands of material and the encouragement of an individual taste in the consumer were new in British interior design. Arts and Crafts philosophy, as we have seen, encouraged the learning of skill and the employment of that skill in production. The artist was also the craftsman. While clearly Fry drew on the same ameliorative philosophy as Morris—employing poor artists who could not live by their paintings and sculptures alone to produce affordable, enlivening homewares, and by so doing, bridge the distance between design and the home constantly being widened by the rise of the machine—he also felt strongly that the Arts and Crafts privileging of skill and reproducibility only encouraged mass-produced, bourgeois taste. Arts and Crafts philosophy had clearly, from the vantage point of 1913, not effected any larger change in the social or artistic landscape in Britain, and Fry drew instead on alternative workshop models being developed on the continent. He went to Paris in May 1912 to exhibit new English works by Vanessa Bell, Duncan Grant, Frederick Etchells and Wyndham Lewis in an exhibition that was to be called 'Quelques Indépendants Anglais' and held at Galerie Barbazanges. This was at the site of Paul Poiret's École Martine, undoubtedly a significant influence on the formation of Omega: indeed, when Fry announced his plans to set up the workshops in 1912, he explicitly connected what he envisaged as a revolution in the standards of home design with concomitant programmes on the continent. 'Already in France', Fry remarked, 'Poiret's École Martine shows what delightful new

[43] Clive Bell, *Art* (New York: Frederick Stokes and Company, 1914), 8.
[44] Roger Fry, 'Pictures and the Modern Home', unpublished, undated MS for *Vanity Fair*, King's College Archives, Cambridge, 1/45.

possibilities are revealed in this direction, what added gaiety and charm their products give to an interior.'[45]

Paul Poiret hardly offered Fry the most Ruskinian model on which to base Omega, his products being high-end fashion and perfume, but his methods struck a chord with Fry. A couturier by trade, whose fashion house had been in operation since 1903, Poiret became aware of the possibilities that interior design might offer after a visit to the Wiener Werkstätte in 1910. Moving away from the gilded veneers of a professional finish, he employed a group of teenage girls to produce naïve, exuberant drawings of floral themes, which were then printed as textiles and wallpapers. It was Poiret's aim to allow creativity to develop unchecked, away from any formal training, in order to promote and nurture a modern school of folk art that would preserve authenticity and self-expression. Though their work superficially resembled the work done by C. R. Ashbee's Guild of Handicrafts or even Morris & Co., Poiret encouraged his students to work against the grain of learned technique, eschewing formal rules for freedom of expression and design, rather than helping them to refine and develop the skills of craftsmanship. It is not hard to see an antecedent in Poiret of Fry's later stated belief that the concept of 'teaching art' was 'wrong, somehow, like "baking ices", "polishing mud" or "sliced lemonade".'[46] The philosophy behind Atelier Martine, set up in 1911, must have struck a chord with Fry, who at the time was beginning to formulate connections between Postimpressionist aesthetics and the decoration of the home. Poiret, like Fry, saw the connections between avant-garde design and the revitalisation of the interior. In 1911, he set up Petite Usine, and employed the Fauvist painter Raoul Dufy to produce textiles from woodcut and print designs. Dufy would remark later that 'the decorative tendencies in contemporary painting, aided by new methods of manufacture, have brought the art of fabric painting to an unparalleled degree of perfection'.[47] Though their partnership was to be short lived—Dufy was poached by the Lyons silk firm Bianchini-Férier—Dufy would continue to produce patterns for commercial production until 1933. Fry attempted to establish Omega along the same lines—using avant-garde artists to draft, but not to make, to retain their artistic autonomy in the freedom of design and not slavishly

[45] Quoted in Isabelle Anscombe, *Omega and After: Bloomsbury and the Decorative Arts* (London: Thames and Hudson, 1981), 15.
[46] Roger Fry, 'Teaching Art', *The Athenaeum* (12 September 1919): 887.
[47] Quoted in H. G. Hayes Marshall, *British Textile Designers Today* (Leigh-on-Sea: Frank Lewis, 1939), 10.

capitulate to the demands of the material. If they did make, they would not labour to learn a technique, but always place formal abstract design ahead of the practical demands that might face them. If the result was a want of finish, all the better: as Fry argued in 'Art and Socialism', the cult of *patine* masked a philistine love for perfection, and he warned against the 'deadness of mechanical reproduction' in the applied arts.[48]

It is clear, therefore, that in his conception of Omega, Fry found room to distance himself from the pedagogical and philosophical principles of the Arts and Crafts. Critics have long been attentive to the artistic departure that Omega represented, but consistently sought to place it at the end of a tradition in guild socialism in Britain. Fry's own writings go some way to undermining this: by reformulating the idea of workshop production along continental lines, by encouraging freedom of expression and ultimate autonomy in the artist and by denigrating the extant teaching methods in British crafts that placed greater emphasis on technique than vision, Fry's experiment for interior design marks a sea change in the relationship between the advanced artist and the home. Omega's ultimate collapse in 1919 had more to do with financially strained times than a failure of its products. Critics have long held that the visual art of Bloomsbury was continental and elitist, and that Omega represented an abortive attempt to engender a wider appreciation for foreign, conceptual, non-representative art. While Fry's patrons were largely of the liberal-elite, cosmopolitan buyers who had already supported him financially with exhibitions of modern art, and while the decorative canvases of Omega were, by and large, the private rooms of the wealthy, what gets lost in this narrative is the fact that Fry saw Omega as an experiment, an embryonic enterprise devoted to exploring the viability of the premise. Christopher Reed usefully frames the issue in terms of a distinction between utopian and subcultural theory.[49] In these terms, it is unproductive to think about an initiative such as Omega as a failure in a wider popular or commercial sense—the subcultural desire, for Reed, 'sustain[s] opposition to dominant norms without the promise of eventually becoming, themselves, normative'.[50] In his written works on interior decoration and on homewares, in his attempt to draw on successful continental models for his activity rather than historical, Arts and Crafts precedent, and his egalitarian and democratic statements about the role of applied art in the early 20th century, Fry was at pains

[48] Fry, 'Art and Socialism', 199.
[49] See Reed, *Bloomsbury Rooms*, 13.
[50] Ibid.

to explain that interior design is one method through which the distance between avant-garde art and quotidian life might be spanned. In 'Art and Socialism' he looked forward to a time when 'we might hope to see such a considerable levelling of social conditions that the false values put upon art by its symbolising of social status would be largely destroyed', before going on to claim that 'objects of daily use and ornament' might help to destroy that elitist cachet.[51]

Omega's amalgam of British and European aesthetics is obvious: its organisational heritage from the continent, however, has been far less discussed. If Fry drew on continental models for the philosophy of his venture on Fitzroy Square, other, later initiatives did the same. While the historiography of British design since Nikolaus Pevsner's *Pioneers of the Modern Movement* has stressed just how much British design borrowed from abroad, there has been little commentary on how individuals and groups in Britain drew on the organisational structures, pedagogical principles and working practices of continental groups. The success of the Deutscher Werkbund, for instance, the loose affiliation of designers, architects, craftsmen and artists that flourished in Munich in the early years of the 20th century, was the model behind the construction of the DIA in 1915. In 1916, when heightened anti-German rhetoric prevailed in almost all of the arts, H. H. Peach, one of the founders of the DIA, expressed an admiration of German organisation in design matters. 'The aim of the Werkbund', he wrote, 'is the ennobling of German industrial work through the cooperation of art, industry and handicraft, by means of education, propaganda, and the adoption of a definite attitude on allied questions.' German designers and manufacturers 'have worked towards the production of sound goods which should give the death-blow to the shoddy'.[52] What the Werkbund seemed to prove for the founders of the DIA was that holistic thinking in design and manufacturing would produce well-made, well-conceived products for the home that would be inexpensive. It is not hard to find the same sentiments in the DIA's mission brief as late as 1931: '[The DIA] should bring the manufacturer and all people with powers of recommendation into touch with competent designers. At the moment, the manufacturer regards the designer as an artist. That idea has got to be smashed. He has got to come around to the view that a designer is just as

[51] Fry, 'Art and Socialism', 53.
[52] H. H. Peach, 'Museums and the Design and Industries Association', *American Magazine of Art*, 7, 5 (March 1916): 197–200; 198.

essential a part of modern industrial personnel as a Works manager and an Electrical Engineer.'[53]

Embedded more centrally in the production process in this way, the modernist designer would benefit from the closer collaboration with the makers of his or her products. Herbert Read came to the same conclusion: that 'the abstract artist [...] must be given a place in all industries in which he is already established, and his decision on all questions of design must be final'.[54] By being involved in the process more directly, the design would be conditioned more acutely by viability and by price: it was, in particular, the disconnect between design and price that the DIA felt had caused British design to fall behind its European counterparts. In an unpublished pamphlet in 1931, the organising committee wrote:

> Standards of design are changing in the direction of greater simplicity and there is a growing appreciation on the part of the general public for better designed goods at inexpensive prices. This demand is at present being met by imports from abroad and the demand is being fostered by this supply. The impetus towards modern design, therefore, is coming from abroad, and the foreign manufacturer is gaining on the English manufacturer. It is up to the English manufacturer to do as the foreign industrialist has done, foster this changed outlook in the home market and with the experience gained challenge in the markets abroad.[55]

The cost of good design was of course a major consideration in a period of austerity in Britain, so much so that the cause was taken up by the government. The Gorrell Report of 1932 was perhaps the first attempt in British civic affairs to use domestic taste as an important indicator to national well-being. Comprising important aesthetes, designers and critics—such as Fry and Margaret Bulley—the committee that produced the report was tasked with finding an answer to the problem of how best 'to raise the level of Industrial Art in the United Kingdom'.[56] Though it reached no conclusions about the way in which this improvement in the quality of design and manufacture might be achieved, the committee's report strongly asserted its belief that the time had come to make significant changes to the way in which British manufacturers and designers communicated with each

[53] 'Aims of the DIA'.
[54] Herbert Read, *Art and Industry: The Principles of Industrial Design* (London: Faber and Faber, 1934), 53.
[55] Unpublished Pamphlet, PP/28/2/18.
[56] Lord Gorrell [Roland Barnes], *Art and Industry: Report of the Committee Appointed by the Board of Trade under the Chairmanship of Lord Gorrell on the Production and Exhibition of Articles of Good Design and Everyday Use* (London: HMSO, 1932), 14.

other and to the ways in which the public could be better educated about interior design and decoration. Even in an age of economic hardship, plans could be made to re-energise British markets for interior goods—indeed, the committee felt that economic pressures, perversely, could be the driving force behind 'positive measures to improve the quality of design and workmanship, and to foster an intelligent appreciation of design by the public [...] Educative propaganda will, we believe fall on more receptive ground in these times of adversity than in times of plenty.'[57]

The main achievement of the Gorrell committee was the establishment of the CAI, set up in 1933, as a means to make real the findings of the report. The CAI, in addition to producing reports on the condition of the working-class home and the role of the designer in industry, was involved in organising large-scale exhibitions devoted to the problem of the home.[58] It was at these exhibitions such as 'Art in the Home' (1933) and 'Contemporary Industrial Design in the Home' (1934) that some of the more advanced domestic designs premiered. These were some of the first exhibitions in Britain to really embrace the spirit of the modern design movement, and they also reflected some of the new developments in exhibition culture across Europe and the United States. They also served to reassert the importance of British design on an international stage. The failure of British design to fully embrace modern advances meant, according to the organisers of the 'Art and Industry' Exhibition at the Royal Academy in 1934, that 'markets both home and abroad [...] have been filled up with goods of foreign competitors that have readily found buyers on account of their cheapness and of the intrinsic beauty of their conception'.[59]

Such exhibitions were designed to market and to educate, building on exhibition techniques developed on the continent. There was a pronounced shift in the early 20th century from displaying and selling the interior as an ad hoc collection of individual decorative or functional objects to more holistic ways of advertising. Increasingly, interiors were represented in exhibitions on a much larger scale, with whole rooms and sets of rooms constructed in situ. Merchants and exhibitors even went so far as to show kitchens complete with toast and boiled eggs to give a sense of that 'just lived in' feel. As early as the Salon d'Automne in 1910, Bruno Paul and Richard Riemerschmid—two of the leading figures of the Werkbund

[57] Ibid., 14, 18.
[58] These two reports were *The Working Class Home: Its Furnishing and Equipment* (London: CAI, 1937) and *Design and the Designer in Industry* (London: CAI, 1937).
[59] *British Art in Industry, 1935: Illustrated Souvenir* (London: Royal Academy, 1935), 1.

movement—displayed rooms on the theme of a 'House of an Art Lover', filled with objects that were mass produced but would appeal to a cultured Parisian audience. The setting of objects in a legitimately liveable space (boudoir, music rooms, dining rooms and even a bathroom) meant that attendees were not just viewing individual objects of merit but were being encouraged to visualise a particular lifestyle associated with such ownership and decoration. Such strategies also borrowed from the way in which interiors were sold and packaged in department stores. From the 'Exposition internationale des arts décoratifs et industriels modernes' in Paris in 1925, the close relationships forged between exhibitors and department stores meant that displays at such events were well funded and very reproducible. 'Although actual shopping was not possible anywhere in the exhibition,' says Penny Sparke, 'many of the displays reinforced the fact that Paris was a city in which consumption took place on a spectacular scale.'[60] Similar connections were being forged in major cities around the world, and the modern trade show format was embraced.[61]

Exhibitions began to reify the interior as a way of life and a way of being in the world. Instead of reflecting the preoccupations and taste of its occupiers, the new modernist interior became complicit in constructing personal identity within wider social structures. By the 1930s, events such as the Ideal Home Exhibition routinely used whole-room sets that did more than just market the sum total of their parts. Room designers developed an increasingly sophisticated relationship with a better informed purchasing public, marketing lifestyles and identities far more than ever before. By 1946, and the seminal 'Britain Can Make It' exhibition at the Victoria and Albert Museum, rooms were given incredibly specialised titles—right down to the occupations of potential occupiers—and visitors to the exhibition were invited, by a sign on the wall, to 'view the rooms as if the family had just vacated them'.[62]

Several modernist voices in the early 1930s reacted quite strongly against this kind of exhibition culture, on a number of grounds. For one, the interiors on display were often felt to be beyond the means of the purchasing public. For another, what was being sold as 'new' or 'modern' was often a sham imitation of what would later be known as Art Deco style. With ostentatious use of surface material, high production cost and

[60] Sparke, *Modern Interior*, 68.
[61] For more on the department store as a site for domestic modernism, see ibid., 62–3, 88–9, 118–19.
[62] Ibid., 68.

derivative aesthetic value, such objects and designs were emptied of the philosophical impulse behind the 1925 Paris show and were derogatorily termed 'modernistic' by many commentators sympathetic to the kind of organic aesthetics and truth to material that Art Deco embodied. As Julian Holder says, 'sunburst motifs formed part of the vocabulary of the speculative builder of the period. To many a Modernist this treatment, restricted to surface decoration, was as "bogus" as the mock-Tudor.'[63] Betraying none of the philosophy behind home-grown modernist experiments in design— low-cost materials, reproducibility, robustness—the fact that such designs were heavily marketed meant that profit motive overtook good design, and many households were being marketed lifestyles that they simply could not afford. Jack Pritchard and W. F. Crittall drafted a letter on behalf of the DIA to *The Times* to complain about the Royal Academy exhibition 'Art and Industry', held in early 1934:

> In spite of the announcement that it should be concerned with articles produced by mechanical means for everyday use, the emphasis throughout is on decorative art and on things produced individually for the rich. While a few standardised things are to be seen in most sections, the general impression is that of a luxury exhibit. For instance, in furniture there is hardly a room or piece which could be considered for people of ordinary means. The implication is that design is a matter of extravagant and fancy styles.[64]

Such elitism was not new, of course. As Penny Sparke argues about Art Nouveau, 'it was really only fully successful in the highly idealized homes that architects created for themselves and their families, and in those of a relatively small number of "far-sighted" wealthy clients who were prepared to live with a high level of aesthetic control in their homes in exchange for the cultural capital they gained from it'.[65] This accusation of elitism was levelled, too, at the more extreme and puritanical designs in the Le Corbusier style. The difficulty with the ultra-modern, or 'the new' as Wyndham Lewis derogatorily called it in a series of essays in the early 1930s, was that it alienated the individual from his or her own home: 'Those modernist suites of furniture—even 'attractive' up to a point—are undeniably ultra-puritan in conception [...] An "ideal home" furnished with these uncompromisingly severe bookcases, rugs, steel chairs and aluminium beds, angular

[63] Julian Holder, '"Design in Everyday Things": Promoting Modernism in Britain, 1912– 1944', in Paul Greenhalgh (ed.), *Modernism in Design* (London: Reaktion, 1990), 123–45; 137.

[64] Draft of letter to *The Times*, PP 28/4/26.

[65] Sparke, *Modern Interior*, 38.

armchairs and so forth, would be *ideal* only for the very few.'[66] Critiquing the 'approved chromium-plated, vitriolic manner' of such interiors, Lewis found that the promotion of new, 'modernistic' lifestyles served to disconnect the individual from any real sense of what purpose his home was to serve: 'Interiors of any pretensions to beauty in the past tended to signify that the person inhabiting them was spiritually a match for his surroundings. It is only today, owing to the conditions of machine-production, and the machine technology that goes with it, that what a person *uses* tells us nothing whatever about what he *is*.'[67] Slick advertising of lifestyles ('such as you see advertised in the luxury-magazine') led, for Lewis, to 'robotic tastes, with an itch for the rigours of the anchorite, and a sentimental passion for metal as opposed to wood, and a super-Victorian conviction that cleanliness is next to godliness'.[68]

There were, however, attempts in Britain to navigate these concerns about elitism and apery. Wells Coates, whom Lewis singles out for praise in the article just quoted, was one of a group of architects and designers—among them Maxwell Fry, Elizabeth Denby, Basil Ward, Amyas Connell, Colin Lucas and Jack Pritchard—who were deeply concerned by the social aspects of design and alive to the dangers to taste that mass-consumption brought to standards of taste. Coates's modernist credentials can hardly be stronger: a founding member of Unit One, he moved in avant-garde circles in the early 1930s, and he recalled later on that his intellectual development in the 1930s was shaped by his reading in modernist literature, art and philosophy.[69] Coates was committed to designs that were affordable, easily reproducible, modular and—above all—responsive to the problems of daily life for the average man and woman. In this sense, the Lawn Road Flats that Coates designed in 1933–4 for Jack and Molly Pritchard were part of a broader attempt in Britain to mediate, modify and make affordable modernist design principles. Christened with a ceremonial bottle of beer—in lieu of champagne—by the MP for Islington East, Thelma Cazalet, in July 1934, the Lawn Road Flats housed a number of artists and intellectuals, including Agatha Christie, sculptor Naum Gabo and Walter Gropius, throughout

[66] Wyndham Lewis, 'Home-Builder: Where Is Your Vorticist?', in Paul Edwards (ed.), *Wyndham Lewis: Creatures of Habit and Creatures of Change: Essays on Art, Literature and Society 1914–1956* (Santa Rosa, CA: Black Sparrow Press, 1989), 246–56; 246–7.

[67] Wyndham Lewis, 'Art in Industry', in Paul Edwards (ed.), *Wyndham Lewis: Creatures of Habit and Creatures of Change: Essays on Art, Literature and Society 1914–1956* (Santa Rosa, CA: Black Sparrow Press, 1989), 241–5; 245.

[68] Lewis, 'Home-Builder', 254–5.

[69] Coates's reading at the time is recounted in Darling, *Re-Forming Britain*, 33.

the next few decades. Built as an experiment in communal living, Isokon embraced many of the design principles of streamline moderne and of the rather more puritanical Le Corbusier style, but built with frugality and an awareness of the rather mundane aspects of daily living in mind. Rent was £96 for a single-occupant apartment for a year, up to £170 for double-occupancy, and included heating, cleaning and shoe polishing, and could be extended to include meals. Many of the facilities in the building were shared.

The building met with mixed reviews. The *News Chronicle*, though wary of the building's aesthetics, opined that 'the experiment is the signpost to a new order—it represents in concrete and steel the new attitude towards this business of living which is beginning to emerge from our present day chaos'.[70] For *The Observer*, it 'consist[ed] of a four-storey structure of a somewhat fortress type of ferro-concrete. Most conservative minded folk would say that any partiality in this direction must needs be an acquired taste, as the saying goes.'[71] Even as late as 1946, the building was capable of causing controversy. *Horizon*, the influential arts magazine edited by Cyril Connolly, declared it to be the second ugliest building in Britain in the December 1946 issue. Pritchard was outraged: 'We all know it is a highly controversial building but surely there is plenty of ugliness in London that requires condemnation before this pioneer effort [...] I feel that an example of architecture of the Gropius-Moholy-Nagy school should be encouraged rather than the reverse.'[72] Gropius was also annoyed by the tone of Connolly's piece, but defended the building on its utilitarianism rather than its aesthetic appearance. It was, he wrote to Connolly, 'the result of careful study of contemporary living'.[73] One subject of this 'careful study' was the housewife. Pritchard recalled a desire to ease the work of the housewife at Isokon, and 'Miss Cazalet, speaking on the Roof Garden, said that at a time when work in education and industry was being simplified it was right that they should lessen and lighten the work of women in the home'.[74] The *Portsmouth Evening News* wondered, however, that 'if this sort of ménage becomes generally available, will not the housewife become a modern and feminine example of an occupationless Othello?'.[75] The *Bournemouth Daily*

[70] Gerald Barry, 'Design for Living', *News Chronicle* (12 July 1934).

[71] 'Hampstead Housing Novelty: Human Nest Building', *The Observer* (17 June 1934).

[72] Letter from Jack Pritchard to Anthony Hunt (16 December 1946), PP 16/1/3275.

[73] Letter from Gropius addressed to the Editor of *Horizon* (10 January 1947), PP/16/2/27/26.

[74] 'Modern Flats. Miss Thelma Cazalet MP Opens a Hampstead Block', *Islington Gazette* (10 July 1934).

[75] *Portsmouth Evening News* (23 July 1934).

Echo went further, suggesting that the functional living space of Isokon 'seemed to make the housewife herself a superfluity'.[76] Debates about the implication that the new interior design would have on traditional gender roles abounded during the 1930s. The introduction of efficiency into the home—through mechanisation and rationalisation—prompted significant debate about the role that the housewife would play in the 20th-century home. Certainly, as Penny Sparke argues, labour-saving devices and ration- alist planning of working spaces in the home (especially the kitchen) began to erode the idea that the home was a place of labour and, in turn, 'the emphasis in housework had moved to nurturing and consuming rather than producing'.[77] Isokon is a good example of such a space. Even the visual presence of the labours of the home is erased: service elevators, room- cleaning and shoe-cleaning services, meals delivered through a system of dumb waiters from large central kitchens—these all placed domestic labour outside the skin of the living space.

The interior of the Lawn Road Flats demonstrated just how much Wells Coates and Jack Pritchard had studied the demands of contempo- rary living. Embracing a muted version of the *gesamtkunstwerk*, the Isokon flats had many inbuilt features, including floor coverings, light fittings, sliding table, divan with overlay, dressing table, cooker and refrigerator. Decoratively, though, they were a blank canvas (Figure 4.2). White walls came as standard, and the visual effect produced by the interiors was a mix of healthiness and cleanliness, of the kind promoted by Le Corbusier in *Towards a New Architecture*: 'Our houses disgust us,' he remarked: 'Let us purge [them].'[78] To this end, reviewers of the building felt that this functionalist outlook would afford occupants the chance to develop the interior in their own personal ways: 'the built-in equipment is strictly functional and unobtrusive', said the *Medical Officer*, 'and cannot offend the individual taste as someone else's furniture and accessories are almost bound to offend'.[79] The danger, of course, was that occupants would soon clutter the place up:

> the chief danger from the point of view of those who admire the simplicity and airiness of the contemporary style is that, from force of habit, the tenants of such new flats will ruin their character and abolish half their advantages by

[76] *Bournemouth Daily Echo* (13 July 1934).

[77] Sparke, *Modern Interior*, 41.

[78] Le Corbusier, *Towards a New Architecture* [1923], trans. Frederick Etchells (New York: Dover, 1986), 14; 20.

[79] *Medical Officer* (28 July 1934): 40.

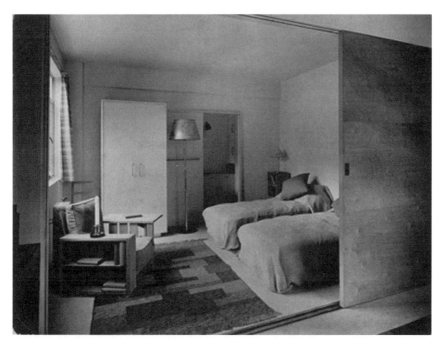

Figure 4.2. Lawn Road Flats, bedroom (courtesy of Pritchard Papers, University of East Anglia)

> overloading with knick-knacks [...] Twentieth century houses need twentieth century tenants; you won't get the best out of a 1934 supercharged sports car if you've still got a horse-and-trap mentality.[80]

If blank spaces could be provided, and the working classes educated on how to best design them, then a revolution in the standards of taste could be effected. For Wyndham Lewis, it was a case of it being

> far better to have *nothing* on the walls than vulgar and trivial things; and it must always be remembered that [the average person] possesses no taste at all, and should if possible be restrained from buying those coloured prints of comic Bonzos he naturally favours and putting them up on his walls [...]. He should put himself humbly in the hands of a competent modernist designer, and cubist-bungalow architect, and allow them to *ration* him, very strictly indeed, in the matter of everything barring strict necessities.[81]

It was not necessary to hang modernist pictures of the most geometric kind everywhere: 'you can with advantage hang *any* picture on the most

[80] *News Chronicle* (16 June 1934).
[81] Lewis, 'Home Builder', 255.

modernist wall'.[82] Isokon took advantage of its publicity photographs to demonstrate the point. The promotional shot of the living rooms (Figure 4.3) shows a collection of functional objects and a geometric sculpture alongside what are clearly figurative and not abstract paintings on the wall. Figure 4.5 shows the bottom half of a painting that is clearly figurative too.

High functionality is mixed with low-cost material everywhere at Isokon. Yet there is a surprising intimacy at work in these interiors. The Long Chair (Figure 4.3) was designed by Marcel Breuer, who had never used plywood before. It is markedly different from his rectilinear, cold Bauhaus designs, and is illustrative of the general invitation to luxuriate in the living and sleeping spaces. This design, among others, was featured in the first Isokon furniture catalogue, produced to give occupants the chance to buy functional, sleek, modernist designs inexpensively. Founded by Pritchard, Gropius and Breuer, the company made low-cost solutions to everyday demands. Bookcases were the first design that Isokon Furniture worked on: functional, two-material shelves were designed to be modular and easily moved around, and the price was relatively cheap: a 42in long set of three shelves was 28s 6d. The modular nature of the units is clear in Figure 4.5. Pritchard's papers reveal that, though popular with residents, Isokon furniture was difficult to market more widely at first, but the importation of Scandinavian furniture in the mid-1930s from Aalto in particular meant that these similar designs soon gained a place in some of the larger department stores in Britain: in Dunns of Bromley, in Crofton Ganes of Bristol, and in Heals, Bowmans, Fortnum and Mason, and John Lewis in London. Pritchard received communication from Fortnum and Mason in 1935 that the 'Finnish Exhibits' were selling so fast that they 'were beginning to feel nervous about the continuity of supplies'.[83]

Far from being an isolated test case for modernist living in Britain, the records of the Isokon company clearly demonstrate that they were to be the first in a series of similar projects across the country, with flats planned in Manchester and in Birmingham (both of which failed owing to the difficult economic climate of the later 1930s). Designed with reproducibility in mind, the modular interior structure of each flat meant that the erection of new buildings could be undertaken quickly and without excessive waste. The lifestyle it promoted was part of a wider move to educate the public about the ways in which to best furnish the home.

[82] Ibid., 255.
[83] Letter to Jack Pritchard from Fortnum and Mason Sales Department (6 June 1935). PP 18/4/24.

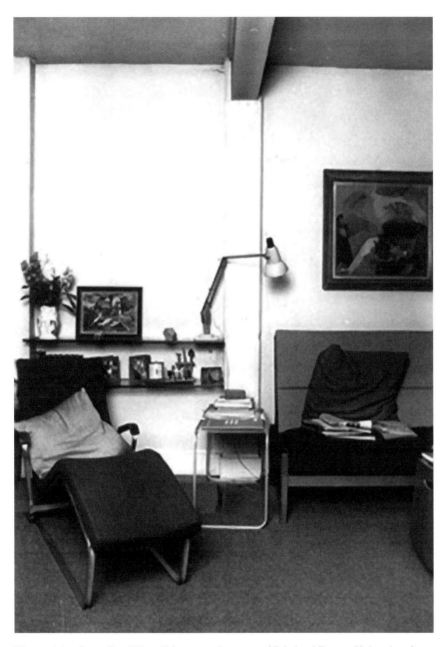

Figure 4.3. Lawn Road Flats, living room (courtesy of Pritchard Papers, University of East Anglia)

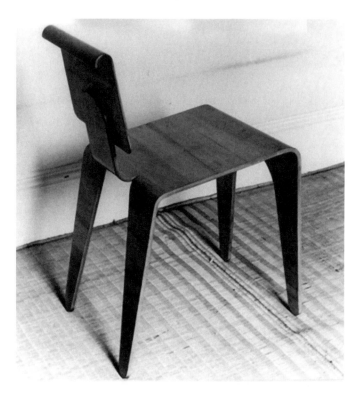

Figure 4.4. Isokon chair (courtesy of Pritchard Papers, University of East Anglia)

The DIA, too, was busy attempting to effect a change in the way that the British public consumed interior goods. Founded in 1915, its early years were dominated by a membership with a rather fuzzy remit to encourage better design and with a firmly Arts and Crafts philosophy. For the first years of its existence, the DIA was a fairly reactionary group, its staid committee composed of people such as craftsman H. H. Peach, the painter, draughtsman and poster designer Ernest Jackson and a leading silversmith, Harold Stabler. By the early 1930s, however, its membership included Maxwell Fry, the Cambridge academic and Bloomsbury acolyte Mansfield Forbes, and the Australian architect and interior designer Raymond McGrath, along with Coates and Pritchard. While it was involved in the organisation of many exhibitions during the period—in particular the Dorland Hall exhibition of 1933 at which Isokon premiered its designs—it endeavoured to place education and propaganda at the heart of its activities. A redrafted 'Aims of the DIA' for internal debate included the desire to 'create Liaison Officers between design and industry, men of taste and business ability who will steer

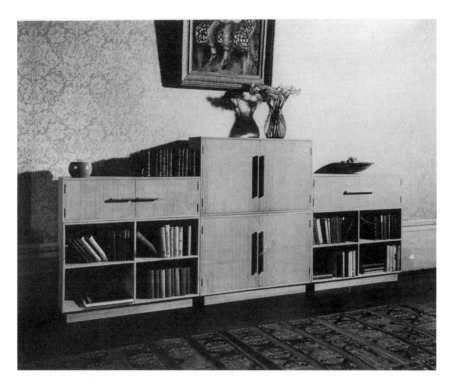

Figure 4.5. Modular unit (courtesy of Pritchard Papers, University of East Anglia)

manufacturers from employing incompetent half-wits who masquerade as designers, and who really represent the annual deposit of refuse from the Art Schools of this country'.[84] The DIA had also started to make better use of advertising, marketing and broadcasting channels, particularly after the mid-1920s arrival of John Gloag and Noel Carrington. Both men were involved in publishing before they arrived at the DIA, and both contributed to a reinvigorated new programme of propaganda aimed at the public at large. In 1930, the DIA was featured on the BBC radio programme *Changing World*. J. E. Barton, the headmaster of Bristol Grammar School and a member of the DIA, was selected by the BBC to offer talks that 'range[d] over architecture and pots and pans as well as sculpture and painting'.[85] The talks ran the gamut of art and design, stressing the importance of individual appreciation ('Do we use our eyes?', 'What is taste?') and the social aspects of urban design ('Will the new city make new men?'). As part of a wider shift in

[84] 'Aims of the DIA'.
[85] *BBC Quarterly Journal* (January 1932), n.p.

BBC broadcasting policy in the 1930s, which opened up topics previously deemed too controversial for discussion, these talks offered a way to bridge the perceived gap between advanced aesthetics and the public, keenly felt by the DIA and by Modern Architectural Research (MARS), a loosely affiliated chapter of Les Congrès internationaux d'architecture moderne, formed in 1933 by Maxwell Fry, Morton Shand and F. R. S. Yorke. If Maxwell Fry's policy at MARS in the 1930s was to have 'nothing to do with the general press [...] because the ideas were too difficult to bridge the gap between ourselves and the *Daily Mail*', then such broadcasts, with accompanying text in the new BBC periodical *The Listener*, meant that there was another way to mediate modernist domestic design.

If mediation of these ideas was to work, however, there needed to be some mechanism to fairly estimate the standard of British taste. Of particular concern was the working class—suspected of being susceptible to showiness, gaudiness and purchasing items of doubtful quality. The massive slum clearance that took place in the 1930s meant an opportunity to improve the quality of the poorer urban interior, and a government committee was formed to investigate the standard of the working-class home.[86] Organised by the CAI and staffed with key figures from modernist design in Britain—Frank Pick chaired the committee and Elizabeth Denby, who worked so closely with Maxwell Fry on working-class housing at Kensal Green, was also involved—meant that the solutions that were proposed in the final report emphasised the same solutions that Isokon and the DIA were proposing. The report, *The Working Class Home: Its Furnishing and Equipment*, proposed solutions that involved catalogues of furniture from which working-class occupants could choose and pay via hire purchase or voucher schemes, classes to encourage the purchase of quality homewares and the rationalisation of the kitchen.[87] The report despaired of an 'accumulation of patterns which is often conflicting and tiresome' and stressed a desire to educate the working-class public in household efficiency and in purchasing fewer bulky items for the home—echoing Le Corbusier's *Manual of the Dwelling*, where he cringed at houses in which he 'hardly dare[d] to walk through the labyrinth of their furniture'.[88] While several critics have found the report's premises to be either grossly inaccurate (Jules Lubbock

[86] Between 1933 and 1939, 245,000 slum houses were cleared and 279,000 new ones built, with over 400,000 existing homes reconditioned. See John Burnett, *A Social History of Housing 1815–1985* (London: Routledge, 1986), 240–8.

[87] Council for Art and Industry, *The Working Class Home*.

[88] Le Corbusier, *Towards a New Architecture*, 122.

argues that financial and logistical aspects of such plans were utterly ill conceived), the democratising impulse behind such attempts clearly draws on the need to freely disseminate the premises of domestic modernist design as widely as possible.[89]

Pritchard's democratising tendencies and continental aesthetics were channelled into other programmatic endeavours during the 1930s and 1940s. As a member of the MARS group, Pritchard was instrumental, along with M. Hartland Thomas, in highlighting the need for even the most streamlined moderne forms to express a sense of community and collegiality. MARS's discussion document, 'Architecture and the Common Man: some points for discussion', from November 1946, echoed Pritchard's belief in the need for modern architecture to connect with and enliven the life of the masses: 'A modern aesthetic,' they write, 'must not be restricted to the taste of an esoteric coterie [and] must come to terms with common people.'[90] The influence of Pritchard's furniture designs was felt keenly through the war and after. Pritchard was, for a short time at the end of the Second World War, chair of the Design Sub-Group of the Furniture Working Party, set up by the government as part of a broader effort (known as the Utility Scheme) to ensure that materials made scarce by the war effort were used to best effect. It is perhaps somewhat ironic that the war forced designs on the British public of the kind that Pritchard, Coates and the DIA were struggling to promote in the decade before hostilities broke out. Pritchard acknowledged, in the 'Preface' to the *Working Party Report on Furniture* of 1946, that 'in spite of its limitations of choice, we believe that the utility furniture scheme has done much to accustom a wider public to a better standard of design'.[91]

The attempts to refashion the domestic space in Britain in the 1930s represent utopian thinking. Though most attempts before the end of the Second World War to effect a change in working-class living conditions were only isolated successes, the structures and principles for a more radical change were in place and the massive social housing initiatives that blossomed after 1945 are one noticeable legacy of the work of the DIA and the CAI. The productive resonance between the state, quasi-governmental

[89] Jules Lubbock, *The Tyranny of Taste: The Politics of Architecture and Design in Britain, 1550–1960* (New Haven, CT, and London: Yale University Press, 1995), 313.
[90] 'Architecture and the Common Man—Some Points for Discussion' (22 November 1946), PP 7/1/60.
[91] The Board of Trade, 'Preface', *The Working Party Report on Furniture* (London: HMSO, 1946), 47.

organisations and individual designers in the 1930s meant that socially committed modernist domestic design would flourish in the years after the Second World War. If the state of interior design in the 1930s had prompted the need for action—at the level of state, ad hoc and individual enterprise—the end of the decade had seen the implementation of several strategies to better shape the design and use of the domestic interior. By the end of the decade, publications such as *Design for Today* (first issue 1933) and *Art and Industry* (first issue 1936) were field-leading journals that betrayed none of the reactionary spirit and mournful longing of those aging voices from the Arts and Crafts movement, and which were involved in the process of forging modernist design based on 'British' values. The pages of these journals are home to various attempts to isolate and distil a 'British' design identity and to analysing how new, modernist forms might help forge that identity. It is telling that some of the most experimental designers and planners of the domestic space in the 1930s—such as Frank Pick, Wells Coates, Maxwell Fry and Elizabeth Denby—were remembered by John Gloag in 1947 to be working in an English tradition running 'back to medieval England, back to the wisdom of men who worked with simple tools, few materials and abundant ingenuity'.[92] If 1930s experiments in living laid the path for social housing and urban design, their adaption and mediation of European avant-garde aesthetics is marked by what Elizabeth Darling calls an 'anglicization of continental European tropes'.[93] The design ethos displayed and exhibited at the Festival of Britain in 1951 is one legacy of British domestic experimentation in the 1930s, which I discuss in the Conclusion. A 'product of the socially reformist agenda dominating post-war Britain', the Festival celebrated in part the opportunities offered by the new welfare state to transform quotidian, everyday Britain.[94] But at a more esoteric level, the Festival embraced the same philosophical imperatives as 1930s 'exhibit-and-educate' culture: it was, for Becky E. Conekin, 'simultaneously a public celebration, an educational undertaking, and a constructed vision of a new democratic national community'.[95]

Though even a casual reader must note the disparity in aesthetics and political world view across the case studies here, the shared principles of

[92] John Gloag, *The English Tradition in Design* (London: Penguin, 1947), 35.
[93] Darling, *Re-Forming Britain*, 143.
[94] Buckley, *Designing Modern Britain*, 133.
[95] Becky E. Conekin, *The Autobiography of a Nation: The 1951 Festival of Britain* (Manchester: Manchester University Press, 2003), 9.

the democratisation of the tasteful interior, a more articulated relationship between artist-designer and consumer, and the education of the public in design principles unite the disparate activities of the Omega Workshops, the Isokon project and the DIA. Competing definitions of what defines the modern, or modernist, home abound in British design culture from Omega to the outbreak of the Second World War—the tension between foreign and British styles and between the individual, one-off modernist interior of Bloomsbury and the mass-reproducible modernism of modularity and the International Style. The domestic modernist interior in Britain did not coalesce around one philosophy or organising aesthetic principle. Rather, as this study has charted, the efforts of modernisers in the early 20th century were directed towards amelioration, towards a gradual improvement in the material conditions and aesthetic lives of the population. Whether initiatives such as Omega or Isokon contained within them the seeds for a more sweeping change in the home lives of the masses in Britain remains debatable. Certainly, both offered templates for radical change, transforming the ways in which the objects that filled the home would be made and consumed. Though Omega has perhaps endured a similar, if less marked, fate than Morris & Co., mass produced and subsumed within mainstream culture, it still possesses a modernist, subcultural, resistant, non-bourgeois cachet thanks to the lives of its key figures and its relatively short-lived moment. Though it did not achieve an alternative idea of a whole society (to paraphrase Raymond Williams's accusation against Bloomsbury more broadly defined), it offered a radically different mode of the production and consumption of homewares and laid siege to the conventional. Omega's aesthetic was borne out of a belief, in Christopher Reed's words, that 'the objects of daily life reveal and perpetuate the social and moral conditions of their creation'.[96] As such, they constitute an assault *through* rather than *against* decoration. Abstract design, deep and bold colouring, geometric and mosaic patterns combined with human forms mark out Omega as reformulating rather than rejecting the decorative.

More importantly for my purpose here, all of the initiatives described were working on educative agendas to improve public taste. In the exhibition culture of Omega and of groups such as the DIA and the CAI, the marketisation of a lifestyle went hand in hand with the education of the buyer: if Omega came to represent a subcultural space attractive to a discerning consumer for what was encoded in its aesthetics, the activities of those later

[96] Christopher Reed, 'Architecture and the Decorative Arts', in Christopher Reed (ed.), *A Roger Fry Reader* (Chicago and London: University of Chicago Press, 1996), 169.

projects that sought to transform the home along British lines followed a similar philosophy. If these small-scale efforts achieved only small successes, financially and conceptually at least, they helped raise the level of discourse about and public engagement with the design of the home, and crucially assisted in narrating the gap between high-modernist principles and domestic organisation, decoration and furnishing. Mediators such as Fry and his associates at Omega, Maxwell Fry, Wells Coates and Jack and Molly Pritchard, and the associated activities of groups such as the DIA and the CAI, helped to shape a discourse that brought advanced artistic principles into constellation with the domestic sphere. If the radical opposition between modern, non-representational or experimental art and the home was effaced in the early 20th century, it was through the efforts of these mediators.

5

'A transformed world':
Herbert Read, British Surrealism and
the institutionalisation of modernism

'British Surrealism is the history of the knotting and almost immediate unknotting of energies.'[1]

On Monday 27 July 1936, in its opinion column, the *Yorkshire Evening Post* ran a short article titled 'Unthinkable in 1910', reporting the comments made by Professor F. J. C. Hearnshaw, Professor of History at the University of London, at the Royal Empire Society conference. He opined that 'there has been a great loosening of the old beliefs, a certain relaxation of moral standards [...] and with that relaxation a certain worsening of manners. I cannot conceive anyone in the year 1910 calling his father an old bean.'[2] The occasion of these comments was the International Surrealist Exhibition in London, open since the early summer at the New Burlington Galleries and soon to be broken up and delivered to a number of galleries around Britain for more public mockery. The totemic nature of 1910 for Professor Hearnshaw—that human character had indeed changed in that year—is useful to chart the changing nature of the relationship between art, critics and publics during the first decades of the 20th century. If 1910 had been year zero for a new art in Britain, provoking a sea change in the public and private tastes of the nation and a change in the tone of art criticism, then by 1936 there was a sense that the project might be stalling. The British art and design scene, as we have seen over the course of the last four chapters was, by the early 1930s, still dominated by continental—especially French—aesthetics. If Postimpressionism, Futurism, Fauvism and Dada had sent shockwaves through British artistic culture, these decades-old continental movements remained 'modern' in

[1] Michel Remy, *Surrealism in Britain* (Aldershot: Ashgate, 1999), 328.
[2] *Yorkshire Evening Post* (27 July 1936): 3.

the public mind only because a home-grown avant-garde had failed to take root. Moreover, the utopian visual democracy, and attendant social change, envisaged by some of the modernist promoters and mediators I have discussed had also not happened as might have been imagined. As late as 1928, at the retrospective exhibition organised by Roger Fry for the London Group—perhaps the most well-supported and successful collective of British modernist artists in the early 20th century—Fry would ask frankly 'whether the British public might for once have shown its belief that serious art was worth at least giving trial to [...]? My own belief is that it would not have happened, that the British public is too painfully conscious of its insensibility to visual form ever to abandon its habitual attitude of suspicious contempt.'[3] All the while, galleries continued to show French art, and critics bemoaned the staleness of the offerings: for Frank Rutter, who was art critic for the *Sunday Times* among other roles, London 'was in danger of being surfeited with exhibitions of French art'.[4] The qualified successes that this book has charted—the development of a socially committed art criticism, the deepening relationship between art and education, the potential benefits of modernist design and the changing dynamics of regional, civic and provincial cultures of art—were all tempered by the fact that a true home-grown avant-garde had not really achieved any wider impact or lasting legacy by the 1930s. If one of the aims of the Postimpressionist exhibition had been to catalyse a native art community into action, it is strange to find Clive Bell opining as late as April 1935 that 'the next phase of English painting will be the exploitation of the national heritage by artists whose sensibilities have been tempered by Cézanne and the abstract painters'.[5]

By the time Bell made these comments, a group of left-wing artists and critics in Britain had begun to slough off the legacies of Postimpressionism and to make noises about a new god: Surrealism. On the face of it, however, Surrealism was just the next in a line of French-driven movements to be paraded before a gawking British public. By the early 1930s, André Breton's manifesto announcing the birth of the movement was a decade old, and several iterations of visual art, music, photography and literature had made Surrealism a sprawling continental colossus by the time it was introduced to the British public. The lateness of this arrival is somewhat surprising, but despite the close connections forged between the art markets of Britain

[3] Roger Fry, 'The London Group', *Nation and Athenaeum* (12 May 1928): 11.
[4] Frank Rutter, 'Art Exhibitions', *Sunday Times* (9 April 1933): 13.
[5] Quoted in 'Art Periodicals', *The Times* (22 April 1935): 8.

and France in the 1910s and 1920s, there was surprisingly little established cultural dialogue between the two nations. Little magazines, mainly in English, offered the only real ready supply of French art and literature, in titles such as *the transatlantic review* (1924), *transition* (1927–38) and *This Quarter* (1932), and it was in these places that Surrealist art and writing first garnered attention in Britain. Even the first stirrings of Surrealist activity in Britain made themselves known not in English but in French. David Gascoyne's 'First English Surrealist Manifesto' appeared in *Cahiers du Art* and some of the first native contributions to the movement also appeared in foreign tongues. From the beginning, then, Surrealism was an import into Britain, a movement cut off from its radical politics and continental flavour. Indeed, some figures associated with the movement felt that it was a kind of stillbirth, a mix of idolatry, nostalgia and bourgeois dissidence. By the time of the International Surrealist Exhibition in June 1936 at the New Burlington Galleries, even those sympathetic to the work of continental Surrealists were squeamish at the mix of unabashed adulation for (and imitation of) the work of its key protagonists. For Humphrey Jennings, the exhibition smacked simply of revivalism, and on reading Herbert Read's edited collection *Surrealism*, produced in the wake of the exhibition, he asked:

> how can one [...] compare it even for a moment with the passion, terror and excitement, dictated by absolute integrity and produced with all the poetry of bare necessity, which emanated from *La Révolution Surréaliste* and *Le Surréealisme au Service du Révolution*, without facing a great wave of nostalgia, and bringing up a nauseating memory of the mixed atmosphere of cultural hysteria and amateur-theatricality which combined to make the Surrealist Exhibition of June so peculiar a 'success.'[6]

For Jennings, the lateness of the movement's arrival—and the fawning praise given to Breton and Dalí by the show's organisers—represented all that was wrong with British attitudes to the avant-garde. I begin with these notions of lateness here because some studies read the activities of British Surrealism in the context of a national—or in some cases international—'late modernism', the mournful and elegiac cul-de-sac of artistic creativity that awaited renewal in the post-war period.[7] Certainly, it was an autumnal blossoming. However, Surrealism did have an impact in Britain artistic culture, though it was not necessarily the one it imagined for itself.

[6] Humphrey Jennings, 'Surrealism', *Contemporary Poetry and Prose*, 8 (December 1936): 167.
[7] See, for example, Thomas S. Davis, *The Extinct Scene: Late Modernism and Everyday Life* (New York: Columbia University Press, 2016), especially ch. 1.

While Herbert Read, in his introduction to *Surrealism*, would rail against 'the self-complacency, ever-elastic sectarianism and rampant capitalistic oppression' of British culture and proclaimed that a Surrealist republic would revolutionise British society, any revolutionary potential that the movement might have had in Britain dissipated relatively quickly.[8] Such has been the narrative constructed around British Surrealism. This chapter, however, looks at the afterglow that the movement left behind: the ways in which Surrealism made itself native in Britain, particularly through Herbert Read's strategy of creating connections between Surrealist thought and British literary, artistic and cultural traditions, and also its role in the institutionalisation of modernism in Britain.

Most histories of the British Surrealist movement are not institutional histories at all—they record the activities of the Surrealists in England as a series of brilliant flashes very quickly burned out, either by the end of 1936 or certainly before the outbreak of war. Some recent work has built on Michel Remy's invitation to extend Surrealism's history in Britain further. James Gifford finds a long afterlife in the networks that grew around the Villa Seurat in the 1940s and beyond, with the political energies of the movement being reformulated as anarchism by writers and artists as diverse as Robert Duncan, Henry Miller, Lawrence Durrell and Anaïs Nin.[9] Gifford's study is part of a recent reassessment of the characterisation of the period as one dominated by the Auden generation's version of 'late modernism' in Britain. In a similar way, Sam Cooper's recent study of the Situationist International movement in Britain begins with a study of Surrealism to demonstrate how the impact of the exhibition and the subsequent activities of the British Surrealists influenced later Marxist movements, as well as provocateurs and psychogeographers such as Charles Radcliffe and the later King Mob.[10] In both of these studies, however, British Surrealism is used very much as a point of origin in a much larger formulation of British art across the 20th century—for Cooper, 'the Surrealist Group in England coalesced only briefly, and primarily in an administrative capacity as signatories and organisers'.[11] Building on this idea of the committee-nature of the Surrealists, this chapter suggests that while it might be difficult to

[8] Herbert Read, *Surrealism* (London: Faber and Faber, 1936), 13.

[9] James Gifford, 'Anarchist Transformations of English Surrealism: The Villa Seurat Network', *Journal of Modern Literature*, 33, 4 (Summer 2010): 57–71.

[10] Sam Cooper, *The Situationist International in Britain: Modernism, Surrealism and the Avant-Garde* (London: Routledge, 2017).

[11] Ibid., 45.

describe the British Surrealist moment as an example of an autonomous, native movement, its attempts to insert itself into British culture and to authorise its activity by laying claim to the collective or communal power of avant-garde art mark new departures in British artistic life, and that the legacies of this communal thinking took the shape of collective and institutional bodies in the years during and after the Second World War. In other words, I want to suggest that the legacy of Surrealism in Britain was not revolution, but rather institutionalisation.

Michel Remy's observation, in the epigraph that begins this chapter, is drawn from what is a sometimes mournful last section in his fulsome and erudite book *Surrealism in Britain* (1999), reflecting on the often ethereal and directionless Surrealist activity that persisted in Britain after the Second World War. The legacies that artistic movements leave behind are always problematic at best, and at worst their afterlives can pervert and water down the energies that made them dynamic and vital. For Remy, that fate befell Surrealism in Britain in the 1950s and after, the work undertaken by its dynamos in the 1930s undone by the competing claims made on its legacy; by artists, filmmakers, musicians and anyone with a subversive axe to grind. The fleeting attachments to causes—to feminism, to Trotskyism, to the protection of individual freedoms in anarchism and libertarianism— and the loose application of the term 'Surrealist' to artists and writers whose work bears only a passing affinity with the work of the movement's founders meant a significant dilution of the artistic philosophy that drove Breton, Ernst and Dalí decades earlier. Remy's narrative, in a chapter called 'The Search for A Fading Prospect', is a lugubrious one, with Surrealism's revolutionary potential dissipating in vagueness of purpose. Yet even with this unfulfilled revolutionary energy, Surrealism—the activities of a diverse group of critics, artists and promoters in the 1930s—left an indelible mark on the British cultural scene and on the relationship between art and the public. One of the important arcs across these chapters has traced the ways in which an infrastructure grew around modernist art and design, and that seminal moments helped to catalyse public interest and pre-empt collectivism and quasi-state involvement.

I use the word 'institutional' neutrally here. One legacy of the International Surrealist Exhibition I explore in what follows is the establishment of institutions—and those I discuss in detail are Mass-Observation and the Institute for Contemporary Art, but there are others, such as the London Film Society, the GPO Film Unit and the British Film Institute—by many of the main promoters and mediators of the event, most notably Herbert Read, Roland Penrose and Humphrey Jennings.

Many of these institutions—Mass-Observation and the ICA in particular—were constructed in the 1930s and 1940s according to many of the politically revolutionary tenets of Surrealist philosophy: they would help unmask British collective fantasy, expose capitalist hypocrisy through interventionist aesthetic means and challenge establishment thinking. Despite these professed aims, these particular offshoots of Surrealism were very quickly bogged down in the quagmire of post-war bureaucracy and state involvement in the arts, and the co-opting of some of these initiatives as governmental or quasi-governmental entities over the course of the next few decades meant that their energies were dissipated. In the case of Mass-Observation, for Jed Esty, the 'attempt at a radically democratic and decentralised representational apparatus [...] ended up becoming normative and even statist in its effects. The centralizing effect of Mass-Observation, particularly with the onset of World War II, took the litany of shared Englishness on a short trip from radical intentions to conservative organicism.'[12] In the case of an institution such as the ICA, which benefited from government support and had a complicated history in the 1940s and 1950s that involved deep entanglements with both private funding and the state, the resulting legacy was less radical than its founders might have hoped. One of the longer stories told in this book has been the ways in which continental aesthetics were adapted by British artists, educators and other mediators in response to the complex negotiations between art and its publics. In this story, Surrealism's place is cemented by its adaption, modification and dissemination of continental energies for British viewers and consumers.

The other key factor in Surrealism's institutional after-effects in Britain was its resistance to some of the abstract and non-representational forms of other iterations of modernism, such as Postimpressionism, Cubism, Vorticism and Futurism. In many ways, Surrealism is an anti-modernist movement, resistant to the strategies that other versions of visual modernism adopted in the early 20th century to embrace the modern world and one that constituted a far stronger challenge to the institutional basis of art. As I will explore, the critical culture built up around Surrealism in Britain in the 1930s stressed at least as many breaks with the other versions of modernist experimentation as it did continuities. Here, and in the Conclusion, I will examine some of the ways in which these anti-modernist tendencies helped Surrealism to find a home in Britain—by

[12] Jed Esty, *A Shrinking Island: Modernism and National Culture in Britain* (Princeton, NJ: Princeton University Press, 2009), 188.

stressing continuities with British Romanticist (and irreverent, humorous) traditions, Surrealism's promoters and mediators in Britain could effective circumvent European abstract and non-representational modernism and claim Surrealism as an authentic, national avant-garde. One legacy of the Surrealist moment in Britain was a post-war institutional flowering of advanced, challenging art in Britain, especially in the early activities of such organisations as the ICA, whose gallery spaces drew on the work of home-grown artists who were directly or indirectly connected to British Surrealist activity. Surrealism's challenge to the imbrication of modernism and the marketplace, in particular, led to the formation of a new breed of arts institutions resistant to the hegemony of European abstraction. The promoters of Surrealism in Britain such as Read, Penrose, Jennings and Peter Gregory, were all involved in the establishment of this new institutional framework for experimental and conceptual art in the post-war period, establishing for the first time an authentically British display and curatorial culture around that art.

'June 1936. After a winter long drawn out into bitterness and petulance, a month of torrid heat, of sudden efflorescence, of clarifying storms. In this same month the International Surrealist Exhibition broke over London, electrifying the dry atmosphere, stirring our sluggish minds to wonder, enchantment and derision.' So wrote Herbert Read in his introduction to *Surrealism*, which appeared in 1936, the year in which Surrealist art and concept first consolidated itself before a British public.[13] The organising committee was an eclectic group of writers and artists—Rupert Lee, member of the London Group and husband of Diana (née Brinton), who was for a long while subeditor of the *Burlington Magazine* under Roger Fry, chaired the group, with Read, Nash, Henry Moore and the poet and novelist Hugh Sykes Davies also in attendance. Both Rupert and Diana Lee had extensive experience with the organisation and promotion of exhibitions, and both had been involved in the design and running of the retrospective exhibition for the London Group in 1928. The 392 exhibits at the 1936 show were drawn from the spectrum of Surrealist activity, with canonical artists such as Max Ernst, Salvador Dalí and Marcel Duchamp displayed alongside work by English artists such as David Gascoyne, Robert Medley and Henry Moore. On 11 June, the exhibition was opened at the New Burlington Galleries, with over 1,000 people attending the

[13] Read, *Surrealism*, 13.

opening event; the traffic stopped temporarily in Piccadilly at the commotion. André Breton, dressed head to toe in green, opened the exhibition while Sheila Legge, the 'surrealist phantom' as she was to become known, strolled through the crowds, her face obscured by roses, holding a wooden leg and a pork chop. Lectures took place—Read himself delivered one on 'Art and the Unconscious' and Breton delivered his famous 'Limits Not Frontiers of Surrealism' talk—and Dalí and Buñuel's intermittently grotesque *Un Chien Andalou* was shown to bewildered visitors. Dalí's own infamous appearance at the exhibition—dressed in a deep-sea diving costume accompanied by two borzoi dogs and a billiard cue—drew much comment in the press, most of it derisory. There were poetry readings, too—from Paul Éluard, Gascoyne, Jennings and others. It was, in short, a multifaceted performance as much as an exhibition, a demonstration of Surrealism in the round. The show highlighted the international breadth of the movement, with work displayed by artists from fourteen nations, and in his introductory lecture announcing Breton, Rupert Lee drew attention to the fact that the movement was 'completely international, and has adherents in almost every country in the world'.[14] Critics objected to the work of European Surrealists on aesthetic and moral terms. Even those more consistently sympathetic to abstract art and design found Surrealism a fad too far—Kenneth Clark said that he 'felt nothing whatever, except a mild distaste for' the work of Max Ernst, and Edward Crankshaw felt that Joan Miró was a 'third rate mind with limited intuition'.[15] For *Apollo*, a periodical that had often embraced abstract art, Dalí possessed 'deplorable skill'.[16]

Despite the reviews, the show attractive massive public attention, with 23,000 visitors, and its organisers demonstrated a clearly learned ability to blend chaos, publicity, shock and art all under one roof. The parallels with Fry's Postimpressionist exhibitions in 1910 and 1912 are all too obvious. Organised quickly and with a quaint amateurishness, the exhibition was designed with public outcry in mind. They had learned from Fry's work. The organisers hoped, according to *The Scotsman*, that the exhibition 'will do for the movement what the famous post impressionist show of 1910 did for Cézanne, Van Gogh, &c. The public stormed, the Press sneered, and a

[14] Rupert Lee, typescript of introductory lecture, quoted in Denys J. Wilcox, *Rupert Lee: Painter, Sculptor and Printmaker* (Bristol: Sansom and Company, 2010), 113.
[15] Quoted in *Surrealism in England: 1936 and After* [exhibition catalogue] (Canterbury: Kent County Council, 1986), 5.
[16] Ibid., 5.

new group of masters came into their own.'[17] But if Fry's Postimpressionist exhibitions caused a public outcry unexpected not in tone but in volume, the organisers of the event at the New Burlington Galleries understood that provocation was not only the key to financial success but also the intellectual and aesthetic dialectical clash they hoped to produce, and the event eventually sold well—the total sales reached nearly £1,000, with Edward James paying large sums for work by Paul Nash and Giorgio de Chirico, and a host of small buyers paying smaller amounts for work by now household names. The advertising and promotion of the event was also carefully—and cynically—conceived. At one of the first meetings of the organising committee, Hugh Sykes Davies suggested that one method to promote the event might be that the members of the committee all call up Selfridges and ask what surrealism was.

The exhibition also benefited from new curatorial practices developed on the continent. After the original hanging of the exhibition in early June, by Rupert Lee and Roland Penrose, the Belgian surrealist E. L. T. Mesens was unsatisfied and rehung everything, which disturbed the hierarchies of display that had shaped the first attempt, mixed media and destroyed any notion of theme or concept. Paintings were double- and triple-hung, and the installation had a chaotic look to destabilise the viewing experience. This was not the first exhibition that refused order in its design of course, and Surrealism inherited curatorial practices from Berlin and Paris galleries, particularly those such as Galerie Otto Burchard, the site of the First International Dada Fair in 1920. Adam Jolles has written persuasively about the ways in which the origins of Surrealist display and performance in Paris in the 1920s were marked by experimental curatorial practice, arising out of 'an interest in the manner in which art and historical artefacts were being presented to the public and a burgeoning skepticism in the ability of entrenched institutions—either public museums or private galleries—to address their concerns'.[18] Such suspicion of the institutions of art arrives out of both the perseverance of 19th-century standards of taste in public galleries and museums, but also out of the stultifying apparatuses that quickly grew up around modernist culture: Jolles quotes André Breton's mournful realisation that, even in 1923, art had failed to break away from its own institutionalisation—art was still 'under the sway of dealers', and Breton thought it 'unfortunate that so few opportunities exist for a painter

[17] *The Scotsman* (13 June 1936): 17.
[18] Adam Jolles, *The Curatorial Avant Garde: Surrealism and Exhibition Practice in France, 1925–1941* (Philadelphia: Pennsylvania State University Press, 2013), 5.

to bring his work to public attention, apart from art galleries. His presence in those evil places almost always leads him to make compromises that I am not prepared to forgive.'[19]

The 1936 exhibition in London attempted to undermine this culture of the exhibition by refusing the hierarchies of art, by breaking down narratives that might be told—there was, emphatically, no 'story' to be told about Surrealism by looking at the images and objects on display. Part of the aim of the exhibition, in contrast with Fry's constructed narrative of French artistic inheritance from Manet to the moderns, was to stress the atemporal nature of the Surrealist impulse. Read's lecture on the unconscious impulse in art, which he later elaborated in a number of essays and chapters on the subject, stressed the fact that the Surrealists were only laying bare a primal urge or instinct to express latent psychological energies that existed throughout time. This would be a central idea in Read's post-war years, when he would be involved, with Roland Penrose, in exhibitions such as '40,000 Years of Modern Art' with the ICA. But if the organisers were doing their best to disturb the art-historical narratives that might place Surrealism within a genealogy of styles and movements—in other words, its diachronic context—they were very active in stressing its synchronic correspondence with art that celebrated its unconscious origin and its role as dialectical opposition to mainstream, hegemonic culture. In other words, Read and Penrose desired to unshackle Surrealism from its popular, public conception as the latest de rigueur fad in order to stress its ties to older forms of art that celebrated intoxication, dream, reverie—and indeed crudeness. There was also no sense of development of the movement from its inception—the show included not only a large number of African and Pacific Island art objects but also many *objets trouvés*, which were exhibited alongside original works by both continental and home-grown surrealists, as if to destroy any aura that might persist around the paintings. For Lewis Kachur, such play with exhibition design amounts to what he terms the 'ideological spaces' of the Surrealist show.[20] Kachur argues that the trail of avant-garde exhibitions across Europe during the 1920s and 1930s all abandoned 'seemingly straightforward or avowedly neutral presentation in favor of a relatively subjective format'.[21]

[19] André Breton, *The Lost Steps*, trans. Mark Polizzotti (Lincoln: University of Nebraska Press, 1996), 104–5.
[20] Lewis Kachur, *Displaying the Marvellous: Marcel Duchamp, Salvador Dalí and Surrealist Exhibition Installation* (Boston, MA: MIT Press, 2001), 4.
[21] Ibid., 6.

Moreover, this exhibition space 'coincides historically with the rise of the marketing of brand name goods, as well as the spread of the site consecrated to such display, the department store. Not surprisingly, the display as spectacle has its overlapping histories in commercial and fine art realms. Exhibition space is often where the two most obviously mingle and compete.'[22] The appearance of the exhibition in London—objects found, bought and recycled positioned around paintings—must have strongly resembled the space of the department store, and later exhibitions in Paris and New York actively incorporated the visual language of the shop: mannequins dressed in what superficially resembled haute couture sat alongside repurposed everyday objects that could easily have been for sale.

If the space of the gallery was ideologically changed by Surrealist practice, the movement's heterogeneity meant that 'art' was replaced by mixed-media performance. The connections between the various disciplines of avant-garde art that had been cultivated in the 1920s and 1930s—what Kevin Brazil adroitly describes as the 'interdisciplinary phenomenon' of modernism—meant that the exhibition could draw on a multimedia definition of Surrealism to demonstrate not just the variety at the heart of the movement, but the capacity for different forms of art to provoke both individual and collective responses.[23] The meetings of the organising committee—which soon included Read, Paul Nash, Hugh Sykes Davies, Henry Moore, Man Ray, David Gascoyne and Humphrey Jennings—record the interest in this multimedia approach. In addition to sourcing paintings, Jennings was to source surrealist films from the nascent London Film Society, and several collectors—including Kenneth Clark—were to be approached for loans of primitivist objects, such as masks and ritual totems. The exhibition also included photographic experiments by Man Ray, Dora Maar and Len Lye, and photography and film became important tools to record the events that took place at the exhibition: documentary evidence of the exhibition as it unfolded, some of which became emblematic (Legge's performance, especially; see Figure 5.1), was important not just for intellectual reasons, but also to improve visitor numbers. Critics continued to bemoan such distractions—'accessories for presentation' as one reviewer of the 'International Exhibition of Surrealism' in Paris in 1938 described

[22] Ibid., 7.
[23] Kevin Brazil, 'Histories of the Future: The Institute of Contemporary Arts and the Reconstruction of Modernism in Post-War Britain', *Modernism/modernity*, 23, 1 (January 2016): 193–217; 195.

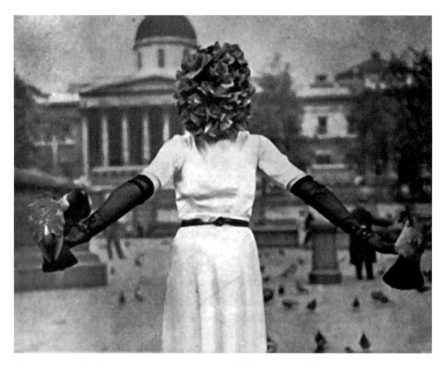

Figure 5.1. Sheila Legge, International Surrealist Exhibition, 1936 (with permission from Tate Gallery Archive)

them.[24] Shifting art into the background, or at least sublimating the experience of viewing painting through immersive involvement in performance, served the dual purpose of disturbing the dynamics of spectatorship.

If the exhibition benefited from the presence of Mesens and a nascent ideological exhibition practice that had grown up on the continent, it also inherited equally from the Postimpressionist events of 1910 and 1912, and Fry's creation of a new public discourse about art. In Chapter 1, I explored some of the legacies of the Grafton Galleries shows and, more concretely, some of the ways in which Fry's exhibitions of modern art in 1910 and 1912 conditioned a new set of responses to advanced art in the public domain. Postimpressionism, for Fry and for the promoters of its aesthetic experiments in Britain, represented an egalitarian, democratic ideal whose social energies might be harnessed for public good. It also raised art to the level of sacred object in the process, its perturbations and reverberations to

[24] François Fosca, 'Les arts: La duperie du surrealism', *Je suis partout*, 375 (28 January 1938): 9–11; 10.

be felt at a deep, existential level rather than appealing simply to the more superficial aesthetic sense. If such art might serve a social function, it also helped to marketise modernism in Britain, fostering a coterie or subcultural desire for its products, and for decorative avant-garde work more broadly, most notably in the designs of the Omega Workshops and the Charleston style, but eventually a consumer demand for a broad concept of 'modern' decoration and design that included Art Deco, Streamline Moderne and Scandinavian styles. I recall these legacies of Postimpressionism because, at first glance, the sanctification of modernist art performed by Fry, and the attendant creation of an elite lifestyle attractive to consumers of modern art, seems antithetical to the kind of work being done by Surrealism. Not just governed by an expressly non-hierarchical aesthetics, Surrealist work was very active in undermining the special nature of the art object, shocking viewers in its reappropriation of the quotidian and its attacks on the moral, and indeed the tasteful, dimensions of art. Yet while there was an undeniably destructive tendency in Surrealist work, its social and political goals are clearly demonstrable. Revolutionary in a way more authentically Marxist than any other avant-garde movement of the early 20th century, Surrealism's connection with its social milieu was everywhere emphasised in the theory and practice of its artists and supporters. In Britain, the work of writers and critics such as Read, Roland Penrose and Julian Trevelyan—along with those such as Charles Madge and Humphrey Jennings whose Surrealist roots would shape the social work done by Mass-Observation—always tied the aesthetic practices of the movement to possibilities for social change and renewal. Socially committed to a programme of change through art, in ways that Fry could not possibly have imagined, Surrealism's desire to elicit transformations in the real world was demonstrated not just in its visual art and its various treatises and expositions, but also in its institutional practices.

Read's indebtedness to Fry goes beyond the latter's creation of the role of public promoter of modernist art. Though markedly different in background, personality and indeed taste, Fry and Read shared a common view that modernist art possessed a democratising potential that could be made manifest by the right promotion and discussion. Read, like Fry, was not just an able critic of modernism, but a mediator for its publics, and—despite a loftier academic profile than Fry—was ill at ease in academia. Inheriting Fry's zeal for able, informed and varied dialogue about modern art (quite literally, in that he took over editorship of the *Burlington Magazine* in 1933, the year before Fry's death), Read admired his forebear's ability to translate difficult visual aesthetics into understandable

prose filled with formal and stylistic analysis. 'Fry was the first critic in the country', he wrote in his obituary of Fry in 1934, 'to use the method of formal analysis [...], the first to make it a popular method of exposition.'[25] Read, too, was acutely aware that his own position depended on the trail-blazing activity of Fry as a promoter and mediator of the arts. But if Read inherited Fry's position as perhaps the most influential critic of modern art in Britain during the 1930s, he also found himself and the movement that he spearheaded accused of the same kind of disconnect between the art he was promoting and the quotidian life of the British public. If Fry's parable of aesthetic disinterestedness was misunderstood as a circumven-tion or evasion of the everyday, or as slavish idolatry of the continental over the British, Read and the organisers of the 1936 Surrealist show were to be accused of the same intellectual abdication of social responsibility. Read (and others) attempted to combat these accusations in two ways— by stressing the connections between non-representational art and social change more theoretically through leftist philosophy and by attempting to embed Surrealism more firmly within English culture through recourse to national traditions.

Read's 'English' interests have been explored by a number of crit-ics. Mark Cheetham has situated Read in a lineage of English art writers obsessed by ideas of nation and race: 'as definitively as Hogarth in the eighteenth century [...] or his intellectual mentor Ruskin in the nineteenth, Read personifies [Englishness in art criticism]'.[26] Yet Read has also been characterised as the archetypal international critic, divorced from his own countrymen by his love of foreign intellectual and artistic culture, and dismissive of the tastes of his own nation. In an article that appeared in 1935, goadingly called 'Why the English Have no Taste', Read argued that British peevishness and incredulity in front of new art was a form of defence mechanism, a repressive attempt to avoid issues of sex or death and to preserve 'normality' at all costs. The unartistic attitude of the British he attributed to its post-Renaissance traditions of Puritanism and mercantile capitalism, which combined to cause 'a death of the spirit'.[27] Yet Read quickly realised that success for Surrealism in Britain could only come about by an animated discussion of why the movement was authentically

[25] Quoted in George Woodcock, *Herbert Read: The Stream and the Source* (London: Black Rose Books, 2008), 150.

[26] Mark A. Cheetham, *Artwriting, Nation and Cosmopolitanism in Britain: The 'Englishness' of Art Theory since the Eighteenth Century* (Farnham: Ashgate, 2012), 92.

[27] Herbert Read, 'Why the English Have no Taste', *Minotaure*, 7 (1935): 67–8.

English, and he believed fervently that only by jolting the British public from its capitalist slumber—through avant-garde art—could this 'death of the spirit' be reversed. Read connected British Surrealism to a revolution in thought through a series of rhetorical steps that joined the movement's social commitment to its philosophical and aesthetic principles of shock, disgust and surprise. Yet proving the social and political grounds for the movement was more difficult in Britain.

Though Read would try to establish the connections between Surrealism and communism from the outset of the movement's activities in Britain, the subjective and introspective nature of the art and the much more pronounced absence of communism from daily political life in Britain mean that such claims were difficult to authenticate. His speech at the opening of the exhibition, later published in its entirety in the *International Surrealist Bulletin*, made the claim that the Surrealist artist was 'naturally a Marxian Socialist', and that 'The Surrealist is profoundly conscious of that lack of organic connection between art and society which is characteristic of the modern world. He sees that fundamentally the fault lies in the economic structure of society. He is therefore revolutionary, but not merely in matters of art.'[28]

This was simply not the impression that many commentators took from the event. The political background to British Surrealism was not at all as pronounced as it was in continental Europe. Certainly, British Surrealists were without exception left-wing intellectuals, and in the months after the International Exhibition in London the leaders of the movement in Britain were condemning the government for their policy of non-intervention in Spain. In the 'Declaration on Spain', which appeared in *Contemporary Poetry and Prose* in late 1936, the group agitated for a more committed national response to fascism, and at home they demonstrated against Oswald Mosley and the Blackshirts. Commentators have also worked to outline the radical politics of the members of the movement through the periodical culture that grew up around it in the 1930s, particularly in leftist periodicals such as *Axis* (edited by Myfanwy Evans, later Piper), *Experiment* and the earliest work of Cyril Connolly's *Horizon*. Yet the group's commitment to a particular political strategy was never forthcoming. They were criticised in the *Left Review* for their bourgeois intellectualism—Anthony Blunt wrote that they were too focused on interiority and the subconscious to effect any social change

[28] Quoted in Remy, *Surrealism*, 79.

and A. L. Lloyd wrote that chance and play in art and writing would never 'make the proletariat conscious of its social and revolutionary responsibilities'.[29] Critics refused to see the potential of the movement to effect any real world change, and its proponents—perhaps expecting to be accused of quackery—were accused of undermining modernism's social project of rational critique. Some, like Wyndham Lewis, found Surrealism's introspective gaze trite, childlike in its wonder at the libidinal urges of the unconscious, and aesthetically moribund: 'the subconscious is ransacked to provide the super-realist with an alibi to paint like a Pompier'.[30] For Lewis, the utopian potential found in the libidinal unconscious by Surrealism was never more than a smokescreen, or a capitulation to the subjective. A retreat into the recesses of the mind could never be emancipatory in a socially productive way. Public-minded mediators of modernist activity in Britain likewise found Surrealism to be an anarchic retreat into subjective indulgence. Frank Pick, so heavily involved in the dissemination of modernist design and craft through his activities with the DIA and with the London Underground, found in Surrealism the dashed hopes of socially progressive art. The Surrealists he said, in a talk given to the students of the Royal College of Art in February 1937, were 'untutored' and 'unaided' and concerned only with 'shut[ting] themselves up in their minds', the antithesis of his own view of the value of art, which was 'the enlargement of the province of reason'.[31] Pick's retreat away from modernist art in the late 1930s was, according to Michael Saler, at least partially due to his mounting frustrations about self-indulgent irrationality of Surrealism—'surrealism was to become Pick's bête noire, representing all his fears about the irrational, anarchic potential of the new art'.[32]

To counter such accusations, many of the movement's leaders made stronger claims for Surrealism's power to incite revolutionary thinking, if not to actually be revolutionary itself. Roger Roughton declared in September 1936 that 'surrealist work, while not calling directly for revolutionary intervention, can be classed as revolutionary insofar as it can break down irrational bourgeois-taught prejudices, thus preparing mental ground

[29] Anthony Blunt, 'Surrealism', *Left Review*, 2, 10 (July 1936): iv–vi; A. L. Lloyd, 'Surrealism and Revolutions', *Left Review*, 2, 16 (January 1937): 895–8; 897.

[30] Wyndham Lewis, 'Super-Nature versus Super-Real', in *Wyndham Lewis The Artist: From 'Blast' to Burlington House* (New York: Haskell House, 1939), 54.

[31] Frank Pick, 'The Creative Purpose Leading up to Art and Industry' (13 February 1937), 2, London Transport Museum Archive, B39.

[32] Michael T. Saler, *The Avant-Garde in Interwar England: Medieval Modernism and the London Underground* (New York: Oxford University Press, 1999), 149.

for positive revolutionary thought and action'.[33] For Read, Surrealism's power as a transformational aesthetics lay not merely in its social commitment but in the way it might expose the unconscious energies and the sublimations and rationalisations of everyday materialist existence. Read fully embraced the connection between Surrealist mining for psychoanalytical material and the social change that might be achieved by so doing. It was never the case that the Surrealists were just tillers of the id. For all their critics accused them of self-indulgent fantasy, their attacks on bourgeois collective psychology were at bottom attacks on capitalism. Recent work has been done connecting the thought of radical left-wing thinkers such as Antonio Gramsci and Walter Benjamin with Surrealist philosophy. For E. San Juan Jr, Gramsci's theorisation of the artist's role in society has much in common with Surrealist pronouncements about the artist as agitator. San Juan Jr argues that the Surrealists, like Gramsci, 'believed that material conditions and the means of expression/communication are inseparable. Radically questioning the accepted modes of representation, they sought to express a coherent answer to nihilistic cant and the facile "progressivism" of business society witnessed in the cult of patriotism, family, religion, and material acquisitions.'[34]

For both, in other words, the artist should be concerned with externalising fantasies that will reveal the dialectical struggle between reactionary establishment and revolutionary vanguard. Gramsci argued that 'the artist does not write or paint — that is, he does not externalize his phantasms — just for his own recollection, to be able to relive the moment of creation. He is an artist only insofar as he externalizes, objectifies and historicizes his phantasms.'[35] The power of uncovered and unconscious phantasms to open up fault lines in dominant—Gramsci would say hegemonic—cultural patterns and expose their hidden capitalist structures clearly appealed to Read as a useful way to describe Surrealism to a British public.

Read was certainly not the first theorist to make the connection between Surrealism and radical political change, and his politicisation of the movement is clearly related to the theoretical work done by early critics of Surrealism, in particular Walter Benjamin. Benjamin's 1929 essay,

[33] Roger Roughton, 'Surrealism and Communism', *Contemporary Poetry and Prose*, 4 (August–September 1936): 74–5.

[34] E. San Juan Jr, 'Antonio Gramsci on Surrealism and the Avant Garde', *Journal of Aesthetic Education*, 37, 4 (Summer 2003): 31–45; 34.

[35] Antonio Gramsci, *Selections from the Cultural Writings*, trans. William Boelhower (Cambridge, MA: Harvard University Press, 1985), 112.

'Surrealism: the Last Snapshot of the European Intelligentsia', describes the connection between Surrealism's dialectical opposition to the rational and its attacks on bourgeois social practices. Surrealism's evocation of what Benjamin called 'profane illuminations', revelations about the world that, unlike those introspective ones offered by religious experience, do more to unpick the bonds of social and material reality, are central to its revolutionary message.[36] The apocalyptic ending of the essay stresses the potential for Surrealism to embrace the technological—elsewhere a pejorative term for Benjamin—to remake the body collective in its own terms:

> Only when in technology body and image so interpenetrate that all revolutionary tension becomes bodily collective innervation, and all the bodily innervations of the collective become revolutionary discharge, has reality transcended itself to the extent demanded by the *Communist Manifesto*. For the moment, only the Surrealists have understood its present commands. They exchange, to a man, the play of human features for the face of an alarm clock that in each minute rings for sixty seconds.[37]

Several critics have pointed towards the anarchist tone of Benjamin's essay, and Read's later anarchist writings would take on some of Benjamin's millenarianism.[38] In *Art and Society*, he wrote that 'we have reached a certain crisis in the development of our civilisation in which the real nature of art is in danger of being obscured; and art itself is dying of misuse'.[39] To counteract this obscurity, art had to embrace the technological world in which it found itself and—much as Benjamin suggested in his essay on Surrealism—slacken the ties of capitalist economy from within. In his 1943 book, *The Politics of the Unpolitical*, Read would find renewal in the destructive power of the war. Like Benjamin, he would assert that 'the whole of our capitalist culture is one immense veneer: refinement hiding the cheapness and shoddiness at the heart of things. To hell with such a culture! [...] When Hitler has finished bombing our cities, let the demolition squads complete the good work.'[40] In addition to this work on Surrealism's potential to tear asunder capitalist culture, Read also realised that there was

[36] Walter Benjamin, *Selected Writings*, 4 vols, vol. 2, ed. Howard Eiland and Michael W. Jennings (Cambridge, MA, and London: Harvard University Press, 1991–9), 212.

[37] Ibid., 217–18. More has been written on Benjamin's importance as a critic of Surrealism. See, for instance, Margaret Cohen, *Profane Illumination: Walter Benjamin and the Paris of Surrealist Revolution* (Berkeley and Los Angeles: University of California Press, 1993).

[38] See, for instance, Michael Löwy, 'Revolution against Progress: Walter Benjamin's Romantic Anarchism', *New Left Review*, 152 (July–August 1985): 42–59.

[39] Herbert Read, *Art and Society* (London: Faber and Faber, 1967 [1936]), 2.

[40] Herbert Read, *The Politics of the Unpolitical* (London: Routledge, 1943), 66.

something recuperative in the movement's aesthetics. His understanding of the psychological impulse in art, so visible in his promotion of Surrealism, broadened during the 1930s and 1940s to encompass not only the work of a number of analysts (Freud, Jung and Adler in particular), but also to develop connections between the individual, unconscious drive to art and the collective power of such art—what he would call in *Art and Society* the 'social function of the artist'.[41] In that book, he wrote that though 'the work of art [...] has its immediate origin in the consciousness of an individual, it only acquires its full significance, however, to the extent that it is integrated with the general culture of a people or period'.[42] It approaches this integration, if it is good art, because the artist's unconscious is congruent with a much wider collective one: 'at that level we suppose the mind to be collective in its representations, and it is because the artist can give visible shape to these invisible fantasms that he has power to move us deeply'.[43] The Jungian inflection here is hard to miss: for Read, the symbolic interpretation of works of art and literature that Jung's theories about collective unconscious offer proved fertile for his interpretation of Surrealism as an individual and social liberation. Writing in *Art and Society*, Read argued that 'art is not merely irrationality; it is rather the interpenetration of reason and unreason, a dialectical counterplay, a logical progression whose end is a transformed world'.[44]

The British Surrealists, in different ways, would also attempt to show that the movement was relevant in Britain not just because it critiqued the current status quo, but that it was quintessentially British in the first place. If accusations of late Romanticism undermined the British Surrealism's national relevance, Read, Gascoyne, Madge and Jennings each attempted to authorise the movement in traditions of English thought and art. From the beginning there was significant effort by the leading Surrealist figures in Britain to establish a national lineage for the movement. Gascoyne's very early '*Premier Manifeste anglais du surréalisme*', published in 1935 after his early discussions about a British exhibition in Pairs with Breton, Éluard and Penrose, refused the idea that Surrealism would be an '*apport exotique*', but would rather embrace an English tradition of satire and whimsy. In that manifesto, he found continuities between Surrealism the works of Jonathan Swift, Edward Yonge, William Blake and Lewis Carroll, and

[41] Read, *Art and Society*, 95.
[42] Ibid., 83.
[43] Ibid., 95.
[44] Ibid., 121.

though he proclaimed complete affinity with the manifestoes of Breton, he found in contemporary English life—in particular, the forthcoming Silver Jubilee celebrations of George V and the capitalist press frenzy whipped up around it—a breach where a truly native Surrealist movement might take root. Likewise, for Herbert Read, in his lecture at the exhibition, the mining of the English literary past for Surrealist antecedents offered an opportunity to situate the movement in British revolutionary thinking more broadly. Defending the movement against accusations of 'foreignness', and annexing contemporary avant-garde movements in England as at least sympathetic to surrealism, Read said that:

> On the contrary, the general character of the English imagination has been very much in the direction of surrealism, and there have been many individuals in the post-war period who have not allowed themselves to be diverted from the problems handed down to us *historically* by the nineteenth century: problems the solution of which inevitably takes us very near surrealism. But such individuals until now have remained individuals. They have only known one another slightly, if at all, and have never attempted to consolidate a general position to be held and advanced in common.[45]

As a side note, Read's bigger claim here was that it was in artistic collectivism—the shared activities of an avant-garde held together despite their aesthetic differences by the common goal of social change—that was the important political principle. By stressing the common goals of avant-garde activity in Britain, a dialectical antagonism to the establishment and to capitalist and consumerist culture and a rejection of a narrow morality of art, Read was of course co-opting a range of diverse artists and movements for his own purpose. If the homogenisation was problematic (if not entirely impossible), by collapsing a wide range of aesthetic styles and political sentiments into the vague category of 'opposition', Read was attempting to synthesise the value of difficult art in producing social good. It is in collaboration across communities of art, Read argued, where social change might actually be effected. Indeed, in the same talk, he went on to blame individual thinking, a product of a national capitalism 'older than any other, more highly organized, more deeply rooted in our national life', for the tendency of artist to work as individuals. By this, Read meant that the demands placed on artists to succeed aesthetically and financially are more clearly driven by the consumer-driven demands of the gallery and the marketplace here than on the continent, and that this tendency towards

[45] Quoted in J. H. Matthews, 'Surrealism in England', *Comparative Literature Studies*, 1, 1 (1964): 55–72; 58.

individual achievement and distinction had stunted the growth of collectivism in British art culture.

Some critics—Michel Remy and J. H. Matthews included—have stressed that this annexation of literary and artistic traditions for the purpose of authenticating the movement is a regressive and defensive step, and as we have seen, many of the British contributors to the exhibition felt likewise. However, if we read into this move a desire not to legitimise, or even sanitise, the revolutionary energy of Surrealism but rather a kind of pedagogical attempt to make sense of the movement's social purpose for a reactionary British press and public, then Read's purpose is directed less at appeasing critics and the public than towards refiguring the social potential of the movement for Britain. One of the key legacies of the exhibition was not simply the establishment of international Surrealism within the public consciousness, but the birth of an authentic, home-grown avant-garde committed not only to the foundation of a British movement that distinguished itself aesthetically from the Parisian Surrealist scene, but one that would most strongly antagonise the British public and arts establishment. Early attempts to cement Surrealism's place as a home-grown avant-garde included Charles Madge's essay 'Surrealism for the British', which appeared in a special issue of *New Verse* dedicated to the movement. This was written to coincide with an exhibition held at the Mayor Gallery in April 1933, which included work by Miró, Picabia, Arp and Klee alongside the work of British artists such as Paul Nash and Henry Moore. In that essay, Madge claimed that a true British Surrealism would interrogate the quotidian quirks, the sublimations, the idiosyncrasies of the native public, rather than indulge in simple apery. Acknowledging the age of the movement already, Madge suggested that an understanding of the social and cultural situation in Britain—'a remedying of our own ignorance'—was necessary 'before exposing ourselves to a ten-years-belated imitation of Paris'.[46] Success for Surrealism in Britain would not be the result of any transplantation or importation but rather spontaneous growth from the conditions of everyday life at home—the essay stressed that British Surrealists 'should rather imitate their example in the motives and fundamental methods of their working, than the works themselves'.[47]

Indeed, Madge's focus on the peculiarities and strangenesses of British customs and manners in this essay, and on the way in which only a Surrealist eye could penetrate the individual and collective unconscious that produced

[46] Charles Madge, 'Surrealism for the English', *New Verse*, 6 (December 1933): 14–16; 14.
[47] Ibid.

them, was to be reprised just a few years later in the statement that Madge made—along with Jennings and Tom Harrisson—to introduce the activities of Mass-Observation. There, they wrote that though many of the objects of their study would be of physical behaviour—the public at work and play—'other inquiries involve mental phenomena which are unconscious or repressed, so that they can only be traced through mass-fantasy and symbolism as developed and exploited, for example, in the daily press'.[48] The Surrealist nature of the glance at the British people's everyday lives is captured in the list of some of the targets the authors assume they will be studying, which includes 'the shouts and gestures of motorists', 'Funerals and Undertakers', 'Distribution, diffusion and significance of the dirty joke' and the 'anthropology of football pools'.[49] This Surrealist glance at everyday Britain—the decoding and unravelling of the collective uncon-scious through exploration of conversations at the butcher's shop, chants on the stands of a football match and the daily ablutions of the popu-lace—was a significant outgrowth from Read's theories about the power of institutions of art to shape and effect social change. British Surrealism also strongly influenced the documentary work that established itself in the 1930s and continued to develop during the post-war years. The relation-ship between modernist aesthetics and the documentary genre has been well explored, with Tyrus Miller claiming that it is only by juxtaposing modernism and documentary film-making that 'the mixtures of radical montage, reportage, state- or commercially orientated advertising, and surrealist defamiliarization in the documentary works of John Grierson's film-making team and the texts of Mass-Observation reveal their underly-ing coherence'.[50] Indeed, Miller finds overlap between the activities of Madge, Gascoyne and Jennings in their written, documentary reports produced for Mass-Observation and their contemporaneous experiments in Surrealist film-making and prose-poetry. British Surrealism played an important role in the institutional enshrinement of modernism as a peda-gogic concept.

However, for Read, as for other early theorists of the British movement such as Hugh Sykes Davies, Nash and Jennings, the fashioning of an English or British Surrealism was not just about conglomerating philosophical and

[48] Tom Harrisson, Humphrey Jennings and Charles Madge, 'Anthropology at Home', *New Statesman and Nation* (30 January 1937): 155.
[49] Ibid.
[50] Tyrus Miller, 'Documentary/Modernism: Convergence and Complementarity in the 1930s', *Modernism/modernity*, 9, 2 (April 2002): 226–41; 226.

aesthetic principles drawn from multiple continental traditions, but rather the establishment of a Surrealist spirit within an explicitly British artistic tradition. Paring off a native Surrealist aesthetic from much more established, politically engaged and philosophically assured European traditions meant identifying what it was that made Surrealist culture idiosyncratically British. One of the ways in which Read and others sought to do this was by connecting Surrealist experimentation by native artists to other British artistic styles, demonstrating that it was as much an outgrowth of a *genius loci* or a national literary and artistic spirit. Read did this by stressing the continuities with English Romanticism. Surrealism's connection with Romanticism was used pejoratively for much of the 1930s (for *The Scotsman*, for example, the International Surrealist Exhibition was 'Romanticism Run Riot'.)[51] More recent criticism has also reinforced the connection: Surrealism was 'the prehensile tail of Romanticism'.[52] For Michel Remy, the attempts to find common ground with Romanticism were abortive, 'exhausting the meaning of surrealism'.[53] The lists of Surrealist forebears compiled by Read and Davies certainly do little to distance the movement from 19th-century baggage. But there is, however, a serious attempt here not simply to give Surrealism a tradition, but to help explain its aims through comparison with other writers and artists who were dialectically opposed to the establishment in Britain. The writers and artists lauded by Read share little in their styles, genres or even political philosophy, but they are in one way or another oppositional writers, a fact that Read tried to explain in his introductory essay in *Surrealism*. The British Romantics—a consistent object of study for Read, who wrote studies of Wordsworth and Shelley and a first book of literary criticism, *Reason and Romanticism* (1926)—were natural bedfellows with the Surrealists, given their shared introspectiveness, their belief in the revelatory power of intoxication and their obvious social commitment. Read's literary criticism also celebrated the Romanticist world view, championing poets and artists whose work was directed towards the dialectical relationship between inner and outer worlds. In 'In Defence of Shelley' (1936), Read took aim at T. S. Eliot's denigration of the poet, accusing him of 'irrelevant prejudice' in his 'definite ethical and theological standpoint'.[54]

[51] *The Scotsman* (13 June 1936): 17.

[52] C. W. E. Bigsby, 'Surrealism', in Roger Fowler (ed.), *A Dictionary of Modern Critical Terms* (London: Routledge and Kegan Paul, 1973): 187.

[53] Remy, *Surrealism*, 97.

[54] Herbert Read, 'In Defence of Shelley', in *In Defence of Shelley and other Essays* (London: Heinemann, 1936), 71.

Celebrating Shelley's hallucinatory writing, his interest in incest and his dense, overwrought subjectivity, Read staked out a claim for Shelley as a progenitor-Surrealist, exposing collective fault lines through the free-play of the unconscious: indeed, the sensitive critic of Shelley would be able to trace 'the origins of the work of art in the psychology of the individual and in the economic structure of society'.[55] In *Art and Society*, Read also wrote that it 'would be possible to show how closely the romantic theory of poetry, as elaborated by a great critic like Coleridge [...] corresponds to the theory of surrealism'.[56] He was, in short, firm in his conviction that Surrealism was the last Romantic movement—not simply the successor to British Enlightenment thinking or *fin de siècle* aestheticism but rather *the* movement to forever assert the supremacy of the subjective impulse and liberate the individual from absolutes and ideals. In *The Philosophy of Art* (1954), Read would go so far as to say that Surrealism had sounded the death knell for classicism:

> So long as romanticism and classicism were considered as alternative atti-
> tudes, rival camps, professions of *faith*, an interminable struggle was in pros-
> pect, with the critics as profiteers. But what in effect surrealism claims to do is
> to resolve the conflict [...] by liquidating classicism, by showing its complete
> irrelevance, its anaesthetic effect, its contradiction of the creative impulse.[57]

Read's later championing of a number of artists who are perhaps best described as para-surrealists, Henry Moore, Ben Nicholson and Barbara Hepworth in particular, would connect them with this notion of the 'complete' aesthetic in Surrealism. He theorised on Moore's work a lot: in his later book *The Art of Sculpture* (1956) he would find in Moore's sculpture the synthesis of classical and romantic impulses and an afterlife to the Surrealist philosophy. Undoubtedly, the efforts undertaken by Read and Madge to fully authenticate Surrealism as a 'British' aesthetic—or one at least with important things to say to the British public—meant that they were more fully able to justify the movement's presence in Britain than Fry was able to do with Postimpressionism.

The legacies of the show in 1936 also lie in institutional developments after the end of the war, and it is towards these the remaining part of this chapter will turn. The post-history of the event reveals the ways in which Surrealism—and modernism more broadly—became the subject of a debate

[55] Ibid., 71.
[56] Read, *Art and Society*, 124.
[57] Herbert Read, *The Philosophy of Modern Art* (London: Faber and Faber, 1954), 74.

around the ownership of the spirit of modernism in Britain, which included new institutions such as the ICA, the state and international actors. What resulted in Britain was what Kevin Brazil calls 'a tangled postwar ecology of cultural institutions'.[58] The future of the modernist project was at stake, and Read was at the centre of the attempts to keep the socially ameliorative aspects of modernist art alive and well. Read's essays near the end of the war expressed an almost millenarian attitude to existing cultural standards: modern art would be the tool for social change after the end of hostilities. In 'The Threshold of a New Age', written close to the end of the war, he wrote with fervent belief that 'individuals in whom the spirit of modernism is embodied still survive, still work, still create [...] When the cloud of war has passed, they will re-emerge eager to rebuild the shattered world.'[59] There were threats, though, particularly in the form of state involvement and the increased marketisation of modern art after the end of the war. Read expressed, in typically anarchist terms, hesitation at the drawing together of art, market and state, and concern about what we might now recognise as a nascent cultural tourism. In 1961, in a proposal for a festival of contemporary art, Read distinguished between the 'pilgrimage of grace' he felt that art deserved and an 'undisciplined scramble' for consumable culture.[60]

The founding of the ICA in 1946 is an excellent example of the way in which modernist artistic, curatorial and educational practice shaped a group committed to national change, and one that demonstrates the conflicted nature of modernist art institutions after the war. The ICA, for Nannette Aldred, self-identified 'as a space dedicated to the professional development of the artist working in postwar Britain'.[61] Kevin Brazil has also recently written persuasively about the ground-breaking interdisciplinarity of the ICA—it was 'one of the sites for the reconstruction of modernism as an interdisciplinary phenomenon'.[62] Socially committed from its inception, the ICA was involved in keeping the Surrealist project alive, and its formation from the embers of the Surrealist movement, by Read and Penrose, was an attempt to really integrate innovative artistic practice into

[58] Brazil, 'Histories of the Future', 194.
[59] Herbert Read, 'Threshold of a New Age', in J. R. R. Brumwell (ed.), *This Changing World* (London: Readers Union, 1945), 12.
[60] Quoted in Nannette Aldred, 'Art in Postwar Britain', in Alistair Davies and Alan Sinfield (eds), *British Culture of the Postwar: An Introduction to Literature and Society, 1945–1999* (London: Routledge, 2000), 146–69; 152.
[61] Ibid., 146.
[62] Brazil, 'Histories of the Future': 197.

everyday life. One of the ways in which this social commitment manifested itself was in the promotion of modernist sculptural aesthetics in public construction after the end of the war. Sculpture's connection to Surrealism has been ill explored. As early as 1930, before Surrealism had really arrived in Britain, Rupert Lee organised an exhibition of modernist sculpture on the roof gardens of Selfridges in Oxford Street, with the dual aims of convincing the public that sculpture would have an important role to play in future imaginations of social space and showing off the work of London Group contemporaries soon to be affiliated with Surrealism, such as Henry Moore. Lee's prescience about the Brutalist philosophy that was to overtake the design of British public space is unnerving:

> It is worth noticing that as yet although concrete is the main building material of the day, architects have not begun to use it as such. [...] I can foresee a time when architects of imagination will not be afraid to design concrete buildings which look like concrete buildings. Then the new opportunity for the sculptor will come.[63]

In one of the first entanglements of modernist sculpture and the market, Lee's exhibition drew criticism for its celebration of a sculptural aesthetics at odds with public understanding. Read's own later championing of Moore's work—and his opportunistic incorporation of Moore as an artist with Surrealist affinities—also focused on the power of non-representational sculpture to transform social space, and the ICA's focus on sculptural aesthetics also helped to cement Surrealism—and other non-representational styles—in public spaces. In important ways, this devotion to the transformation of public space through large-scale stone installations—and the relationship between sculptural forms and the building material of choice for post-war reconstruction, concrete—built upon the foundation of Surrealist interest in the form. Building on the public successes of Henry Moore and Barbara Hepworth, sculpture became a topic of more widespread public debate in the years after the war: partly because large parts of metropolitan space needed to be rebuilt, the topic excited individual, collective and state comment. In the capital, the LCC organised debates to consider the role of sculpture in these new spaces. The ICA, despite its penury, held a competition in 1951 to erect a monument to 'The Unknown Political Prisoner'. In some ways, this competition exposed some of the fraught and complex negotiations between individual taste-makers, quasi-governmental organisations

[63] Rupert Lee, 'How to Appreciate Sculpture' [typescript for lecture, 1930], quoted in Wilcox, *Rupert Lee*, 95.

and state actors that began to shape the legacy of modernism in Britain. Read was already inured against the entanglement of state and art, and his post-war anarchist essays betray a deep concern with the financialisation of the arts. He was also deeply suspicious of the institutionalisation of modernism that took place after the Surrealist moment in Britain. One of the legacies he wished to secure for Surrealism in Britain was the establishment of the ICA as a 'microcosm of a modern, anarchistic society'.[64] This role for the ICA was complicated, however, by the activities of its increasingly active promotional and public outreach work, and the undermining of any organically anarchist principles by bureaucratisation and complicity with the state (or states). Read wrote mournfully of these stirrings in the ICA:

> If you sup with the devil you must use a long spoon. [The] scheme involves, as a preliminary, securing royal patronage. [...] He also hints that of course our policy will not have to be too offensive to such people. [...] I am very sceptical—indeed, I see the beginning of the end for any ideals I ever had for the ICA [...] I do not believe that we could possibly maintain any degree of independence if we become a charitable dependency of Big Business.[65]

By 1951, Read was also far more suspicious of the nefarious uses of public sculpture than a utopian Rupert Lee could have been in 1930, having seen the way in which both fascist and communist movements across Europe had utilised the form. Yet it is easy to see how such a monument might have appealed to the Surrealist art critic who had seen the worst excesses of political organisation and abandoned communism for anarchism. Even though he was conflicted about involvement, he and Moore formed part of a Central Committee, and lent an artistic authenticity to what was a difficult exercise in international relations.[66] The winner of the competition, which attracted over 3,000 entries, was Reg Butler, whose modernist design created political and public tensions, including a protest by forty MPs. His maquette—the actual design was never completed—was certainly not Surrealist in design, but Butler's piece was provocative and its political content hard to ignore. The proposed installation, too, of the sculpture in British-occupied Berlin meant that the political implications of the piece became doubly explicit, looking over Soviet-occupied territory perched atop the last outpost of democracy in Eastern Europe. Read and Penrose were both uncomfortable

[64] Quoted in Remy, *Surrealism*, 146.

[65] Herbert Read letter to Philip James, Art Director of the Arts Council (21 January 1951), AAC: Arts Council Archive.

[66] See Robert Burstow's article on the subject: 'The Limits of Modernist Art as a "Weapon of the Cold War": Reassessing the Unknown Patron of the Monument to the Unknown Political Prisoner', *Oxford Art Journal*, 20, 1 (1997): 68–80.

with the overt political statement, and the design seemed destined to further sully cultural ties between East and West. The financial backers eventually pulled out, for the nominal reason that 'the Butler sculpture was too ultra modern', but the story has a much more sinister hinterland and, as Robert Burstow has demonstrated, the commissioning and patronage operation that lay behind the monument to 'The Unknown Political Prisoner' betrays the politicisation of modernist art that had started to take shape after the war.[67] The funding for the erection on the monument came from John Hay Whitney, a collector of impeccable modernist credentials and a prominent financial and public supporter of the Museum of Modern Art in New York, yet his connections with the Central Intelligence Agency (CIA), and with the ICA's Director of Public Relations, Anthony J. T. Kloman, betray a murkier history to the project, one that Burstow retells at length, revealing some of the competing claims made on modernist art after the war. The infiltration of the CIA in artistic affairs—most notably its role in the Congress for Cultural Freedom, but also its funding of major exhibitions of American Abstract Expressionism—has been well documented.[68] A multitude of reasons lie behind these repeated infiltrations into the arts, ranging from a desire to project a sophisticated cultural face to the eastern side of the Iron Curtain, the promotion of a home-grown American art and an attack designed to win cultural supremacy. Moreover, the CIA's leadership was far more liberal and educated than might be expected in the early years of the Cold War, with intellectuals and well-educated academics in senior posts, in stark contrast with the rabid anti-left agenda of the Federal Bureau of Investigation. The involvement, mostly unwitting on their part, of non-United States arts institutions was an important part of the CIA's scheme to colonise modernism for the West, and although the CIA's interest in European modernism was perhaps short lived and fleeting, it demonstrates the complexity of vested interests in modernist art and design in the West in the years after the war. It also demonstrates the extent of state, or multi-state, involvement in the ICA during its early years.

The ICA's conflicted politics aside, it is clear that it was the most visible institutional result of Surrealism's activity in Britain. Its programme

[67] Letter from Anthony J. T. Kloman to John Hay Whitney (4 October 1954), J. H. Whitney papers, New York.
[68] See Frances Stonor Saunders, *Who Paid the Piper? The CIA and the Cultural Cold War* (London: Granta, 2000); Christian G. Appy (ed.), *Cold War Constructions: The Political Culture of United States Imperialism, 1945–1966* (Amherst: University of Massachusetts Press, 2000); Hugh Wilford, *The Mighty Wurlitzer: How the CIA Played America* (Cambridge, MA, and London: Harvard University Press, 2008).

of exhibitions in the 1940s and 1950s foregrounded the significance of the European avant-garde and saw modernism as a perpetual unfolding of artistic experimentation, dialectically arranged to challenge existing cultural norms and standards. It is perhaps unfair to characterise the ICA as a knowing participant in state agendas and as an instigator and promoter of a new kind of elite culture industry in the 1940s and 1950s, and certainly its existence as a space of free development for artists since the 1950s has fostered movements such as the Independent Group and nurtured the careers of Eduardo Paolozzi, Richard Hamilton, Francis Bacon and Damien Hirst. Indeed, while these later groups and individuals did not necessarily share the same enthusiasm for modernism's project as Herbert Read and Roland Penrose, they embraced their vision of what the ICA should stand for more completely than their state-conflicted predecessors in the early years of the institution. Nannette Aldred rightfully claims that the ICA continues to offer an institutional space that is 'the "other" to dominant British Culture'.[69] Like the other case studies in this book, the brief moment of artistic energy captured by British Surrealism in the years around 1936 had a long institutional and structural afterglow in the arts. Though somewhat interrupted by the outbreak of war in 1939, the post-war activities of Herbert Read and those other mediators of Surrealist artistic practice in Britain meant the continuing survival of artistic modernism in Britain and a deeper, institutional enshrinement in ways I discuss in the Conclusion.

[69] Aldred, 'Art in Postwar Britain', 164.

6

Conclusion: 'Half-baked if you like'—modernist afterlives in Britain, 1945–1951

Criticism has often tended to see modernism's social and pedagogical impulse burned out by 1945. In such a narrative, the huge social, welfare and economic changes that swept a war-weary, poverty-stricken Britain in the decade after hostilities meant a termination for the modernist enterprise, and the arts and cultural policy constructed by government overtook and bureaucratised some of the networks of patronage upon which modernism in Britain had depended. Undoubtedly, one facet of the term 'late modernism', conceptualised by Tyrus Miller but elaborated on by a host of critics in the last few decades, is the running aground of the modernist enterprise owing to the deaths, retirements or marginalisation of many of its key actors.[1] Moreover, Miller describes increasing doubt about the value of modernist aesthetics in the new world: he notes early in his study that many of the writers and critics he discusses—Djuna Barnes, Wyndham Lewis, Mina Loy and so on—exhibit 'a growing skepticism about modernist sensibility and craft as a means of managing the turbulent forces of the day'.[2] While undoubtedly a good description of the waning of modernism's revolutionary potential in British cultural life as the Second World War approached, this narrative presupposes modernist culture's continued

[1] Tyrus Miller's *Late Modernism: Politics, Fiction, and the Arts between the World Wars* (Irvine: University of California Press, 1999) is the point of origin of this term, but ensuing critical work has built on Miller's conceptualisation. See, for instance, Robert Genter, *Late Modernism: Art, Culture, and Politics in Cold War America* (Philadelphia: University of Pennsylvania Press, 2010), which argues persuasively for the ways in which modernism was assimilated in the years after the Second World War. Other works, such as J. M. Bernstein, *Against Voluptuous Bodies: Late Modernism and the Meaning of Painting* (Stanford, CA: Stanford University Press, 2006), find modernism 'comes almost to an abrupt halt, nearly bottoms out, all but ends' with abstract expressionism (2).

[2] Miller, *Late Modernism*, 22.

opposition to the mainstream and the middlebrow, and doesn't always do justice to the ways in which British artistic culture imbibed and appropriated, and was in turn shaped by, modernist practices. Specifically, the mediation of modernism by way of habituating audiences to its experimental aesthetics and delivering a message that an avant-garde, oppositional and challenging artistic culture has a role to play in everyday life meant that it achieved a quieter assimilation than many studies afford.

One of the stories this book has uncovered—through the use of discrete case studies charting some modernist moments and their after-effects—is that modernism's 'lateness' after the war is an artefact of its incorporation into the social and cultural life of Britain through institutions, initiatives and schemes, many of which persevere to this day. It is one of the larger claims of *Insane Acquaintances* that this assimilation happened not merely at an aesthetic level—that the art-going and reading public became inured to the techniques and forms of modernism—but also, and indeed because of, institutional frameworks (educational, market-based, policy-driven) that provided fora for experimental art practices. Undoubtedly, by 1945, Postimpressionism, Cubism, Futurism and even Surrealism had lost much of their shock value and, as we have seen, became enshrined in galleries, in public spaces, in the home and even in schools. The sheer volume of arts and cultural policy changes that occurred after 1945 went some way towards attaining the legacy that the individuals and groups discussed in this study wanted to secure for modern art in Britain. The years between the end of the Second World War in 1945 and the Festival of Britain in 1951 saw massive infrastructural changes to British cultural institutions and policy as part of the wider upheaval in government, town planning and urban renewal, and welfare that followed the Allied victory, and many studies have explored the ways in which social change and physical rebuilding projects went hand in hand with large-scale cultural projects, culminating in the events of the Festival of Britain.[3]

Complementing this forward-looking governmental policy was the establishment of several organisations and institutions that are, in the final analysis, the most visible socio-cultural legacy of modernist art in Britain. This study is filled with the creation of institutions and initiatives—some short lived and abortive, others still thriving today—that were a direct result of modernism's challenge to Britain. Postimpressionism, in my

[3] See especially Frank Mort, 'Fantasies of Metropolitan Life: Planning London in the 1940s', *Journal of British Studies*, 43 (January 2004): 120–51; Jim Fyrth (ed.), *Labour's Promised Land? Culture and Society in Labour Britain, 1945–1951* (London: Lawrence and Wishart, 1995).

reading here, is the first recognisably *British* artistic modernism: though its artists were almost universally continental, the conception of the term and its promotion resulted in the first critical debates in Britain of what work experimental, avant-garde art could do in the world. The legacy of the 1910 Grafton Galleries show (and subsequent shows) was a staunch defence of non-representational art on egalitarian and democratic grounds and a whole swathe of new exhibition and marketing strategies. That same moment also led to the creation of a new kind of exhibiting and collecting body—the CAS—which was committed to supporting a nascent British modernism by a regional and provincial exhibition culture. The activities of Marion Richardson in Dudley, and the subsequent marketing of contemporary art to schools, led slowly to educational policy changes that encouraged an arts-based education for its non-utilitarian cultural good, and began to dispel the moralistic and quasi-religious dimension to the study of art in schools. The revolution that took place in the marketing of a modernist interior to the British public led in a similar way to a newly envisaged outlook for the architecture of domestic life, and the formation of groups and committees to deliver new ways of living to the masses. Even the plans for the architectural revival of London—such as *The County of London Plan* (1943), the *Report of the Preliminary Draft Proposals for Post War Reconstruction in the City of London* (1944) and *The Greater London Plan* (1944)—contained within them the same kinds of ideas for housing the poor that we formulated by those modernist minds at work in the DIA, MARS and the Isokon project. In a similar vein, the inheritor organisations of the social and political vision of the Surrealists in Britain, such as the ICA, offered a future to a socially committed, oppositional, combative and challenging art.

Though each chapter here has been concerned with the piecemeal and fragmentary, the combined efforts of the mediators of modernism in Britain led, in the years after the war, to a consolidation of the exhibition, marketing and educational strategies spearheaded by them. It is worth dwelling on the activities of a few of these inheritor institutions because they show just how quickly some of the initiatives I have described here— that in some instances struggled to establish themselves in the 1910s, 1920s and 1930s—found fertile ground in post-war Britain. The Council of Industrial Design (COID), founded in 1944, is one of many examples of a new funding model for arts and design institutions that were inheritors of modernist activity in Britain in the 1920s and 1930s. Formed out of the need to continue the work of the DIA and CAI, COID was one of the first quasi-governmental organisations in Britain. Its executive board—which

included Kenneth Clark and least three members of the DIA—published a mission statement in their first annual report that makes many of the same claims that missives from the DIA and CAI had made decades earlier. The public needed to be taught the principles of good design and the importance of filling the home and the workspace with well-made goods. Familiar, too, was the old message of the DIA: that the impasse between designer and manufacturer resulted in each believing that the other thwarted their best efforts. The report laments the divide between the artist/designer and manufacturer, complaining that the '"artistic" plan, if it exists, is never realised in practice. Either it discredits its creator in the eyes of the manufacturer (not always without reason) as a long-haired dreamer, or it discredits, in the eyes of the artist and his teachers, the manufacturer who mangles it.'[4]

These perennial concerns aside, in other ways COID regarded itself as a more modern institution than the DIA or CAI. The first report includes a section devoted to 'Publicity and Propaganda', outlining a media campaign that would include coverage from the BBC, articles in both trade press and in 'popular feminine magazines', exposure in schools and public information films. Flagship exhibitions were also planned, the best known and most successful being the 'Britain Can Make It' exhibition—designed with these clear pedagogical purposes in mind—held at the Victoria and Albert Museum in South Kensington in late 1946.[5] An enormously successful show, with nearly one and a half million attendees, 'Britain Can Make It' represented the first post-war attempt to establish British design, rather than just manufacturing, as a potentially world-leading export. Moreover, its unified purpose—it was a tightly organised affair, with an inbuilt narrative of British technological and aesthetic superiority—and its pedagogy were clearly inherited from its modernist predecessors. Scripted with educative intent in mind, with an opening exhibit entitled 'What Industrial Design Means', the event was filled with cultural propaganda both to demonstrate that British design was at the leading edge and that the public could benefit from such innovation in their homes and places of work. There were sections of the exhibition devoted to the crafts—pottery,

[4] *The Council of Industrial Design, First Annual Report 1945–46* (London: HMSO, 1946), 10.
[5] For more information on this exhibition, see Patrick J. Maguire and Jonathan M. Woodham (eds), *Design and Cultural Politics in Postwar Britain: The Britain Can Make It Exhibition of 1946* (Leicester: Leicester University Press, 1997); Jonathan Woodham, 'Design and Everyday Life at the Britain Can Make It Exhibition, 1946', *Journal of Architecture*, 9, 4 (2004): 463–76; Matthew Hollow, 'Utopian Urges: Visions for Reconstruction in Britain, 1940–1950', *Planning Perspectives*, 27, 4 (2012): 569–86.

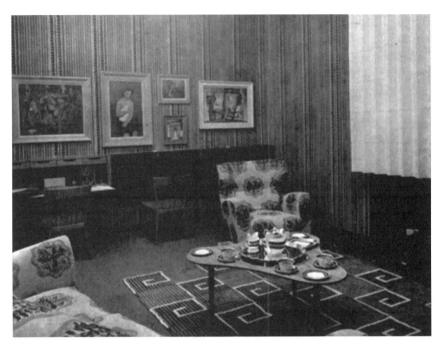

Figure 6.1. Furnished living room, 'Britain Can Make It', *Country Life* (4 October 1946): 681.

glass, soft furnishings—and others focused on specific milieux within the home, including a furnished rooms section, which was the most visited space.[6] Though by no means a modernist exhibition, the modernist and pedagogical inheritance of the event has not been attended to by criticism, and even a cursory glance at its exhibits and structure reveals modernist echoes. In similar ways to the Dorland Hall exhibition in 1933, and other displays of interior design in the pre-war years, 'Britain Can Make It' utilised modernist art to signpost the à la mode interiors it promoted. Several of the furnished rooms featured non-representational art on the walls (see, for example, the living room display in Figure 6.1). Likewise, in a similar vein to those exhibitions detailed in Chapter 4, 'Britain Can Make It' used holistic design to educate the viewing public's taste. The organisers constructed fully designed rooms, helping viewers to get a sense of objects, decorations and fashions working in unity, and working to conceptualise achievable 'lifestyles'. Interviews conducted by Mass-Observation reveal

[6] Mass-Observation reported on the attendance and the responses to the objects on display at the exhibition. See 'Mass Observation Online', Topic Collection 26, box 4, 2.

that it was this conceptualisation that saved viewers becoming lost and bewildered.[7]

The design and display philosophy of 'Britain Can Make It' is in some ways the most interesting aspect of the exhibition for our purposes here. If COID was the exhibition's overseeing body, the event was stage-managed by one of the first successful modern advertising and marketing campaigns by another kind of new enterprise: design consultancy. The Design Research Unit (DRU), whose later campaigns included those for British Railways, P&O, London Transport and the City of Westminster, was formed out of the desire to provide solutions to design and mar-keting problems using many of the modernist precepts this book has charted: an attentiveness to formal arrangements, educative and ameliora-tive philosophy and a democratic ideal. Housed in the same building as Mass-Observation on Kingsway in London, the DRU counted Herbert Read (who was its first member), Misha Black and Milner Gray as its founders, and was committed to propagandising British craft, design and culture. Herbert Read was convinced of the need for 'the State, Municipal Authorities, Industry [and] Commerce' to have adequate design support from professionals, and this close relationship between the manufacture of art and design products and their promotion and marketing was another new feature of 'Britain Can Make It'.[8] Indeed, Noel Carrington, writing in *Country Life*, singled out the exhibition's strategies, and the work of the DRU staff in particular: 'One thing which will strike any visitor is the outstanding quality of the display throughout the galleries, and the inge-nuity in using and camouflaging the ugly building in which it is housed. The organisers have mobilised a brilliant team of display experts, includ-ing [...] Mr. Milner Gray and Mr. Misha Black of the late Ministry of Information.'[9]

While Read's modernist credentials are bona fide, Black and Gray have hardly been recognised for their connections with the avant-garde. Heavily involved in left-wing politics, Black was a member of both the Artists International Association and the MARS group, which included modernist architects such as Morton Shand, Maxwell Fry, Wells Coates and F. R. S. Yorke, and had attempted to venture into town planning with

[7] See exit interviews conducted by Mass-Observation interviewers. 'Mass Observation Online', Topic Collection 26, Box 3.

[8] Milner Gray, 'Notes on the Formation and Operation of a Design Group' (20 October 1942) [unpublished], 1.

[9] Noel Carrington, 'Britain Can Make It', *Country Life* (4 October 1946): 681–3; 682.

a bold, socialist plan for new architecture in London in 1942. Gray, too, was involved in modernist design circles before the war. In 1936, he started working part time at the Reimann School in London, and offshoot of the Reimann Schule in Berlin, which was devoted to design and commercial art. In particular, his remit was to teach classes in display design. The journal *Commercial Art* had questioned British standards of display in the 1920s, suggesting that those responsible for exhibitions showed 'little or any art knowledge about modernist design or the fundamentals governing [...] "presentation"'.[10] German design, on the other hand, was seen as cutting edge. Frederick Kiesler's study *Contemporary Art Applied to the Store and Its Display* was translated into English in 1930, and it contained images from the Reimann Schule. The London branch of Reimann featured tutors such as artists E. McKnight Kauffer and Richard Hamilton, both of whom taught design, and other well-known figures from the modern art and design world were members of the advisory committee, such as Eric Fraser, Marion Dorn, Jack Beddington and John Grierson. Unquestionably modernist in its outlook, Reimann was one of the pioneering marketing schools before the war, and its influence on the DRU was considerable.[11]

Acutely aware of the need to frame 'Britain Can Make It' for a public audience, Black conceived of the high-concept 'The Birth of an Eggcup' (Figure 6.2) exhibit, narrating the conception of a problem and its solution (in what was recognised even at the time as pedantic terms):

> Here is the Man
> He decides what the eggcup shall look like
> He is the Industrial Designer
> He works with the Engineers, the Factory Management—and is influenced by what you want.[12]

Nevertheless, this strategy of 'baring the bones' of the process of artistic or design conception was very much praised by commentators and, though stymied by lack of funds, there was a plan to tour this particular exhibit, or even to create a miniature version in cases that could be sent around to schools and women's institutes.[13] The educational dimension of 'Britain Can Make It' was also supported by quiz machines, designed by the DRU,

[10] *Commercial Art*, VII (1929): 56.

[11] For more on the Reimann School in London, see Yasuko Suga, 'Modernism, Commercialism and Display Design in Britain: The Reimann School and Studios of Industrial and Commercial Art', *Journal of Design History*, 19, 2 (2006): 137–54.

[12] 'How the Industrial Designer Works', Design Council Archive, University of Brighton Archives.

[13] See Maguire and Woodham, *Design and Cultural Politics*, 133.

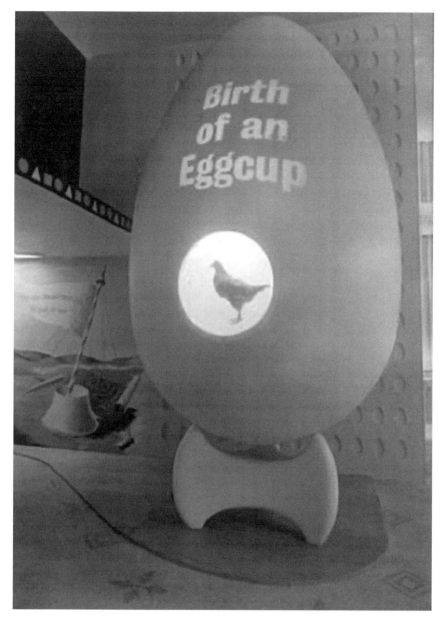

Figure 6.2. 'The Birth of an Eggcup' (reproduced with permission of University of Brighton Archives)

which were dotted around the exhibition. The quiz was both didactic—with participants essentially being asked to confirm the standards of taste they had been exposed to—and an information-gathering exercise: the catalogue reports that 'the Quiz device will give you an opportunity to exercise your judgment and record your preferences' and 'by the time the Exhibition closes, the Council will be left with a useful record of public feeling about design'.[14]

Paul Reilly, Director of what is now the Design Council, argued in a retrospective on the Festival of Britain that the lessons learned about scale and scope from 'Britain Can Make It' were invaluable to the pedagogical planning of the events of 1951.[15] The public were there to enjoy the events, but also to learn. Mary Banham, recalling the events from a quarter of a century later, recalled that 'the Festival organising team would not have been seen to have done their job unless visiting families went away feeling instructed and, in some undefined way, improved'.[16] COID and the DRU were later tasked with much of the preparation and running of the Festival of 1951, and the same desires—to entertain and educate the public's taste—were scaffolded by a programme of events and pedagogical literature. Though the Festival was a heterogeneous event, its modernist features (particularly the sculpture garden at Battersea and on the South Bank) were framed with pedagogy in mind. Accompanying the South Bank exhibition—the most visible external face of this exhibition was the sculptures and murals of modernists such as Henry Moore, Jacob Epstein, Barbara Hepworth, Victor Pasmore, Ben Nicholson, Feliks Topolski and John Piper—was a guide to the philosophy of the event. 'The Story the Exhibition Tells' was, in some ways, akin in philosophy to Desmond MacCarthy's 'Preface' to 'Manet and the Post-Impressionists'. Attempting to harmonise what were discordant displays, the guide affirmed that 'the story—as any visitor whose feet follow the intended circulation will observe—begins with the past, continues with the present, and ends with a preview of the continuing future'. The connecting themes were 'People of Britain' and 'Land of Britain'.[17] Though some scoffed at these themes—several critics found them generalised to the point of meaninglessness—the unity of the pavilions and exhibits

[14] 'Britain Can Make It' catalogue (London: Council of Industrial Design, 1946), 2.

[15] Paul Reilly, 'The Role of the Design Council before, during and after the Festival of Britain', in M. Banham and B. Hillier (eds), *A Tonic to the Nation: The Festival of Britain 1951* (London: Thames and Hudson, 1976), 58–61.

[16] Mary Banham, 'A National Enterprise: Introduction', in ibid., 70–5; 72.

[17] Extract of 'The Story the Exhibition Tells', in ibid., 74.

that they provided helped to make sense of what were some challenging works of art.[18] Misha Black recalls that:

> It was odd that this [contemporary sculpture exhibition] raised little comment from the eight and a half million visitors or the press. Only a few years previously Epstein's *Rima* in Hyde Park had been tarred and feathered for reasons which were explicit only to barbarians, but on the South Bank, Epstein seemed barely noticed, Hepworth was accepted with a shrug.[19]

Though Black would attribute this reception to '*embarras de richesse*', the framing device and narrative surrounding the exhibits undoubtedly gave the viewing public a vantage point. 'It was a *narrative* exhibition', he recalled.[20]

The reception to the Festival as a whole was of course mixed, and its legacies are invoked whenever large, state-sponsored events are held in Britain. Notwithstanding this heritage, it is clear that the influence of a number of modernist supporters and mediators on the event's design, ethos and pedagogy drew upon pre-war conceptions of educating the masses to appreciate modern art and design. It also represented what Frank Mort termed a 'high moment of collectivism [and] practical utopianism' in British cultural life.[21] The piecemeal adoption of educative policy changes aligned with the arts in the 1930s blossomed into national, and indeed international, action by the 1950s. The formation of UNESCO immediately after the Second World War led to increased international collaboration across humanities and led to a number of satellite committees, most notably the International Society for Education through Art, which installed Herbert Read, by then elevated to a knighthood, as Honorary President, a position he held until his death in 1968. Not long after that, the National Arts Education Archive was established at the Yorkshire Sculpture Park, preserving and enshrining the connection between visual modernism and pedagogy in a tradition that is flourishing today.

Events such as those of 1946 and 1951 saw a much closer rapprochement of the state with modern art and design. One of the persistent failures I have documented in this study was the inability to secure long-term funding for modernist and quasi-modernist groups for projects ranging from the teaching of art to schoolchildren to the design of the home. In the years after the war, the economic scaffolding for the arts in Britain became sturdier.

[18] See, for instance, Hugh Casson's reflections on the reception of the South Bank show, 'A National Enterprise: South Bank Show', in ibid., 78–81.

[19] Misha Black, 'Architecture, Art and Design in Unison', in ibid., 82–5; 83.

[20] Ibid.

[21] Mort, 'Fantasies of Metropolitan Life': 121.

It is possible to see this phenomenon—the economic and social policy estab-
lished after 1945—as a direct legacy of Bloomsbury. While Roger Fry's phi-
losophy and sheer energy were important in the institutional developments
in the arts in the 1930s (and even after his death in 1934), John Maynard
Keynes's influence was more concretely responsible for a holistic policy of
funding and planning in the arts. Precious little has been written on Keynes
as a mediator of modernism in Britain, to use the term I have championed in
this study, though a number of recent studies have pointed to his central role
in the preservation of art and culture through the difficult years of war. The
mediators of modernism who survived the war—many of the Surrealists, for
instance, and those artists who began their careers during the war, such as
Patrick Heron—were deeply affected by the lacuna in arts appreciation that
resulted from conflict. Virginia Woolf's acute realisation that 'art is the first
luxury to be discarded in a time of stress' seemed a dangerous observation
in the dog days of the war.[22] Keynes and others, such as Kenneth Clark
and W. E. Williams, believed in art and culture's power to heal the nation.
Studies of these figures have stressed their social-mindedness and position
in relation to government and power (especially Keynes), yet rarely has their
connection to experimental and avant-garde artistic culture been examined.

Keynes' educative philosophy was undoubtedly developed in Blooms-
bury circles. Patricia Lawrence sees his role in the arts arising out of his ear-
lier embeddedness in Bloomsbury's artistic culture, arguing that 'Keynes's
interest in structuring national arts policies in the last decade of his life grew
out of his early sympathy and feeling for his artistic friends.'[23] Jed Esty, too,
points to Keynesian philosophy's kinship with the late modernism of Eliot,
Woolf and Forster, arguing that 'he combines Bloomsbury liberalism with
Burkean organicism, embodying the ideological blend that carried English
destiny from imperial center to welfare state'. For Esty, 'just as English
modernists shifted orientation from the free-flowing anomie of artistic cote-
ries in European capitals to the everyday life of a more integrated insular
culture, so too did Keynes shift orientation from a classical international
capitalism to a restructured macroeconomy based on the formalization of
collective interest in the state'.[24] There is, however, another strand to the

[22] Virginia Woolf, 'The Artist and Politics', in *The Moment and Other Essays* (New York:
Harcourt Brace, 1948), 227.
[23] Patricia Lawrence, 'The Intimate Spaces of Community: John Maynard Keynes and the
Arts', in *Journal of the History of Political Economy*, 39 (Supplement 1) (2007): 292–313; 292.
[24] Jed Esty, *A Shrinking Island: Modernism and National Culture in England* (Princeton, NJ:
Princeton University Press, 2003), 20.

arc of Keynes's development as a holistic thinker important to his post-war influence on arts policy: his development of the Bloomsbury aesthetic philosophy, so castigated by Raymond Williams among others as individualistic and committed to the maintenance of class boundaries along lines of taste and erudition, into something more expansive and inclusive. In an essay Keynes wrote in 1938, 'My Early Beliefs', he castigated himself and his young, idealistic peers for their narrow-minded abandon and naiveté. 'I can see us as water-spiders, gracefully skimming, as light and reasonable as air, the surface of the stream without any contact at all with the eddies and currents underneath.' With war looming, Keynes was able to see that frivolity could no longer be excused in the artist or intellectual: man could no longer exist 'secure in the undisturbed individualism which was the extraordinary achievement of the early Edwardian days'.[25]

Keynes's expansive and inclusive vision for the arts came with a political and financial power that Roger Fry could never have possessed. Connected to sources of governmental power and finance, Keynes spearheaded the development of new funding streams and policy initiatives that would have an enormous effect on the culture of the nation. He would also encourage the transportation of the arts to regional and municipal sites across Britain during and immediately after the war, so as 'to provide hundreds of factory concerts, to carry the drama to mining villages and war hostels where many of the audience see the living stage for the first time, to assist holidays at home and the provision of entertainment in parks and public spaces'.[26] It was his belief that the end of the war would usher in a new, enlightened age across Britain: 'in every blitzed town in this country,' he wrote, 'one hopes that the local authority will make provision for a central group of building for drama and music and art'.[27] He was a central player in the formation of one of the most important post-war arts institutions—the Council for the Encouragement of Music and the Arts (CEMA) in the early 1940s, the group that became the Arts Council after the war. Keynes's influence gave CEMA a good deal of power and influence in government (he pushed for it to be funded directly from the Treasury), and its model of patronage of young British artists helped to foster a new generation of avant-garde painters, sculptors, film-makers, theatre directors and dancers. While it

[25] John Maynard Keynes, *The Collected Writings of John Maynard Keynes. Essays in Biography*, vol. X (London: Macmillan, 1972), 450.
[26] John Maynard Keynes, *The Collected Writings of John Maynard Keynes. Social, Political, and Literary Writings*, vol. XXVIII (London: Macmillan, 1982), 360.
[27] Ibid., 271.

seems a minor point, this direct funding model—making grants through quasi-governmental bodies to private or council-run institutions, and indeed to individuals—was a radical departure from previous patronage of the arts. Keynes would write of the monumental nature of this change:

> I do not believe it is yet realised what an important thing has happened. Strange patronage of the arts has crept in. It has happened in a very English, informal, unostentatious way, half-baked if you like. A semi-independent body is provided with modest funds to stimulate, comfort and support any societies or bodies brought together on private or local initiative which are striving with serious purpose and a reasonable prospect of success to present for public enjoyment the arts of drama, music and painting.[28]

In 1936, Keynes contributed an essay to *The Listener* on art and the state that repeated so much of what Fry had envisaged as possible in his own essay on the subject over a decade earlier. In Fry's 'Art and the State', he had made a plea for state funding that was from disinterested sources: the state should economically support, but it should grant autonomy to artists and critics. It was the same kind of distance he suggested should exist between patrons and artists, harking back to Renaissance workshop models of production and consumption. Keynes rehearsed the same distaste for the present relationship between money and art: 'The position today of artists of all sorts is disastrous. The attitude of an artist to his work renders him exceptionally unsuited for financial contacts. [...] He needs economic security and enough income, and then be left to himself, at the same time the servant of the public and his own master.'[29]

Keynes, and Fry before him, were hardly alone in calling for distance between the artist and the hand that fed him. Kenneth Clark, who was instrumental in getting Keynes installed as head of CEMA, was wary of the state's ability to be a mediator of taste in the arts. He opposed plans to create a Ministry of Fine Arts because he felt that the cultivation of taste by committee was impossible, preferring that a 'patronage controller' be installed who would be above partisanship and whose taste and discernment would prevent state-funded art projects being either insipid or, worse, vulnerable to political messages.[30] Though practicably impossible to implement, the earnestness of such an idea harks back to Fry's original selection philosophy of the CAS and, more broadly, embraces a philosophy

[28] Ibid., 368.

[29] John Maynard Keynes, 'Art and the State', *The Listener* (7 May 1936): 18.

[30] Letter from Kenneth Clark to Humbert Wolfe (3 October 1939), National Gallery Archive, Central register.

that individual mediators of taste—that is, public art figures who had political clout and a public message—were needed more than government departments. This 'arm's length' funding model was not without its critics: Raymond Williams notes that the only figures who would gain traction in such positions were establishment men:

> The British State has been able to delegate some of its official functions to a whole complex of semi-official or nominally independent bodies because it has been able to rely on an unusually compact and organic ruling class. Thus it can give Lord X or Lady Y both public money and apparent freedom of decision in some confidence [...] that they will act as if they were indeed State officials.[31]

There is no doubt that Keynes and Clark were not whole-hearted supporters of modernist art. Keynes's own collections of modernist art were largely directed by others—Francis Spalding notes that 'either he did not have a good eye or he acted on principles of kindness rather than taste'.[32] Clark, too, was suspicious of some of the experimental works of Surrealism and Abstract Expressionism. Yet it is not fair to categorise either as modernism's enemy. Keynes's perpetual enemy in his writing on art and culture is 'popular art'—that which does not require education in the methods of appreciation. Several contemporary critics of Keynes argued this was evidence of his aloofness and disdain for popular manifestations of artistic expression. W. E. Williams complained that there was 'in this great scholar and art connoisseur a streak of donnish superiority and a singular ignorance of ordinary people'.[33] While he undoubtedly possessed these traits, Keynes's belief that artistic appreciation had to go hand in hand with the cultivation of a taste through education of the senses placed him in sympathy with Fry's philosophy. In a similar vein, Clark's *Modern Painters* booklets for Penguin were designed as a series that would meet modern art halfway and counter the prevailing notion that 'modern painting is unintelligible and that modern Art Galleries are for the selected few initiates'.[34] If they were seen as solid and reliable holders of offices in the arts by government,

[31] Raymond Williams, 'The Arts Council', *Political Quarterly*, 50, 2 (1979), 165.

[32] Frances Spalding, *Vanessa Bell: A Biography* (London: Weidenfeld and Nicolson, 1983), 227.

[33] W. E. Williams, 'The Pre-History of the Arts Council', in E M. Hutchinson (ed.), *Aims and Action in Adult Education, 1921–1971* (London: British and National Institutes of Adult Education, 1971), 51–68; 59.

[34] Kenneth Clark, quoted in R. and. G. Shaw, 'The Cultural and Social Setting', in Boris Shaw (ed.), *The Cambridge Guide to the Arts in Britain*, vol. IX (Cambridge: Cambridge University Press, 1988), 1–14; 6.

they retained a sense of their own autonomy and standards of taste, and their belief that taste for modern artistic culture had to be cultivated—not in academic learning, so much as through the development of an organ of appreciation.

Regardless of the politics behind the support Keynes received in his role, CEMA was instrumental in winning hearts and minds for direct public finding for the arts. It was actually an inexpensive endeavour. Keynes realised that soundly planned events wouldn't need to be heavily subsidised by the state because they would attract paying visitors: as a result, CEMA began to guarantee events against loss, rather than providing them with full funding. Even at the height of hostilities, CEMA saw huge interest in its touring schedule of plays, operas and exhibitions: 'our wartime experience', Keynes wrote in 1945, 'has led us already to one clear discovery: the unsatisfied demand and the enormous public for serious and fine entertainment. This certainly did not exist a few years ago.'[35] In 1940, R. A. Butler presented a film produced by the National Films Council on CEMA, which was co-written by Dylan Thomas, highlighting the ameliorative and pedagogical principles of the group. Throughout, explicit connections are drawn between the war and cultural life. Cut in amid footage of tanks and artillery at the front are clips of a performance of *The Merry Wives of Windsor* (which could be anywhere in the provinces, with a member of CEMA gesturing to that fact by inserting flags of arts events on a map of Britain in places from Manchester to Kingston upon Hull to the South West), soldiers on leave sneaking into the back of a philharmonic performance in the Home Counties and a provincial show of art. Throughout, the film stresses the importance of freedom of thought and the significance of the intellectual victory as much as the military one. It does this with recourse to modernist art. At one point, a couple stand in front of what looks like a Joan Miró painting. The man asks 'What is this? A chamber of horrors?', while his partner says that she 'likes paintings of everyday life'. The guide, the art critic Eric Newton, who explains the significance of the paintings asks one incredulous viewer, 'We all know what we are fighting against, but do we know what we are fighting for?'[36] The film represents the best example of CEMA's utopian offering to Britain for the intrinsic good of the arts.

If Keynes and CEMA were instrumental in shaping new funding policies and providing a new educative agenda for the arts in Britain, they also

[35] Keynes, *Collected Writings*, vol. XXVIII, 369.
[36] 'Council for the Encouragement of Music and the Arts', National Films Council of the Department of Information (1940).

sought to decentralise activity away from London. Though local collec-
tions and activity did exist before the war—the Leeds Art Club is perhaps
the best example of a thriving modernist space outside London—as late as
1938, W. E. Williams would complain that 'in over four hundred towns
with a population of over five thousand, there aren't any municipal col-
lections of modern pictures to be seen'.[37] A few years later, Eric Newton
explained for the British Council in a pamphlet called 'Art for Everybody'
(1943) that the contemporary art scene in the years before 1939 was 'so
completely concentrated in a couple of square miles of the West End of
London that it is no wonder that vast areas of England were, and still
are, unfamiliar with the achievements of our contemporary painters'.[38]
Undoubtedly, British modernist activity was centripetally embedded in a
few postcodes of the capital until the war. Narratives of modernist activity
in Britain before the war are core-located. The materialist approach to the
rise of modernism—that a radical new aesthetic emerged in response to
the economic and social conditions of metropolitan life in the major cities
of the West—is still the dominant explanatory model for most modernist
movements. Peter Brooker's *Bohemia in London* (2007) maps a cultural
landscape in the 1910s and 1920s centred on Soho, Fitzrovia, Kensington
and Bloomsbury in which advanced art thrived. A series of loci strung out
across the west of London forms an auratic geography of early modernism:
the Eiffel Tower restaurant on Percy Street, the Cave of the Golden Calf
and the Café Royal on Regent Street, the interior spaces of Gordon Square.
Andrew Thacker also talks in cartographical terms: 'the story of modern-
ism's emergence in London might be told by reference to a number of key
locations in which movements such as Symbolism, Imagism, and Vorticism
gathered together and flourished as companions in the struggle to innovate
and experiment'.[39] Such narratives privilege origins over legacies: less well
understood are the ways in which modernist cultures of exhibition and
display that originated in the capital helped take art to the regions of the
country. One of the connecting threads across many of the institutions and
initiatives discussed in *Insane Acquaintances* is the desire to devolve funding,
support and infrastructure for the arts to the regions. Postimpressionism

[37] W. E. Williams, Pamphlet for 'Art for the People Scheme' (London: Institute of Adult
Education, 1938), 1.
[38] Eric Newton, 'Art for Everybody' (London: British Council Pamphlet, 1943), n.p.
[39] Andrew Thacker, 'London: Rhymers, Imagists, and Vorticists', in Peter Brooker, Andrzej
Gasiorek, Deborah Longworth and Andrew Thacker (eds), *The Oxford Handbook of Modernisms*
(Oxford: Oxford University Press, 2010), 687–705; 691.

helped to cultivate a regional and provincial exhibition culture, and the CAS's remit—to support modern British artists and sculptors and to ensure the decentralisation of London as the locus of the exhibition of advanced art—coincided with the establishment of modernist art repositories outside the capital (in Leeds, in Glasgow, in Manchester, and later in St Ives and in Wakefield). Surrealism's attempt to curate 'Englishness', though perhaps an abortive effort as discussed in Chapter 5, was still a gesture towards celebrating the non-metropolitan, non-elite modernist dimensions of British identity.

The decentralisation of the arts—though imperfectly implemented in the 1950s and beyond, and subject to the vagaries of the ideology of government—was on the agenda of CEMA and the Arts Council in the years leading up to 1951. CEMA's nationwide tours of events were enormously successful—many of the exhibitions, plays and performances staged were middlebrow, but new forms emerged from the initiatives in the late-1940s onwards. Anne Massey's study of the activities of the Independent Group in the years after the end of the war traces a complex set of negotiations between the tenets of a primarily European modernism and home-grown talent. For Massey, the decade beginning with the Festival of Britain in 1951 represented the gradual sloughing off of Fry's version of a European avant-garde in favour of an authentic expression of British modernity. This new style—Neo-Romanticism—'emerged during the Second World War in the publicly commissioned work of John Piper, Graham Sutherland and Henry Moore'.[40] The term Neo-Romanticism, to capture a new attitude to the human form and to the (idiosyncratically British) landscape, was coined by Robin Ironside in 1947 in an essay entitled 'Art since 1939' for a British Council pamphlet, and for Massey represents an inward turn.[41] Massey suggests that this turn towards 'illustration, lyricism and the British landscape' was best represented by the overarching aesthetic at the Festival by the state-commissioned work of artists such as John Piper, Henry Moore and Barbara Hepworth.[42] Massey is right to point to the reactionary elements in this new style—indeed, as she points out, artworks in this vein attracted little in the way of public comment. The only significant public shaming of a work of state-bought art at the Festival was William Gear's

[40] Anne Massey, *The Independent Group: Modernism and Mass Culture in Britain 1945–59* (Manchester: Manchester University Press, 1995), 8.
[41] Robin Ironside, 'Art since 1939', in Robin Ironside, *Painting since 1939* (London: Longmans, Green & Co., 1947), 6–34; 18.
[42] Massey, 8.

Autumn Landscape (1950), a more familiarly abstract painting and redolent of European expressionism and the work promoted by the ICA. However, dichotomising modernism and new, British styles emergent in the late-1940s is problematic at best, and setting artists such as Henry Moore and institutions such as the ICA on opposite sides of a culture war does harm to the complexities behind debates about modernism's place in Britain after 1945. For one, this turn to a lyrical version of a British past, while nostalgic, was also—as we have seen—a strategy enacted by the Surrealist movement in Britain to authenticate a 'national' avant-garde. The celebration of regional and provincial, non-metropolitan, non-elite culture has a place in the study of British avant-garde activity in the 1930s and 1940s and is far from a simple capitulation to 'Merrie England' myths of tradition and continuity. While the organisers of the Festival might have had what Massey describes as a 'chauvinistic celebration of certain aspects of British culture' in mind, the sculptural forms present at the exhibition on the South Bank were unquestionably modernist attempts to relate abstract forms to ideas of organicism and British rurality.[43] The tangled web of aesthetics and cultural politics is also complicated by the ICA's promotion of similar themes to those of the Festival of Britain: of continuity and organicism in British cultural life. The ICA's exhibition of 1948–9, '40,000 Years of Modern Art', was Herbert Read's attempt to stress the continuities between modern, abstract forms and primitive forms of art and Richard Hamilton's 'Growth and Form' exhibition—which coincided with the Festival—was an attempt to connect to the Festival's championing of the interconnectedness of science and art. Hamilton 'spent hours in the Natural History Museum examining fantastic biological forms from the fossil collection, re-accessing Surrealist biomorphism at its root'.[44] Even more explicitly tied to events on the South Bank, and complicating the ICA's later role as an oppositional force in British cultural life—was the 'Ten Decades—A Review of British Taste, 1851–1951', which exhibited only British pictures and represented, to *The Times*, 'nothing so much as a large provincial art gallery'.[45] These muddled intersections between modernism, post-war avant-garde culture

[43] Ibid., 8.

[44] Hamilton, quoted by David Mellor, 'The Pleasures and Sorrows of Modernity: Vision, Space and the Social Body in Richard Hamilton', in *Richard Hamilton* [exhibition catalogue] (London: Tate Gallery, 1992), 30. For more on this exhibition, see Isabelle Moffat, '"A Horror of Abstract Thought": Postwar Britain and Hamilton's 1951 "Growth and Form" Exhibition', *October*, 94 (Autumn 2000): 89–112. Moffat explicitly connects Hamilton's avant-garde ICA show with the science exhibits at the Festival.

[45] Anon, 'British Taste in Painting', *The Times* (15 August 1951): 8.

and normative, state-sponsored depictions of Britain complicate narratives around the institutionalisation of the arts after 1945.

If the modernist art forms on display at the Festival by artists such as Moore, Hepworth and Piper were, at least in part, a celebration of the non-urban, non-metropolitan, non-London aspects of British culture, the event was also designed to celebrate British regional heterogeneity. Becky E. Conekin emphasises the differences between the Festival of Britain and previous national displays of art and industry at the British Empire Exhibition at Wembley in 1924–5, and the Great Exhibition of 1851. While both the latter sought to present a unified vision of Britain as a global power, the Festival of Britain went to great lengths to promote regional activity. The minutes of the Festival Executive Committee from January 1948 signpost this regionalism, stressing that it 'should not be confined to London but should cover as much of the country as possible'.[46] Gerald Barry, the Festival's chief organiser, wrote in 1949 that 'the motives that inspire the Festival [...] can only be fully translated into action if the whole country takes part'.[47] Though the regional dimensions of the Festival were, in the end, uninspiring, the Festival represents the high point of regional arts thinking in post-war Britain, and its philosophy of taking culture to the provinces can be traced back through Keynes and Read to Fry.[48] Immediately after the Festival in 1951, the Arts Council's annual report was hesitant to commit a great deal of its budget to the provinces and declared its new agenda for the 1950s to change from 'spreading' culture across Britain to 'raising artistic standards'.[49]

If the establishment of regional artistic cultures founded on an engagement with experimental art consisted of only partial successes for the mediators of modernism that *Insane Acquaintances* has discussed, this study has also demonstrated the power of conglomeration and incorporation in the achieved successes of the avant-garde in early 20th-century Britain. Revolutionary political energy lay behind the activities of Futurism, Dada and Surrealism on the continent, with even more movements forming and dissipating around brief political moments. Conversely, in the case of lots of the examples discussed here—Postimpressionism, Surrealism, the

[46] Quoted in Becky E. Conekin, *The Autobiography of a Nation: The 1951 Festival of Britain* (Manchester: Manchester University Press, 2003), 155.

[47] Quoted in Banham and Hillier, *Tonic to the Nation*, 71.

[48] Conekin devotes a chapter to the regional and provincial philosophy of the Festival. See Conekin, *The Autobiography of a Nation*, 153–82.

[49] Quoted in ibid., 157.

influence of European design principles on the British home, especially—the establishment of movements involved processes of assimilation and annexation rather than organic or generative artistic drive. Part of the reason why this is the case is the temporal lag between aesthetic innovation and take-up in Britain. Postimpressionism and British Surrealism were after-the-fact terms imposed to congeal, or even to reify, concepts that their promoters believed contained important aesthetic and pedagogical lessons for the British public. Both movements had arguably expended their artistic or political energy by the time their reputations waxed and waned in front of a British audience. The stars of Fry's first show at the Grafton Galleries had all passed away by 1910, and the version of Surrealism that Read, Penrose and Rupert Lee presented at the New Burlington Galleries in 1936 was, if not quite as old, then symbolically at least as out of date. Certainly, it is not hard to make the case that Postimpressionism amounts to a kind of violence done on very different aesthetic and stylistic principles for the sake of a public-facing clarity of purpose. In a related process of assimilation, many of the British artists on display at the International Surrealist Exhibition in 1936 felt that their work had been appropriated by the committee to fit with the principles of the exhibition. Julian Trevelyan was visited by the organisers of the exhibition, who chose paintings in a matter of a few minutes that appealed to them as Surrealist, making him a de facto member of the movement.[50] Others reported similar annexation and co-option, and several of the British artists included at the show, including Henry Moore and Graham Sutherland, could only be called Surrealist with tremendous hesitation. The 'put together' nature of Postimpressionism and a British Surrealist canon demonstrates the power of their most prominent respective mediators in launching artistic concepts onto the British public. None of this is to suggest that those continental movements that rose up organically from particular social and political milieux were in some way purer of purpose, nor were they more authentic. Rather, I hope to have shown across a range of examples that the principle of pedagogy, or ameliorative change, was often more important than the artistic features of modernist art and design for critics and promoters such as Herbert Read and Roger Fry. This has often had the effect of encouraging critics to see the bulk of British avant-garde activity during the early 20th century (with the exception, perhaps, of Vorticism) as paler versions of their continental counterparts, diluted, late and short lived, if not abortive. This narrative is of course true.

[50] Anecdote recalled in J. H. Matthews, 'Surrealism and England', *Comparative Literature Studies*, 1, 1 (1964): 55–72; 56–7.

However, as I hope to have demonstrated here, there are some significant legacies of these acts of conglomeration and annexation.

This institutionalisation of modernism was perhaps not necessarily entirely felicitous. As we have seen, the post-1945 institutional legacies of avant-garde activity in the previous decades were not entirely what their promoters and mediators had envisaged. The fashioning of modernist activity by groups that were, or would soon be, quasi-governmental meant a mixture of interests—state, civic, intellectual and consumer—shaped organisational activity, and that the bequest of modernism to the national social or cultural good was obscure, or at least complicated, by these conflicting demands. Likewise, the new exhibition cultures fostered by modernism's encounters with the public in the period between 1910 and 1936—and the concomitant professionalisation of exhibition design—was also not as transparently ameliorative as might be thought at first. Misha Black, an inheritor of the modernist desire to narrate and educate in exhibitions, was prescient of the Festival of Britain's attempts to stay on message to its visitors: 'the exigency of war propaganda', he wrote the year before the events of 1951, 'has created, in this country, experience in the informative and story-telling type of exhibition [...] which equals in quantity that which the Fascist countries enjoyed'.[51] He had drawn similar connections between the slick professionalism of exhibition design and narration and propagandistic events, such as the Nuremberg Rally of 1935.[52] While confident in the democratic principle of didacticism without extreme results, such concerns hint at the dangers of harmonising conflicting or non-congruent art and culture in the name of education.

While these conflicts continue to mean that modernism has an unresolved space in British artistic life, what this study has demonstrated is that the styles and pedagogical apparatus of modernism quickly became assimilated into the public's taste for art and design. So readily incorporated was the decorative, design and exhibition-culture of modernism in Britain that by the time the immediately post-war events of the inheritor institutions I have discussed here took place, modernism's shock value had dissipated, replaced almost by a blindness to its innovation and experimental nature. I will end with a comparison of two rooms. The first (Plate 10) is the living room exhibited at the Ideal Home Exhibition in 1913 by Omega Workshops. The second (Figure 6.1) is the living room constructed

[51] Misha Black, 'Exhibition Design', in Misha Black (ed.), *Exhibition Design* (London: Architectural Press, 1950), 11.
[52] See Moffatt, 'A Horror of Abstract Thought': 98.

for display at 'Britain Can Make It' in 1946, both images I have discussed in this study. The reader will note the similarities—large decorative works adorn the walls (in the former these are murals, but the figurative design shares clear affinities); in both, a geometric, boldly coloured rug with typical black-line flourishes, archetypal of Bloomsbury design, sits on the floor; patterned soft furnishings rest informally around simply constructed wooden furniture. The first room is a locus of modernism: it sits right at the beginning of Omega's domestic project and is one of the first applications of a Postimpressionist-Bloomsbury aesthetic to living space. Its experimental design, too, has been celebrated by critics since, and the controversy around its construction (with Wyndham Lewis, Frederick Etchells and Edward Wadsworth denouncing the entire project and its rationale in the press) has helped to cement its place in narratives of modernism in Britain.[53] The second room, constructed a third of a century later, drew no such attention.

When the rooms of 'Britain Can Make It' are discussed in reviews of the exhibition, they are praised, and the interviews with visitors betray few negative responses, other than at the perceived expense of some of the designs.[54] While the materials used to make the rooms are likely very different—the one-off objects of the Omega room replaced almost entirely by the mass-produced in the 1946 exhibition—the aesthetic statements both rooms make are the same: that bold colour, line and rhythm, accompanied by simplicity and 'liveability', are desirable outcomes for modern domestic design. With that in mind, it is telling that Noel Carrington could find no evidence of modernism in the latter: 'I had the impression in recent visits abroad that "modernism" was now a thing of the past, and that, using contemporary techniques and material, the designers had regained the classical feeling for proportion. That is what we begin to see here, now that the ground has been cleared.'[55]

Though at times modernism's project of pedagogy might be occluded and unconscious, its final victory might be in assimilation. While it is not particularly insightful to suggest what was once new became old, this study has charted some of the pathways into the British cultural imaginary that

[53] For a detailed account of the layout of the room, the artistic contributions to it, and the public storm that accompanied its display, see Richard Cork, *Art Beyond the Gallery in the Early Twentieth Century* (New Haven, CT, and London: Yale University Press, 1985), 117–76.

[54] Interviews at the exhibition were undertaken by Mass-Observation interviewers—for the hugely detailed archive, see 'Mass Observation Online', Topic Collection 26.

[55] Carrington, 'Britain Can Make It': 620.

modernist art and design was taken by its mediators. The encounters I have outlined here, while no means amounting to a comprehensive study of modernism's reception in British life, demonstrate some of the ways in which an inbuilt pedagogy and desire to educate the public's taste were part of modernism's franchise. Its experimental styles, radical politics and opposition to bourgeois culture survived the Second World War in new institutions—some private, but many drawing from the public purse—founded on the principles of art for all, political confrontation and a reach outside the gallery walls into the work and home lives of the masses.

Bibliography

Adam, Peter, *Eileen Gray, Architect/Designer: A Biography* (New York: Harry N. Abrams, 2000).

Adorno, Theodor, *Aesthetic Theory*, trans. R. Hullot-Kentor (London: Athlone, 1997).

Aldington, Richard, 'Some Reflections on Ernest Dowson', *The Egoist*, 2, 3 (1 March 1915): 37–8.

Aldred, Nannette, 'Art in Postwar Britain', in Alistair Davies and Alan Sinfield (eds), *British Culture of the Postwar: An Introduction to Literature and Society, 1945–1999* (London: Routledge, 2000), 146–69.

Allport, Gordon W., 'Eidetic Imagery', *British Journal of Psychology*, 15, 2 (1924–5): 99–120.

[Anon.], 'Art as a National Asset', *Burlington Magazine for Connoisseurs*, 5, 17 (August 1904): 429–30.

[Anon.], 'Art: Autumn The Salon', *Nation* (7 November 1908): 221.

[Anon.], 'Art Periodicals', *The Times* (22 April 1935): 8.

[Anon.], *British Art in Industry, 1935: Illustrated Souvenir* (London: Royal Academy, 1935).

[Anon.], 'Editorial: Art Education', *Burlington Magazine for Connoisseurs*, 89, 529 (April 1947): 85.

[Anon.], 'Hampstead Housing Novelty: Human Nest Building', *The Observer* (17 June 1934).

[Anon.], 'Modern Flats. Miss Thelma Cazalet MP opens a Hampstead Block', *Islington Gazette* (10 July 1934).

[Anon.], 'Paint Run Mad: Post-Impressionists at Grafton Galleries', *Daily Express* (9 November 1910): 8.

[Anon.], 'The International Society of Plasterer Painters', *Punch*, 139 (30 November 1910): 386.

[Anon.], 'The Last Phase of Impressionism' [unsigned], *Burlington Magazine*, xii (February 1908): 272–3.

Anscombe, Isabelle, *Omega and After: Bloomsbury and the Decorative Arts* (London: Thames and Hudson, 1981).

Appy, Christian G. (ed.), *Cold War Constructions: The Political Culture of United States Imperialism, 1945–1966* (Amherst: University of Massachusetts Press, 2000).

Arnold, Matthew, *Culture and Anarchy and Other Writings*, ed. Stefan Collini (Cambridge: Cambridge University Press, 1993).

Artmonsky, Ruth, *Art for Everyone: Contemporary Lithography Ltd* (London: Artmonsky Arts, 2010).

Artmonsky, Ruth, *The School Prints: A Romantic Project* (London: Artmonsky Arts, 2006).

Ballard, P. B., 'What London Children Like to Draw', *Journal of Experimental Pedagogy*, 1 (1911–12): 185–97.

Banham, Mary, 'A National Enterprise: Introduction', in M. Banham and B. Hillier (eds), *A Tonic to the Nation: The Festival of Britain 1951* (London: Thames and Hudson, 1976), 70–5.

Banham Bridge, Katherine M., *The Social and Emotional Development of the Pre-School Child* (London: Kegan Paul, Trench, Trubner & Co., 1931).

Barry, Gerald, 'Design for Living', *News Chronicle* (12 July 1934).

Bartlett, F. C., 'Experimental Study of Some Problems of Perceiving and Imaging', *British Journal of Psychology*, 8 (1916): 222–66.

Bell, Clive, *Art* (New York: Frederick Stokes and Company, 1914).

Bell, Clive, 'Contemporary Art in England', *Burlington Magazine for Connoisseurs*, 31, 172 (July 1917): 33–7.

Bell, Quentin, *Bloomsbury Recalled* (New York: Columbia University Press, 1995).

Benjamin, Walter, 'Paris, Capital of the Nineteenth Century: Exposé of 1939', in *The Arcades Project*, trans. Howard Eiland and Kevin McLaughlin (Cambridge, MA, and London: Belknap/Harvard University Press, 1999), 14–26.

Benjamin, Walter, *Selected Writings*, 4 vols, ed. Howard Eiland and Michael W. Jennings (Cambridge, MA, and London: Harvard University Press, 1991–9).

Bernstein, J. M., *Against Voluptuous Bodies: Late Modernism and the Meaning of Painting* (Stanford, CA: Stanford University Press, 2006).

Bigsby, C. W. E., 'Surrealism', in Roger Fowler (ed.), *A Dictionary of Modern Critical Terms* (London: Routledge and Kegan Paul, 1973), 187.

Black, Misha, 'Architecture, Art and Design in Unison', in M. Banham and B. Hillier (eds), *A Tonic to the Nation: The Festival of Britain 1951* (London: Thames and Hudson, 1976), 82–5.

Black, Misha, 'Exhibition Design' in Misha Black (ed.), *Exhibition Design* (London: Architectural Press, 1950).

Blunt, Anthony, 'Surrealism', in *Left Review*, 2, 10 (July 1936): iv–vi.

Blunt, Wilfrid Scawen, *My Diaries* [entry for 15 November 1910] rpt. in J. B. Bullen (ed.), *Post-Impressionists in England* (London: Routledge, 1988), 113.

[Board of Education], *The Differentiation of the Curriculum for Boys and Girls Respectively in Secondary Schools* (The Hadow Report) (London: HMSO, 1923).

[Board of Education], *The Primary School* (The Hadow Report) (London: HMSO, 1931).

Board of Trade, *The Working Party Report on Furniture* (London: HMSO, 1946).

Bourdieu, Pierre, *Distinction: A Social Critique of the Judgement of Taste* (London and New York: Routledge, 2010).

Braddock, Jeremy, *Collecting as Modernist Practice* (Baltimore, MD: Johns Hopkins University Press, 2012).

Brazil, Kevin, 'Histories of the Future: The Institute of Contemporary Arts and the Reconstruction of Modernism in Post-War Britain', *Modernism/modernity*, 23, 1 (January 2016): 193–217.

Breton, André, *The Lost Steps*, trans. Mark Polizzotti (Lincoln: University of Nebraska Press, 1996).

Brown, Bill, *A Sense of Things* (Chicago: Chicago University Press, 2003).

Brown, Oliver, *Exhibitions: The Memoirs of Oliver Brown* (London: Evelyn, Adams & Mackay, 1968).

Buckley, Cheryl, *Designing Modern Britain* (London: Reaktion, 2007).

Bulley, Margaret H., 'An Enquiry as to the Aesthetic Judgments of Children', *British Journal of Educational Psychology*, 4 (1934): 162–82.

Bulley, Margaret H., *Have You Good Taste?* (London: Methuen, 1933).

Burnett, John, *A Social History of Housing 1815–1985* (London: Routledge, 1986), 240–8.

Burstow, Robert, 'The Limits of Modernist Art as a "Weapon of the Cold War": Reassessing the Unknown Patron of the Monument to the Unknown Political Prisoner', *Oxford Art Journal*, 20, 1 (1997): 68–80.

Carline, Richard, *Draw They Must* (London: Edward Arnold, 1968).

Carrington, Noel, 'Britain Can Make It', *Country Life* (4 October 1946): 681–3.

Casson, Hugh, 'A National Enterprise: South Bank Show', in M. Banham and B. Hillier (eds), *A Tonic to the Nation: The Festival of Britain 1951* (London: Thames and Hudson, 1976), 78–81.

Catterson-Smith, Robert, *Drawing from Memory and Mind-Picturing* (London: Pitman, 1921).

Cheetham, Mark. A., *Artwriting, Nation and Cosmopolitanism in Britain: The 'Englishness' of Art Theory since the Eighteenth Century* (Farnham: Ashgate, 2012).

Clark, Kenneth, 'Introduction', in Marion Richardson, *Art and the Child* (London: University of London Press, 1948), 2–13.

Clark, Kenneth, 'Introduction', in Roger Fry, *Last Lectures* (Cambridge: Cambridge University Press, 1939), i–xi.

Clement, Alexander, *Brutalism: Post-War British Architecture* (Marlborough: The Crowood Press, 2011).

Cohen, Margaret, *Profane Illumination: Walter Benjamin and the Paris of Surrealist Revolution* (Berkeley and Los Angeles: University of California Press, 1993).

Coleridge, Stephen, [untitled], *English Review* (July 1925): 44–5.

Collings, Matthew, 'Damien Hirst and the British Art Show 2010', *Front Row* (22 October 2010), BBC Radio 4.

Collins, Judith, *The Omega Workshops* (London: Secker and Warburg, 1984).

Comentale, Edward, P., *Modernism, Cultural Production and the British Avant-Garde* (Cambridge: Cambridge University Press, 2004).

Conekin, Becky E., *The Autobiography of a Nation: The 1951 Festival of Britain* (Manchester: Manchester University Press, 2003).

Cooper, John Xiros, *Modernism and Culture of Market Society* (Cambridge: Cambridge University Press, 2004).

Cooper, Sam, *The Situationist International in Britain: Modernism, Surrealism and the Avant-Garde* (London: Routledge, 2017).

Cork, Richard, *Art Beyond the Gallery in the Early Twentieth Century* (New Haven, CT, and London: Yale University Press, 1985), 117–76.

[Council for Art and Industry], *Design and the Designer in Industry* (London: CAI, 1937).

[Council for Art and Industry], *The Working Class Home: Its Furnishing and Equipment* (London: CAI, 1937).

Crary, Jonathan, *Suspensions of Perception: Attention, Spectacle, and Modern Culture* (Cambridge, MA: MIT Press, 1999).

Crary, Jonathan, *Techniques of the Observer: On Vision and Modernity in the Nineteenth Century* (Cambridge, MA: MIT Press, 1990).

Crinson, Mark, 'Architecture and "National Projection" between the Wars', in Dana Arnold (ed.), *Cultural Identities and the Aesthetics of Britishness* (Manchester: Manchester University Press, 2004), 182–200.

Crinson, Mark and Claire Zimmerman (eds), *Neo-Avant-Garde and Postmodern: Postwar Architecture in Britain and Beyond* (New Haven, CT, and London: Yale University Press, 2011).

Crow, Thomas E., *Modern Art in the Common Culture* (New Haven, CT, and London: Yale University Press, 1996).

Darling, Elizabeth, *Re-Forming Britain: Narratives of Modernity before Reconstruction* (London: Routledge, 2006).

Davis, Thomas S., *The Extinct Scene: Late Modernism and Everyday Life* (New York: Columbia University Press, 2016).

Dettmar, Kevin J. H. and Stephen M. Watt (eds), *Marketing Modernisms: Self-Promotion, Canonization, Rereading* (Ann Arbor: University of Michigan Press, 1996).

Doubleday, K., 'The Creative Mind in Education', *New Era*, 17, 2 (February 1936): 19–24.

Edel, Leon, *Bloomsbury: A House of Lions* (London: Hogarth, 1979).

Eliot, T. S., 'Arnold and Pater', in *Selected Essays, 1917–1932* (New York: Harcourt Brace, 1950), 346–57.

Eliot, T. S., *Notes Towards the Definition of Culture* (London: Faber and Faber, 1972).

Eng, Helga, *The Psychology of Children's Drawings*, trans. H. Stafford Hatfield (London: Kegan Paul, 1931).

Esty, Jed, *A Shrinking Island: Modernism and National Culture in Britain* (Princeton, NJ: Princeton University Press, 2009).

[Exhibition Catalogue], *Britain Can Make It* (London: Council of Industrial Design, 1946).

[Exhibition Catalogue], *Surrealism in England: 1936 and After* (Canterbury: Kent County Council, 1986).

Fineberg, Jonathan (ed.), *Discovering Child Art: Essays on Childhood, Primitivism, Modernism* (Princeton, NJ: Princeton University Press, 2001).

Fineberg, Jonathan, *The Innocent Eye: Children's Art and the Modern Artist* (Princeton, NJ: Princeton University Press, 1997).

Fitzgerald, Michael C., *Making Modernism: Picasso and the Creation of the Market for Twentieth-Century Art* (Berkeley: University of California Press, 1996).

Flint, Kate, 'Moral Judgement and the Language of English Art Criticism, 1870–1910', *Oxford Art Journal*, 6, 2 (1983): 59–66.

Flint, Kate, *The Victorians and the Visual Imagination* (Cambridge: Cambridge University Press, 2000).

Fosca, François, 'Les arts: La duperie du surréalisme', *Je suis partout*, 375 (28 January 1938).

Friedberg, Anne, *Window Shopping: Cinema and the Postmodern* (Berkeley and Los Angeles: University of California Press, 1993).

Fry, Roger, 'A Modern Jeweller', *Burlington Magazine*, 17 (June 1910), 169–74.

Fry, Roger, 'Art and Socialism', in J. B. Bullen (ed.), *Vision and Design* (New York: Dover, 1998), 39–54.

Fry, Roger, 'Children's Drawings', *Burlington Magazine for Connoisseurs*, 30, 171 (June 1917): 225–7.

Fry, Roger, 'Children's Drawings', *Burlington Magazine for Connoisseurs*, 44, 250 (January 1924): 35–7, 41.

Fry, Roger, 'Expression and Representation in the Graphic Arts' [unpublished lecture], in Christopher Reed (ed.), *A Roger Fry Reader* (Chicago and London: University of Chicago Press, 1996), 61–75.

Fry, Roger, 'Fine-Art Gossip', *The Athenaeum* (23 May 1903): 665.

Fry, Roger, 'Ideals for a Picture Gallery', *Bulletin of the Metropolitan Museum*, I (March 1906): 59.

Fry, Roger, 'Pictures and the Modern Home', unpublished, undated MS for *Vanity Fair*, King's College Archives, Cambridge, 1/45.

Fry, Roger, 'Post-Impressionism', *Fortnightly Review* (new series) 95 (May 1911): 856–67.

Fry, Roger, 'Prospectus for the Omega Workshops', in Christopher Reed (ed.), *A Roger Fry Reader* (Chicago and London: University of Chicago Press, 1996), 198–200.

Fry, Roger, 'Retrospect' [1920], in *Vision and Design* (London: Chatto and Windus, 1920), 188–99.

Fry, Roger, 'Royal Academy', *Pilot* (12 May 1900): 321.

Fry, Roger, 'Teaching Art', *The Athenaeum* (12 September 1919): 882–9.

Fry, Roger, 'The Administration of the National Gallery', *The Athenaeum* (2 August 1902): 165.

Fry, Roger, 'The Art of Pottery in England', *Burlington Magazine*, 24, 132 (March 1914): 330–5.

Fry, Roger, 'The Artist as Decorator', in Christopher Reed (ed.), *A Roger Fry Reader* (Chicago and London: University of Chicago Press, 1996), 207–11.

Fry, Roger, 'The Chantrey Bequest' [I], in Christopher Reed (ed.), *A Roger Fry Reader* (Chicago and London: University of Chicago Press, 1996), 252–4.

Fry, Roger, 'The Chantrey Bequest' [II], in Christopher Reed (ed.), *A Roger Fry Reader* (Chicago and London: University of Chicago Press, 1996), 255–8.

Fry, Roger, 'The Courtauld Institute of Art', *Burlington Magazine* (December 1930): 317–18.

Fry, Roger, 'The Grafton Gallery: An Apologia', *The Nation* (9 November 1912): 250.

Fry, Roger, *The Letters of Roger Fry*, ed. Denys Sutton, vols 1 and 2 (London: Chatto and Windus, 1972).

Fry, Roger, 'The London Group', *Nation and Athenaeum* (12 May 1928): 11.

Fuller, Peter, 'William Lethaby, Keeping Art Ship-Shape', in Sylvia Backmeyer and Theresa Gronberg (eds), *W. R. Lethaby: 1857–1931: Architecture, Design and Education* (London: Lund Humphries, 1984), 29–38.

Fyrth, Jim (ed.), *Labour's Promised Land? Culture and Society in Labour Britain, 1945–1951* (London: Lawrence and Wishart, 1995).

Garrity, Jane, 'Selling Culture to the "Civilized": Bloomsbury, British *Vogue*, and the Marketing of National Identity', *Modernism/modernity*, 6, 2 (April 1999): 29–48.

Genter, Robert, *Late Modernism: Art, Culture, and Politics in Cold War America* (Philadelphia: University of Pennsylvania Press, 2010).

Gibbs, Evelyn, *The Teaching of Art in Schools* (London: Williams and Norgate, 1934).

Giedion, Siegfried, *Space, Time and Architecture: The Growth of a New Tradition* (Cambridge, MA: Harvard University Press, 1982 [1941]).

Gifford, James, 'Anarchist Transformations of English Surrealism: The Villa Seurat Network', *Journal of Modern Literature*, 33, 4 (Summer 2010): 57–71.

Gill, Eric, 'The Failure of the Arts and Crafts Movement', *The Socialist Review*, 4, 22 (December 1909): 289–300.

Gloag, John, *The English Tradition in Design* (London: Penguin, 1947).

Gluck, Mark, *Popular Bohemia: Modernism and Urban Culture in Nineteenth-Century Paris* (Cambridge, MA: Harvard University Press, 2005).

Goldwater, Robert, *Primitivism in Modern Art (Paperbacks in Art History)* (Cambridge, MA: Belknap Press, 1986).

Gordon, Jan, 'Contemporary Lithographs', *Penrose Annual*, 41 (1939): 42–9.

Gorrell, Lord [Roland Barnes], *Art and Industry: Report of the Committee Appointed by the Board of Trade under the Chairmanship of Lord Gorrell on the Production and Exhibition of Articles of Good Design and Everyday Use* (London: HMSO 1932).

Gottlieb, Adolph and Mark Rothko, 'Letter to *The New York Times*', in E. H. Johnson (ed.), *American Artists on Art from 1940 to 1980* (New York: Harper and Row, 1982), 14.

Gramsci, Antonio, *Selections from the Cultural Writings*, trans. William Boelhower (Cambridge, MA: Harvard University Press, 1985).

Green, Christopher, 'Expanding the Canon: Roger Fry's Evaluations of the "Civilized" and the "Savage"', in Christopher Green (ed.), *Art Made Modern: Roger Fry's Vision of Art* (London: Merrell Holberton and The Courtauld Gallery, 1999), 119–34.

Greenberg, Clement, *Art and Culture* (Boston, MA: Beacon, 1961).

Greenberg, Clement, 'Avant-Garde and Kitsch', *Partisan Review*, 6, 5 (1939): 34–49.

Greenberg, Clement, Transcript of a talk given at Western Michigan University (18 January 1983). See http://www.sharecom.ca/greenberg/taste.html for full transcript.

Greenough, Sarah, *Modern Art and America: Alfred Stieglitz and His New York Galleries* (Washington DC: Little, Brown and Co., 2001).

Gronow, Jukka, 'The Social Function of Taste', *Acta Sociologica*, 36, 2 (1993): 89–100.

Hahnloser-Ingold, Margrit, 'Collecting Matisses of the 1920s in the 1920s', in Jack Cowart (ed.), *Henri Matisse: The Early Years in Nice, 1916–1930* (Washington DC: The National Gallery of Art, 1986), 235–74.

Hall, Stuart and Tony Jefferson, *Resistance Through Rituals: Youth Subcultures in Post-War Britain* (London: Psychology Press, 1993).

Harrison, Charles, *English Art and Modernism, 1900–1939*, 2nd edn (New Haven, CT: Yale University Press, 1994).

Harrison, Charles, Francis Frascina and Gill Perry, *Primitivism, Cubism, Abstraction: The Early Twentieth Century (Modern Art: Practices and Debates)* (New Haven, CT: Yale University Press, 1993).

Harrisson, Tom, Humphrey Jennings and Charles Madge, 'Anthropology at Home,' *New Statesman and Nation* (30 January 1937): 155.

Hartman, Gertrude and Ann Shumaker, *Creative Expression: The Development of Children in Art, Music, Literature and Dramatics* (New York: John Day, 1932).

Hayes Marshall, H. G., *British Textile Designers Today* (Leigh-on-Sea: Frank Lewis, 1939).

Helmreich, Anne and Ysanne Holt, 'Marketing Bohemia: The Chenil Gallery in Chelsea, 1905–1926', *Oxford Art Journal*, 33, 1 (2010): 43–61.

Hind, Arthur M., 'Art in a Liberal Education: The Substance of a Paper Read before the Ascham Club, Oxford', *Burlington Magazine for Connoisseurs*, 47, 269 (August 1925): 81–4, 87.

Holder, Julian, '"Design in Everyday Things": Promoting Modernism in Britain, 1912–1944', in Paul Greenhalgh (ed.), *Modernism in Design* (London: Reaktion, 1990), 123–45.

Hollow, Matthew, 'Utopian Urges: Visions for Reconstruction in Britain, 1940–1950', *Planning Perspectives*, 27, 4 (2012): 569–86.

Huxley, Aldous, 'The Unknown God: Being Notes on a Caricature and Some Pictures at the Goupil Gallery by the Talented Young Landscape Painter, Gilbert Spencer', *Vogue*, 61, 2 (January 1923): 54–5.

Ironside, Robin, 'Art since 1939', in Robin Ironside (ed.), *Painting since 1939* (London: Longmans, Green & Co., 1948).

Isaacs, Susan, *Intellectual Growth in Young Children* (London: Routledge, 1944 [1932]).

Jennings, Humphrey, 'Surrealism', *Contemporary Poetry and Prose*, 8 (December 1936): 167.

Jensen, Robert, *Marketing Modernism in Fin de Siècle Europe* (Princeton, NJ: Princeton University Press, 1994).

Jolles, Adam, *The Curatorial Avant Garde: Surrealism and Exhibition Practice in France, 1925–1941* (Philadelphia: Pennsylvania State University Press, 2013).

Joyce, James, 'The Day of the Rabblement', in James Joyce, *The Critical Writings*, ed. Ellsworth Mason and Richard Ellman (New York: Viking, 1968).

Kachur, Lewis, *Displaying the Marvellous: Marcel Duchamp, Salvador Dali and Surrealist Exhibition Installation* (Boston, MA: MIT Press, 2001).

Kandinsky, Wassily, *The Art of Spiritual Harmony* [*Über das Geistige in der Kunst*], trans. Michael Sadler (London: Constable and Co., 1914 [1911]).

Kant, Immanuel, *Critique of Judgment*, trans. James Creed Meredith (New York: Oxford University Press, 2007 [1952]).

Karl, Alissa G., *Modernism and the Marketplace* (London: Routledge, 2009).

Kern, Stephen, *The Culture of Time and Space: 1880–1918* (Cambridge, MA: Harvard University Press, 1983).

Keynes, John Maynard, 'Art and the State', *The Listener* (7 May 1936): 18.

Keynes, John Maynard, *The Collected Writings of John Maynard Keynes. Essays in Biography*, vol. 10 (London: Macmillan, 1972).

Keynes, John Maynard, *The Collected Writings of John Maynard Keynes. Social, Political, and Literary Writings*, vol. 28 (London: Macmillan, 1982).

Kleinman, Kent, Joanna Merwood-Salisbury and Lois Weinthal (eds), *After Taste: Expanded Practices in Interior Design* (Princeton, NJ: Princeton Architectural Press, 2012).

Korn, Madeleine, 'Collecting Paintings by Matisse and by Picasso in Britain before the Second World War', *Journal of the History of Collections*, 16, 1 (2004): 111–29.

Lawrence, D. H., *Psychoanalysis and the Unconscious and Fantasia of the Unconscious* (New York: Dover, 2005).

Lawrence, Patricia, 'The Intimate Spaces of Community: John Maynard Keynes and the Arts', *Journal of the History of Political Economy*, 39 (Supplement 1) (2007): 292–313.

Le Corbusier, *The Decorative Art of Today*, trans. James Dunnett (Cambridge, MA: MIT Press, 1987 [1925]).

Le Corbusier, *Towards a New Architecture* [1923], trans. Frederick Etchells (New York: Dover, 1986).

Lee, Rupert, Typescript of introductory lecture, quoted in Denys J. Wilcox, *Rupert Lee: Painter, Sculptor and Printmaker* (Bristol: Sansom and Company, 2010), 113–14.

Lewis, Wyndham, 'Art in Industry', in Paul Edwards (ed.), *Wyndham Lewis: Creatures of Habit and Creatures of Change: Essays on Art, Literature and Society 1914–1956* (Santa Rosa, CA: Black Sparrow Press, 1989), 241–5.

Lewis, Wyndham, 'Home-Builder: Where Is Your Vorticist?', in Paul Edwards (ed.), *Wyndham Lewis: Creatures of Habit and Creatures of Change: Essays on Art, Literature and Society 1914–1956* (Santa Rosa, CA: Black Sparrow Press, 1989), 246–56.

Lewis, Wyndham, 'Life Has no Taste', *Blast*, 2 (1914): 82.

Lewis, Wyndham, 'Rebel Art in Modern Life', *Daily News and Leader* (7 April 1914), n.p.

Lewis, Wyndham, *The Art of Being Ruled*, ed. Reed Way Dasenbrock (Santa Rosa, CA: Black Sparrow Press, 1989).

Lewis, Wyndham, 'Super-Nature versus Super-Real', in Wyndham Lewis, *Wyndham Lewis The Artist: From 'Blast' to Burlington House* (New York: Haskell House, 1939), 11–64.

Lewison, Jeremy, 'Going Modern and Being British: The Challenge of the 1930s', in Henry Meyric Hughes and Gijs van Tuyl (eds), *Blast to Freeze: British Art in the Twentieth Century* (Amsterdam: Ostfildern-Ruit, 2002), 66–72.

Lloyd, A. L., 'Surrealism and Revolution', *Left Review*, 2, 16 (January 1937): 895–8.

Löwy, Michael, 'Revolution against Progress: Walter Benjamin's Romantic Anarchism', *New Left Review*, 152 (July–August 1985): 42–59.

Lubbock, Jules, *The Tyranny of Taste: The Politics of Architecture and Design in Britain, 1550–1960* (New Haven, CT, and London: Yale University Press, 1995), 313.

MacCarthy, Desmond, *Manet and the Post Impressionists* (London: Grafton Galleries, 1910), 12.

MacCarthy, Desmond, 'The Post-Impressionists' [Introduction to the Catalogue of 'Manet and the Post-Impressionists'], in J. B. Bullen (ed.), *Post-Impressionists in England* (New York: Routledge, 1988), 94–9.

MacColl, D. S., *Confessions of a Keeper and Other Papers* (London: Alexander Maclehose & Co., 1931).

McMillan, Margaret, *Education Through the Imagination* (London: Swann, Sonnenschein & Co, 1904).

Madge, Charles, 'Surrealism for the English', *New Verse*, 6 (December 1933): 14–16.

Maguire, Patrick J. and Jonathan M. Woodham (eds), *Design and Cultural Politics in Postwar Britain: The Britain Can Make It Exhibition of 1946* (Leicester: Leicester University Press, 1997).

Malvern, Sue, *Modern Art, Britain and the Great War* (New Haven, CT: Yale University Press, 2004).

Massey, Anne, *The Independent Group: Modernism and Mass Culture in Britain 1945–59* (Manchester: Manchester University Press, 1995).

Matthews, J. H., 'Surrealism and England', *Comparative Literature Studies*, 1, 1 (1964): 55–72.

Meacham, Standish. *Regaining Paradise: Englishness and the Early Garden City Movement* (New Haven, CT: Yale University Press, 1999).

Mellor, David, 'The Pleasures and Sorrows of Modernity: Vision, Space and the Social Body in Richard Hamilton', in *Richard Hamilton* [exhibition catalogue] (London: Tate Gallery, 1992).

Mickalites, Carey James, *Modernism and Market Fantasy: British Fictions of Capital, 1910–1939* (London: Palgrave Macmillan, 2012).

Miller, Tyrus, 'Documentary/Modernism: Convergence and Complementarity in the 1930s', *Modernism/modernity*, 9, 2 (April 2002): 226–41.

Miller, Tyrus, *Late Modernism: Politics, Fiction, and the Arts between the World Wars* (Irvine: University of California Press, 1999).

Moffat, Isabelle, '"A Horror of Abstract Thought": Postwar Britain and Hamilton's 1951 "Growth and Form" Exhibition', in *October*, 94 (Autumn 2000): 89–112.

Morris, William, 'Making the Best of It', in *The Collected Works of William Morris*, ed. May Morris, vol. 22 (London: Longmans Green, 1910–15), 81–118.

Mort, Frank, 'Fantasies of Metropolitan Life: Planning London in the 1940s', *Journal of British Studies*, 43 (January 2004): 120–51.

Nash, Paul, *Outline* (London: Columbus, 1998), 102.

Newton, Eric, 'Art for Everybody' (London: British Council Pamphlet, 1943), n.p.

Nicholson, Benedict, 'Post-Impressionism and Roger Fry', *Burlington Magazine*, 93, 574 (January 1951): 10–15.

Painter, Colin (ed.), *Contemporary Art and the Home* (Oxford and New York: Berg, 2002).

Peach, H. H., 'Museums and the Design and Industries Association', *American Magazine of Art*, 7, 5 (March 1916): 197–200.

Peppis, Paul, *Literature, Politics and the English Avant-Garde* (Cambridge: Cambridge University Press, 2000).

Pick, Frank, 'The Creative Purpose Leading up to Art and Industry' [London Transport Museum Archive, B39] (13 February 1937).

Pound, Ezra, *Guide to Kulchur* (New York: New Directions, 1970).

Pound, Ezra, 'Murder by Capital', in *The Selected Prose of Ezra Pound: 1909–1965*, ed. William Cookson (New York: New Directions, 1973), 227–32.

Pound, Ezra, 'The New Sculpture', *The Egoist*, 4, 1 (16 February 1914): 68.

Prettejohn, Elizabeth, 'Out of the Nineteenth Century: Roger Fry's Early Art Criticism', in Christopher Green (ed.), *Art Made Modern: Roger Fry's Vision of Art* (London: Merrell Holberton and The Courtauld Gallery, 1999), 31–44.

Rainey, Lawrence, *Institutions of Modernism: Literary Elites and Public Culture* (New Haven, CT: Yale University Press, 1998).

Read, B. I., *The Man from New York: John Quinn and his Friends* (Oxford: Oxford University Press, 1968).

Read, Herbert, *Art and Industry: The Principles of Industrial Design* (London: Faber and Faber, 1934).

Read, Herbert, *Art and Society* (London: Faber and Faber, 1967 [1936]).

Read, Herbert, *Education Through Art* (London: Faber and Faber, 1956 [1943]).

Read, Herbert, 'In Defence of Shelley', in Herbert Read, *In Defence of Shelley and other Essays* (London: Heinemann, 1936).

Read, Herbert, *Surrealism* (London: Faber and Faber, 1936).

Read, Herbert, *The Philosophy of Modern Art* (London: Faber and Faber, 1954).

Read, Herbert, *The Politics of the Unpolitical* (London: Routledge, 1943).

Read, Herbert, 'Threshold of a New Age', in J. R. R. Brumwell (ed.), *This Changing World* (London: Readers Union, 1945), 7–14.

Read, Herbert, 'Why the English Have no Taste', *Minotaure*, 7 (1935): 67–8.

Reed, Christopher, 'Architecture and the Decorative Arts', in Christopher Reed (ed.), *A Roger Fry Reader* (Chicago and London: University of Chicago Press, 1996), 167–91.

Reed, Christopher, *Bloomsbury Rooms: Modernism, Subculture and Domesticity* (New Haven, CT: Yale University Press, 2004).

Reed, Christopher (ed.), *Not at Home: The Suppression of Domesticity in Modern Art and Architecture* (London: Thames and Hudson, 1996).

Reilly, Paul, 'The Role of the Design Council before, during and after the Festival of Britain', in M. Banham and B. Hillier (eds), *A Tonic to the Nation: The Festival of Britain 1951* (London: Thames and Hudson, 1976), 58–61.

Remy, Michel, *Surrealism in Britain* (Aldershot: Ashgate, 1999).

Ricketts, Charles, 'Post-Impressionism', *Morning Post* (9 November 1910): 6.

Robins, Anna Gruetzner, 'Fathers and Sons: Walter Sickert and Roger Fry', in Anna Gruetzner Robins, *Modern Art in Britain, 1910–1914* (London: Merrell Holberton, 1997), 45–56.

Robins, Anna Gruetzner, '"Manet and the Post-Impressionists": A Checklist of Exhibits', *Burlington Magazine*, 152 (December 2010): 782–93.

Robins, Anna Gruetzner (ed.), *Modern Art in Britain 1910–1914* (London: Merrell Holberton, 1997).

Rodker, John, 'The "New" Movement in Art', *Dial Monthly* (May 1914): 185–6.

Rose, Jonathan, 'Lady Chatterley's Broker: Banking on Modernism', in Pamela L. Caughie (ed.), *Disciplining Modernism* (Basingstoke: Palgrave, 2010), 182–96.

Rosenbaum, S. P., *Aspects of Bloomsbury: Studies in Modern English Literary and Intellectual History* (Basingstoke: Macmillan, 1998).

Rosenquist, Rod, *Modernism, the Market, and the Institution of the New* (Cambridge: Cambridge University Press, 2009).

Rosner, Victoria, *Modernism and the Architecture of Private Life* (New York: Columbia University Press, 2005).

Roughton, Roger, 'Surrealism and Communism', *Contemporary Poetry and Prose*, 4 (August–September 1936): 74–5.

Rupprecht, Philip, *British Musical Modernism: The Manchester Group and their Contemporaries* (Cambridge: Cambridge University Press, 2015).

Ruskin, John, *Stones of Venice* in *The Library Edition of the Works of John Ruskin*, vol. 10, ed. E. T. Cook and Alexander Wedderburn (London: George Allen, 1905).

Rutter, Frank, 'Art Exhibitions', *Sunday Times* (9 April 1933): 13.

Rutter, Frank, *Evolution in Modern Art: A Study of Modern Painting 1870–1925* (London: Harrap and Co., 1926).

Saler, Michael T., *The Avant-Garde in Interwar England: Medieval Modernism and the London Underground* (New York: Oxford University Press, 1999).

San Juan Jr, E., 'Antonio Gramsci on Surrealism and the Avant Garde', *Journal of Aesthetic Education*, 37, 4 (Summer 2003): 31–45.

Sassoon, Rosemary, *Marion Richardson: Her Life and Her Contribution to Handwriting* (Bristol: Intellect Books, 2011).

Saunders, Frances Stoner, *Who Paid the Piper? The CIA and the Cultural Cold War* (London: Granta, 2000).

Sharp, Dennis and Sally Rendell, *Connell Ward and Lucas: Modern Movement Architects in England 1929–39* (London: Frances Lincoln, 2008).

Shaw, R. and G. Shaw, 'The Cultural and Social Setting', in Boris Shaw (ed.), *The Cambridge Guide to the Arts in Britain*, vol. 9 (Cambridge: Cambridge University Press, 1988).

Shone, Richard, 'Matisse in England and Two English Sitters', *Burlington Magazine*, 135, 1084 (July 1993): 479–84.

Sickert, Walter, 'Post-Impressionists', *Fortnightly Review* (new series) 95 (January 1911): 79–89.

Siegel, Jonah, *Desire and Excess: The Nineteenth-Century Culture of Art* (Princeton, NJ: Princeton University Press, 2000).

Silverstein, Steven M. and Peter J. Uhlhaas, 'Gestalt Psychology: The Forgotten Paradigm in Abnormal Psychology', *The American Journal of Psychology*, 117, 2 (Summer 2004): 259–77.

Smith, Peter, 'Another Vision of Progressivism: Marion Richardson's Triumph and Tragedy', *Studies in Art Education*, 37, 3 (Spring 1996): 170–83.

Spalding, Frances, *John Piper, Myfanwy Piper: Lives in Art* (Oxford: Oxford University Press, 2009).

Spalding, Frances, *Vanessa Bell: A Biography* (London: Weidenfeld and Nicolson, 1983).

Sparke, Penny, 'Taste and the Interior Designer', in Kent Kleinman, Joanna Merwood-Salisbury and Lois Weinthal (eds), *After Taste: Expanded Practices in Interior Design* (Princeton, NJ: Princeton Architectural Press, 2012), 14–27.

Sparke, Penny, *The Modern Interior* (London: Reaktion, 2008).

Stansky, Peter, *On or About December 1910: Early Bloomsbury and Its Intimate World* (Cambridge, MA: Harvard University Press, 1997).

Styhr, E. H., 'A Summary of Art Teaching', *Athene*, 1, 1 (1939): 6–12.

Suga, Yasuko, 'Modernism, Commercialism and Display Design in Britain: The Reimann School and Studios of Industrial and Commercial Art', *Journal of Design History*, 19, 2 (2006): 137–54.

Teukolsky, Rachel, *The Literate Eye: Victorian Art Writing and Modernist Aesthetics* (Oxford: Oxford University Press, 2009).

Thacker, Andrew, 'London: Rhymers, Imagists, and Vorticists', in Peter Brooker, Andrzej Gasiorek, Deborah Longworth and Andrew Thacker (eds), *The Oxford Handbook of Modernisms* (Oxford: Oxford University Press, 2010), 687–705.

Tickner, Lisa, *Modern Life and Modern Subjects: British Art in the Early Twentieth Century* (New Haven, CT: Yale University Press, 2000).

Tomlinson, R. R., *Picture Making by Children* (London: Studio Ltd, 1934).

Tonson, Jacob [Arnold Bennett], 'Books and Persons', *New Age*, 8 (December 1910): 135.

Unger, Leonard, *T. S. Eliot, A Selected Critique* (New York: Rinehart, 1948).

Vidler, Anthony, 'Outside In/Inside Out: A Short History of (Modern) Interiority', in Kent Kleinman, Joanna Merwood-Salisbury and Lois Weinthal (eds), *After Taste: Expanded Practice in Interior Design* (Princeton, NJ: Princeton Architectural Press, 2012), 54–77.

Viola, Wilhelm, *Child Art and Franz Cižek* (Vienna: Austrian Junior Red Cross, 1936).

Wees, William C., *Vorticism and the English Avant-Garde* (Toronto: Toronto University Press, 1972).

Whistler, James McNeill, *The Gentle Art of Making Enemies* (London: Heinemann, 1892).

Whyte, William, 'The Englishness of English Architecture: Modernism and the Making of a National International Style, 1927–1957', *Journal of British Studies*, 48, 2 (April 2009): 441–65.

Wicke, Jennifer, 'Coterie Consumption: Bloomsbury, Keynes, and Modernist as Marketing', in Kevin J. H. Dettmar and Stephen Watt (eds), *Marketing Modernisms: Self-Promotion, Canonization, and Rereading* (Ann Arbor: The University of Michigan Press, 1996), 109–33.

Wilde, Oscar, *The Soul of Man under Socialism and Selected Critical Prose*, ed. Linda Dowling (London: Penguin, 2001).

Wilenski, R. H., 'Art Matters', *Athenaeum* (19 November 1919): 1402.

Wilford, Hugh, *The Mighty Wurlitzer: How the CIA Played America* (Cambridge, MA, and London: Harvard University Press, 2008).

Williams, Raymond, 'Metropolitan Perceptions and the Emergence of Modernism', in *The Politics of Modernism* (London and New York: Verso, 1997 [1988]).

Williams, Raymond, 'The Arts Council', *Political Quarterly*, 50, 2 (1979): 157–71.

Williams, Raymond, 'The Bloomsbury Fraction', *Culture and Materialism: Selected Essays* (London: Verso, 2005 [1980]), 148–70.

Williams, W. E., Pamphlet for 'Art for the People Scheme' (London: Institute of Adult Education, 1938).

Williams, W. E., 'The Pre-History of the Arts Council', in E. M. Hutchinson (ed.), *Aims and Action in Adult Education, 1921–1971* (London: British and National Institutes of Adult Education, 1971), 51–68.

Wols, *Aphorisms and Pictures*, trans. Peter Inch and Annie Fatet (Gillingham: Arc Press, 1971).

Wolfe, Jesse, *Bloomsbury, Modernism and the Invention of Intimacy* (Cambridge: Cambridge University Press, 2011).

Woodcock, George, *Herbert Read: The Stream and the Source* (London: Black Rose Books, 2008).

Woodham, Jonathan, 'Design and Everyday Life at the Britain Can Make It Exhibition, 1946', *Journal of Architecture*, 9, 4 (2004): 463–76.

Woodham, Jonathan M., 'The Politics of Persuasion: State, Industry and Good Design at the *Britain Can Make It* Exhibition', in Patrick J. Maguire and Jonathan M. Woodham (eds), *Design and Cultural Politics in Postwar Britain* (Leicester: Leicester University Press, 1997), 45–66.

Woolf, Virginia, 'Middlebrow', in *The Death of the Moth and Other Essays* (New York: Harcourt Brace, 1974 [1942]).

Woolf, Virginia, *Roger Fry: A Biography* (London: Hogarth Press, 1991).

Woolf, Virginia, *The Moment and Other Essays* (New York: Harcourt Brace, 1948).

Wörwag, Barbara, '"There Is an Unconscious, Vast Power in the Child": Notes on Kandinsky, Münter and Children's Drawings', in Jonathan Fineberg (ed.), *Discovering Child Art: Essays on Childhood, Primitivism, Modernism* (Princeton, NJ: Princeton University Press, 2001), 68–94.

Index